THE ART OF WRITING
ABOUT ART

THE ART OF WRITING ABOUT ART

SUZANNE HUDSON

University of Colorado

NANCY NOONAN-MORRISSEY

Australia • Canada • Mexico • Singapore • Spain • United Kingdom • United States

PUBLISHER	Earl McPeek
EXECUTIVE EDITOR	David Tatom
ACQUISITIONS EDITOR	John Swanson
MARKET STRATEGIST	Steve Drummond
DEVELOPMENTAL EDITOR	Peggy Howell
PROJECT EDITOR	Laura Hanna
ART DIRECTOR	Sherry Ahlstrom
PRODUCTION MANAGER	Linda McMillan

ISBN: 0-15-506154-2
Library of Congress Control Number: 2001089966

Wadsworth Group/Thomson Learning
10 Davis Drive
Belmont CA 94002-3098
USA

For information about our products, contact us:
Thomson Learning Academic Resource Center
1-800-423-0563
http://www.wadsworth.com

For permission to use material from this text, contact us by
Web: http://www.thomsonrights.com
Fax: 1-800-730-2215
Phone: 1-800-730-2214

Copyrights and acknowledgments appear on page 211, which constitutes a continuation of the copyright page.

Printed in the United States of America
10 9 8 7

PREFACE

We have come to this project from the shared experience of teaching at the same college in our respective fields of art history and English. As colleagues, we felt, and still do feel, that students in all disciplines, not just English, should be required to write and that their instructors should hold these writing assignments to high standards. There are at least two problems with converting this concept into reality. First, instructors do not have time to teach writing in addition to their own subjects, and are therefore often inclined to evaluate papers more on content and less on the quality of the writing itself. The second problem is that although many students desire to write better papers, they do not know how. Writing about art, in particular, demands advanced skills not only in college-level composition, but also in verbalizing the experience of art—the historical, social, economic and political forces that shape art and artists; art theory; and the interplay between artist and viewer. We feel that instructors and students alike need a comprehensive writing guide to accompany art appreciation and art history textbooks such as Lois Fichner-Rathus's *Understanding Art* and *Gardner's Art through the Ages*. Thus is born *The Art of Writing about Art*.

The Art of Writing about Art begins by teaching the principles of effective writing, placing particular emphasis upon the formulation of a clear thesis statement, written in the appropriate mode of discourse. We advocate that students organize their essays according to points of proof—reasons why they believe their thesis to be true. Such a simple frame tends to generate focused, organized essays on art, as well as essays containing insightful and complex ideas that would be difficult to comprehend without a discernible shape. In this regard, art and writing are allies, both driven by the compositon of elements toward the advancement of ideas.

This textbook also provides students with the requisite vocabulary for verbalizing the art experience. The unwieldy task of writing about art becomes manageable when students possess the terminology to discuss the artwork in terms of its components, such as line, perspective, iconography, medium, and style. Students find that concentrating on one component at a time generates more words, more ideas, more understanding of the art than they would have expected.

The Art of Writing about Art further assists students by providing numerous examples of writing about art, produced by arts and humanities students, artists, and professional writers. Examples include formal analyses, expository and argumentative essays, exhibition reviews, essay examinations and research papers. The book assists students in the planning stages

by offering numerous topic suggestions, library and Internet research techniques, templates for planning and outlining essays, exercises in evaluating the workability of thesis statements, and advice in organizing the evidence for their assertions. The book aids students in developing introductions, conclusions, and body paragraphs; citing sources in both the MLA and footnote numbering documentation styles; and in the finishing touches of writing titles, revising, editing, proofreading, and formatting papers. A handbook uses art-based examples to demonstrate principles of grammar and style particular to the discipline of writing about art.

In combining these two applications—composition and critical inquiry into the discipline of art—*The Art of Writing about Art* meets both the needs of arts and humanities students and the needs of instructors whose valuable class time should be devoted not to teaching writing, but to what they teach best—the various forms of art and its role in our cultural heritage.

We would like to thank all of our contributing students as well as the following reviewers for their suggestions: Stephanie S. Dickey, Herron School of Art, Indiana University-Purdue University Indianapolis; Eloise Augiola, University of Alabama; Judy Kay Knopf, Jefferson State Community College; H. Perry Chapman, University of Delaware; Bernadine Heller-Greenman, Florida International University; and Joanne Mannell Noel, Montana State University. We would also like to thank all the people at Harcourt who assisted us with this project: John Swanson, acquisitions editor; Peggy Howell, development editor; Laura Hanna, senior project editor; Sherry Ahlstrom, art director; and Linda McMillan, production manager. We would like to extend special thanks as well to Richard Morrissey for his enthusiastic support.

TABLE OF CONTENTS

INTRODUCTION XIII

 Why Write about Art? xiii

 How Will This Book Help? xiii

CHAPTER ONE
PRINCIPLES OF EFFECTIVE WRITING 1

 The Four Modes of Discourse 2
 Narration 2
 Description 2
 Exposition 3
 Argument 5

 Types of Writing about Art 6
 Essays 6
 Critical Essays 6
 The Comparative Essay 6
 The Formal Analysis 7
 The Exhibition Review 7
 Research Papers 7
 Other Types of Writing about Art 8
 The Artist's Statement 8
 Museum and Gallery Labels 9
 Catalogue Entries 10

 Approaches to Art Criticism 11
 Diaristic Art Criticism 12
 Formalistic Art Criticism 12
 Contextualist Art Criticism 13
 Psychoanalytical Art Criticism 13
 Ideological Art Criticism 14

 The Process for Writing about Art 17
 Planning Your Essay 17
 Choosing a Topic 18
 Posing a Research Question 18
 Researching Your Topic and Taking Notes 19
 Finding a Thesis 19
 Identifying the Counterarguments 20
 Asking the Proof Question 20

Designing Your Points of Proof 20

Outlining Your Essay 21

Writing Your Essay 21

Writing the Introduction 21

Organizing the Evidence 22

Writing the Body Paragraphs 22

Writing the Conclusion 25

Citing Your Sources 26

Writing a Title 26

Revising, Editing, and Proofreading Your Paper 27

Formatting Your Paper 27

CHAPTER TWO
THE LANGUAGE OF ART AND THE FORMAL ANALYSIS 29

The Language of Art 30

Subject Matter 30

Formal Elements 33

Principles of Design 36

Balance 37

Unity and Variety 38

Proportion and Scale 38

Rhythm 39

Medium 39

Style or "Ism" 39

The Formal Analysis 40

Planning the Formal Analysis 40

Writing the Formal Analysis 42

A Sample Formal Analysis Essay 43

"Chantet Lane: A Post-Impressionist Walk in the American Southwest"
by Ron Baxendale II 43

Revising, Editing, and Proofreading Your Paper 50

Revision Checklist 50

CHAPTER THREE
WRITING THE EXPOSITORY ESSAY 51

Planning Your Essay 52

A Sample Expository Essay 57

"Strength in Stone: Michelangelo's *David*" by Nancy Noonan-Morrissey 57

Topic Suggestions for Expository Essays 60

Templates for Planning the Expository Essay 63

Sample Expository Essays 64

"Gothic Nightmares in Romantic Painting"
by Rachel Gothberg 66

Organizing the Comparison-Contrast Essay 73
"Don't Worry, Be Happy: Minoan Art and Architecture"
by Donald Coffelt 75
"Nobility in Human Suffering in the Work of Théodore Géricault"
by Rachel Gothberg 79

Revising, Editing, and Proofreading Your Paper 85
Revision Checklist 85

CHAPTER FOUR
WRITING THE ARGUMENTATIVE ESSAY **87**

Choosing a Topic 87

Topic Suggestions 88

Planning the Argumentative Essay 88
Introduction 88
Thesis 89
Points of Proof 92

Template for Organizing the Argumentative Essay 92

Writing the Body Paragraphs 94

A Sample Argumentative Essay 95
"American Myths, Patriotism, and Art" by Luis Vigil 97

Revising, Editing, and Proofreading Your Paper 103
Revision Checklist 103

CHAPTER FIVE
WRITING THE ESSAY EXAMINATION **105**

Preparing for the Examination 105

Taking the Examination 108
Before You Begin Writing 108
Preparing to Answer the Essay Question 108
Writing the Essay 109

A Sample Essay Examination Question and Answer 109
Before Turning in the Exam 113

CHAPTER SIX
WRITING THE EXHIBITION REVIEW **115**

Audience and Purpose 116

A Sample Review 118

"Knavery, Trickery, and Deceit" by Karen Wilkin 118

Visiting the Gallery or Museum 122
 Written Material at the Show or Exhibition 123
 Audio Program 123
 Moving through the Exhibition 123

Organizing Your Material 124

Writing the Introduction 124
 Writing a Working Thesis 125
 Developing a Controlling Idea for Your Introduction 125
 The Historical Introduction 125
 The Unpopular Opinion 126
 The Analogy 126
 What I Expected versus What I Got 126
 The Comparison 127
 The First Impression 127
 Strength of the Artist 127
 The Question 128
 Ending the Introductory Paragraph with a Thesis 128

Writing the Body Paragraphs 129
 Theme 129
 The Artist(s) 130
 Description of Works 130
 Subject Matter 131
 The Formal Elements 131
 Principles of Design 133
 The Medium 133
 The Style or "Ism" 134
 Uniqueness 134
 Comparable and Influential Artists 135
 Social Context 136
 Historical Reference 137
 Exhibition Display 137

Writing the Conclusion 138
 The Historical Conclusion 139
 The Quotation 139
 Welcome or Congratulations 140
 The Final Impression 140
 Predict the Future 141
 One Work of Art 141

Writing a Title 141

Revising, Editing, and Proofreading Your Review 142
 Revision Checklist 142

CHAPTER SEVEN
WRITING THE RESEARCH PAPER 143

Choosing a Topic 144

Researching the Topic 145

Searching the Library 145

Finding Books 145

Finding Periodical Articles 146

Finding Newspaper Articles 148

Searching the Internet 148

Templates for Planning the Research Paper 149

Writing the Research Paper 152

Using Sources 152

Paraphrasing versus Plagiarizing 152

Original Passage from Source 152

Illegitimate Paraphrase 153

Legitimate Paraphrase 153

Incorporating Quotations into Your Paper 153

Acknowledged Quotation: Correct 153

Unacknowledged Quotation: Incorrect 153

Citing Sources 154

Numbered Notes System 154

First, Full Reference 155

Second, or Subsequent, References 156

Bibliography 156

A Sample Research Paper 157

"Ben Shahn's Use of Photography in His Paintings"
by Peter Scaliese 158

MLA (Modern Language Association) Documentation System 166

Models for Parenthetical Source Citations 166

Special Punctuation Considerations When Citing Sources 167

The Works Cited Page 168

A Sample Research Paper 168

"The Elgin Marbles: Saved or Stolen?" by Emily O'Connor 169

Revising, Editing, and Proofreading Your Research Paper 183

Revision Checklist 183

HANDBOOK 185

Definitions of Basic Terms 185

Parts of Speech 185

Sentence Parts 188

Phrases 189
Clauses 190
Sentence Types 191

Choosing Words 191
Choosing Verbs 191
Choosing Pronouns 193
Wordiness 195
Nonsexist Language 196
Tone 196

Sentence Structures 198
Sentence Fragments 198
Run-on Sentences 199
Awkward Sentence Constructions 200

Punctuation 203
Comma 203
Semicolon 205
Colon 206
Dash 206
Apostrophe 206
Quotation Marks 207

CREDITS 211

NOTES 213

BIBLIOGRAPHY 216

INDEX 219

INTRODUCTION

WHY WRITE ABOUT ART?

Why write about art? After you have seen the artwork, what's the point of transferring that essentially visual experience to a written form? Upon examination, it becomes clear that art lovers derive enormous benefits from writing about art. Knowing that you are viewing art with a writing assignment in mind forces you to look much more carefully at the art. The nature of the exercise itself mandates that you slow down and focus on the work in front of you. You find yourself noticing elements that you might not have noticed had you not been *looking* with *writing* in mind. Information that you have learned in your art appreciation and art history classes comes to mind as you consider what you will write about the work. Then, as the evaluative process develops, you form questions about the art that will undoubtedly assist your written piece.

By seeing more deeply, you understand the work more fully, and your appreciation of the art will intensify. This careful looking will allow you to articulate your perceptions to the reader and will lead to specific word choices, instead of vague and general ones. In essence, you instruct yourself before instructing your readers, enhancing the experience for all concerned. Through your written words, the passion and creativity that went into the artist's vision can be conveyed to the reader, keeping the love and appreciation of art alive in our world. And, after all, what's a world without art and those who love it?

HOW WILL THIS BOOK HELP?

As students enrolled in art appreciation, art history, and even art studio classes, you are frequently required to write papers. It is unlikely that your professor will take class time to go through writing instructions, yet you will be expected to write clear, cogent papers. *The Art of Writing about Art* will assist you in tailoring your writing to the particular language and concepts of art and to the considerations one takes into account when approaching a writing assignment about art. This book will introduce you not only to the language and tenets of art itself, but also to the areas of brainstorming, organizing, developing, and polishing your essays, breaking the writing process down into small, manageable tasks and providing numerous examples and writing suggestions. In essence, *The Art of Writing about Art* will serve as your personal art and writing tutor, combining the two disciplines to assist you in any writing assignment about art.

PRINCIPLES OF EFFECTIVE WRITING

The Four Modes of Discourse	*Narration*
	Description
	Exposition
	Argument
Types of Writing about Art	*Essays*
	Exhibition Reviews
	Research Papers
	The Artist's Statement
	Museum and Gallery Labels
	Catalogue Entries
Approaches to Art Criticism	*Diaristic*
	Formalistic
	Contextualist
	Psychoanalytical
	Marxist
	Feminist
	Multicultural
The Process for Writing about Art	*Planning*
	Writing
	Revising
	Editing
	Proofreading
	Formatting

Kindred spirits, art and writing spring from the same well of inspiration, the desire for personal expression. Eons ago an artist sauntered into a deeply recessed chamber of a cave and, with bristle brush and ocher, set about painting a life-size image of a bison on the wall, an image that has survived through the centuries. William Faulkner explains that same urge from the writer's point of view: "Really the writer [. . .] knows he has a short span of life, that the day will come when he must pass through the wall of oblivion, and he wants to leave a scratch on that wall—Kilroy was here—that some-body a hundred, or a thousand years later will see."[1] For whatever reasons, both artists and writers desire to leave a mark, to create an image, to communicate some idea. And in the process, they often leave something for posterity, a creation for all of us to ponder and enjoy.

Effective writing about art can be achieved through many methods. Most often, the effectiveness of your writing depends upon understanding your audience and purpose and adjusting your tone and style accordingly. An informal style is appropriate in many settings; a formal style is more often appropriate in academic writing. Effective writing also depends upon your understanding of certain principles, such as the differences between descriptive writing and expository writing, the qualities of a workable thesis, and the concept of development. The purpose of this chapter is to explain the terms and concepts that will be mentioned throughout this book and that, through familiarity, you will use to your advantage in the creation of essays and research papers on art.

THE FOUR MODES OF DISCOURSE

Most linguists agree that when we engage in discourse, that is, when we communicate either verbally, in writing, or even in body language, we do so in one of the four modes of discourse—**narration, description, exposition, or argument.** Your papers about art will probably be written in one of the latter three modes, but it is easier to understand exactly what that means when all four modes are defined and explained.

NARRATION

Narration is storytelling. A narrative may be either fiction or nonfiction. In either case, a narrative tells what happened. Generally, there is conflict in a narrative; someone must overcome or be overcome by some force or obstacle. Much art arises from stories. The Greek sculpture of Laocoön and his sons from the Hellenistic period, for example, depicts a scene from Virgil's *Aeneid*. Laocoön, a Trojan priest, had tried to warn the Trojans against bringing the Greeks' wooden horse inside the city walls. The gods who favored the Greeks in their war against the Trojans sent a pair of sea serpents to punish Laocoön. The sculpture captures the moment in which Laocoön and his two sons are strangled and bitten by the serpents. If you were writing an essay on the sculpture, you would likely include the story of Laocoön, but the bulk of the essay would be written in one of the following three modes of discourse.

DESCRIPTION

Often, the definition of a **descriptive essay** is "an essay that tells how a person, place, or thing is perceived by the five senses." For our purposes, this definition is too narrow because it implies that only tangible things can be described. Intangibles, such as your feelings as you stand before an artwork,

can also be described or you could describe an artist's character, which is intangible, rather than his appearance. It would be a descriptive statement, for example, to say that "Caravaggio was temperamental." You could also describe an action, such as Jackson Pollock's technique of dripping and splattering. You might describe the historical context in which a work of art was produced. Even divulging another person's opinion is descriptive writing. For example, if you write that "Picasso disdained nonrepresentational art, remarking that it was inconceivable to work without a recognizable subject," you are writing descriptively. You are describing Picasso's opinion, not your own. Only when you are advancing your own opinion are you engaged in either exposition or argument.

In short, descriptive writing divulges both abstract information and concrete information objectively. The following paragraph from historian Barbara Tuchman's book, *Practicing History,* is descriptive:

> Embellishment was integral to the construction [of Gothic cathedrals]. Reims is populated by five thousand statues of saints, prophets, kings and cardinals, bishops, knights, ladies, craftsmen and commoners, devils, animals and birds. Every type of leaf known in northern France is said to appear in the decoration. In carving, stained glass, and sculpture the cathedrals displayed the art of medieval hands, and the marvel of these buildings is permanent even when they no longer play a central role in everyday life. Rodin said he could feel the beauty and presence of Reims even at night when he could not see it. "Its power," he wrote, "transcends the senses so that the eye sees what it sees not."[2]

EXPOSITION

Exposition (sometimes called **analysis**) is the mode of discourse that evaluates, interprets, or speculates. It differs from description in that **inference** is at its core. An inference is a conclusion derived from facts, but it is not itself a fact. It is a guess or a theory, albeit an educated one. If, for example, your classmate finishes a midterm exam early and walks out of the room with a huge smile on her face, you might infer that she is happy with her performance on the exam. You could be wrong, of course. She might not have known any of the answers but feel elated over her free tickets to the Matisse exhibition at the museum that afternoon. Your inference, however, given the circumstances, is a reasonable, educated one.

An inference is the result of **inductive reasoning.** Inductive reasoning moves from specific to general: you are in possession of some specific facts, and from them you move to a conclusion or inference. That move is called an **inductive leap.** Your inference is considered valid when there are enough facts in support of it to convince an educated, sympathetic, yet skeptical audience. If your inference is based on scant evidence, you'll be accused of "jumping to conclusions," as the common expression goes. In the foregoing example, the pieces of evidence that you put together were the relative importance of the exam to the student's final grade, the quick finishing of the

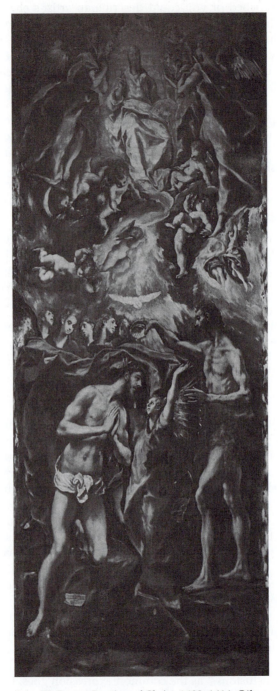

1-1　El Greco, *Baptism of Christ*, 1608–1614. Oil on canvas, 330 cm x 211 cm. Hospital de San Juan Bautista de Afuera, Toledo.

exam, and the smile. Together, they created an impression on you. You inferred something from them.

There are three primary approaches to exposition: **interpretation, speculation about causes or effects,** and **evaluation.** In all three approaches, you will be making an inference about what the artwork means, about what caused the artist to make certain choices, or about the value of the artwork.

The following paragraph, from an essay by Aldous Huxley titled "Variations on El Greco," is expository in that it engages in interpretation:

> And what *did* El Greco want to say? The answer can only be inferred; but to me, at least, it seems sufficiently clear. Those faces with their uniformly rapturous expression, those hands clasped in devotion or lifted towards heaven, those figures stretched out to the point where the whole inordinately elongated anatomy becomes a living symbol of upward aspiration—all these bear witness to the artist's constant preoccupation with the ideas of mystical religion. His aim is to assert the soul's capacity to come, through effort and through grace, to ecstatic union with the divine Spirit. This idea of union is more and more emphatically stressed as the painter advances in years. The frontier between earth and heaven, which is clearly defined in such works as *The Burial of Count Orgaz* and *The Dream of Phillip II,* grows fainter and finally disappears. In the latest version of Christ's Baptism [FIG. **1-1**] there is no separation of any kind. The forms and colours flow continuously from the bottom of the picture to the top. The two realms are totally fused.[3]

Huxley's reader may not interpret El Greco's work in the same way that he has, but the reader will accept Huxley's interpretation if Huxley can convince the reader that his interpretation is a valid one. There is room for more than one interpretation of most works of art, and they coexist amicably. That does not mean, however, that all interpretations are equally valid. Each interpretation must be supported with evidence.

ARGUMENT

Argument is a mode of discourse that assumes a contrary audience, one that is predisposed to disagree with you but is not irrational or ignorant. Your obligation is not only to **defend** your position in **constructive arguments,** but also to **rebut,** through **refutation,** your opponent's position.

Some arguments are written as refutations of other interpretations. For example, Sigmund Freud, who often indulged in analysis of the arts, wrote an essay about Michelangelo's *Moses.* The prevailing interpretation is that the sculpture captures a specific historical moment, when Moses sees his people dancing around the golden calf and is about to rise in his wrath and shatter the Tables of the Law. Freud's interpretation refutes the prevailing one and contends instead that the sculpture captures the moment *after* Moses's burst of fury, when he has overcome the temptation to act and has decided to remain seated. Freud bases his argument upon several pieces of evidence, but primarily the position of Moses's right arm.[4]

Remember that the word *argument* is often used loosely to mean "main point" or "thesis." Your professors may speak of your "central argument" with regard to the thesis or main point of your paper, even if the paper is purely expository and does not engage in refutation at all. Be sure that you understand the meaning of the word *argument* as it pertains to your assignment.

One complication in understanding the four modes of discourse is that the differences among them are not absolute. The difference, for example, between description and exposition is not always crystal clear; some degree of interpretation when describing is often unavoidable. Nor is the difference between exposition and argument always clear because the degree of skepticism in your audience, which is variable, determines whether you are obligated to refute existing attitudes and interpretations. Still, the more you think about writing in terms of mode of discourse, the sharper your critical thinking and writing skills become.

TYPES OF WRITING ABOUT ART

As an artist, art historian, art collector, art teacher, museum curator, or student, you may be called upon to write about art in any of various ways. Following are some of the more widely recognized types of writing about art.

ESSAYS

Essay is a widely used term for many kinds of writing about art. An essay may be written in any of the four modes of discourse—*narration, description, exposition,* or *argument*. An essay consists of more than one paragraph, and it is shorter than a book, but within those parameters, an essay may be any length. An essay may make use of sources, but not to the extent that a research paper would do. Newspaper, magazine, and, often, journal articles are published essays.

CRITICAL ESSAYS: The term **critical essay** is often used with regard to an essay that offers an opinion. Such essays are written in either the expository or argumentative mode of discourse. The purpose of the critical essay is not, as the term might imply, to criticize, but rather to critique. To criticize is to denounce or find fault; to **critique** is to exercise careful judgment, including scholarly interpretation. The essays in this book in Chapter Three, "Writing the Expository Essay," and Chapter Four, "Writing the Argumentative Essay," are critical essays.

THE COMPARATIVE ESSAY: A **comparative essay** on art is one that compares or contrasts more than one artwork or artist. Many discussions of art involve comparison. Our response to an artwork and our appreciation of it depend

in large part upon our memories and perceptions of other works. Therefore, the ability to organize a comparative essay is invaluable. A comparative essay may be written in the descriptive, expository, or argumentative mode of discourse, depending upon the writer's purpose. A descriptive comparison would discuss the artworks' similarities and/or differences without offering an opinion or interpretation. An expository comparison would use the artworks' similarities and/or differences to support an inference. An argumentative comparison would use the artworks' similarities and/or differences to support an opinion for which there is considerable opposition. Rachel Gothberg's essay in Chapter Three of this book, "Gothic Nightmares in Romantic Paintings," is an expository comparative essay.

THE FORMAL ANALYSIS: You may be asked, at times, to write a type of critical essay called the **formal analysis.** To **analyze** means, literally, to take a thing apart to discover how the pieces work together to create a whole. A formal analysis of a work of art is an essay that discusses the ways in which the artwork's *subject matter, formal elements, principles of design,* and *medium* work together to create an overall impression. Ron Baxendale's essay in Chapter Two of this book, "*Chantet Lane:* A Post-Impressionist Walk in the American Southwest," is a formal analysis.

THE EXHIBITION REVIEW: Another type of critical essay is the **exhibition review.** The purpose of the review is to evaluate a collection of art at a museum or gallery, an activity engaged in by an **art critic.** When viewing the work of well-established artists, students should defer to judgment of professional critics as to the merit of the work and discuss the formal elements that make the art worthy of praise. When reviewing the work of artists whose reputations are less well established, exercise your own judgment as to the work's artistic merit. Chapter Six of this book, "Writing the Exhibition Review," instructs students in writing reviews and offers a professionally written review of a Degas exhibition, "Knavery, Trickery and Deceit."

RESEARCH PAPERS

A **research paper,** unlike the critical essay, makes conscious use of sources. It documents sources and includes an alphabetical list of sources in the form of a bibliography or works cited page. Term papers, master's theses, and doctoral dissertations are research papers. So, too, are many journal articles.

A research paper may be written in a descriptive, expository, or argumentative mode of discourse. All research papers select and organize information gleaned from sources. A descriptive research paper would present that information objectively—that is, without supporting an inference or opinion. The research paper in Chapter Seven, "Ben Shahn's Use of Photography in His Paintings," is written in a descriptive mode of discourse. Still, one's attitude is often obvious in descriptive writing: it is obvious that the writer

of the paper on Ben Shahn admires his work. An expository research paper would use information gleaned from sources to support an inference. An argumentative research paper uses information gleaned from sources to support an argument, a position in a controversy that counters an opposite position. The research paper in Chapter Seven titled "The Elgin Marbles: Saved or Stolen?" is argumentative.

OTHER TYPES OF WRITING ABOUT ART

THE ARTIST'S STATEMENT: As an artist, you will need to develop an **artist's statement.** The statement can be used for a variety of purposes, but essentially it describes who you are as an artist and what your art is about. The artist's statement is incorporated into the artist's marketing materials, such as mailers, flyers, or cards, and can accompany the slides of your work that are sent to art dealers. It is also sometimes displayed on the walls of an exhibition of your artwork.

When writing your artist's statement, keep it short, generally not much longer than one page. Include a discussion of your aesthetics, the philosophy that drives your work and the reasons you create it. Describe your own particular style and your medium, perhaps pointing out unique aspects of the technical process you use. Also include experiences, such as apprenticeships, travel, or residence in a foreign country, that contribute to the development of your art. The following is a good example of an artist's statement written by Boulder, Colorado, potter Jim Lorio.

> I am a functional potter. I see the pot as a completed object, standing visually on its own, and at the same time, I ask that it imply or even demand use as a condition for its functional and aesthetic wholeness. This notion is what determines my interest in process, form, surface, color, and embellishment. The dynamics and tension involved in this balancing act provide a continuing renewal for me in making "useful" pots.
>
> The most persistent intent in my work is a concern for "richness"—for the richness in the relationship between pots and me, the richness of form, the quality of glaze and decoration that enlivens that form, the richness of the contact of the pots with fire as they come to final form, and then the richness of the experience possible, in use, between the pots and their owners. I once wrote that I'd like to try "to make pots the way Eubie Blake plays ragtime ... with obvious joy and laughter and attention to easy growth and quality." It's in that kind of spirit that I look to find the "center" for depth and quality in my pottery.
>
> My pots are fired in a thirty-five-foot-long, hill climbing, wood-fired "anagama" style kiln. This labor intensive, time-consuming process yields results unlike those produced by any other type of firing. The firing normally takes six to eight days and uses six to nine cords of wood, hand-fed twenty four hours a day. The exteriors of my pots are unglazed and become a "canvas" for the action of the flame and ash. The pots that are successful have a color, texture, and surface that relate to and enhance the forms in a truly unique manner.
>
> I believe that pots, as objects, have the ability to hold our capacity for growth, warmth, expression. A functional pot holds this potential within a form that

serves other needs as well, those of utility. If the maker has worked well, the pot will reflect much about the potter's attitudes toward generosity, humor, caring and wholeness. And I believe pots can transmit those feelings directly, not as organized thought, but as "felt" language every bit as clear, every bit as precise, and much more intimately than the spoken word. Pots with this capacity glow with life and live, humming just a few fractions of an inch in the air above the surface upon which they are supposed to reside.[5]

MUSEUM AND GALLERY LABELS: Museum curators and staff often have the task of writing **labels for artwork** for both the museum's permanent collection and traveling exhibitions. In smaller gallery shows, the artist is often called upon to write his or her own labels. Be sure to consult with the gallery owner or the show's organizer to ascertain what kind of information is to be included on the labels. These labels inform the viewers about the artwork, providing specifics such as the title, artist's name, artist's dates, and the date the work was done. In a museum's collection or a traveling exhibition, the label also sometimes lists the name of the particular collection of which the work is a part or the museum from which the work has been lent. It is often helpful to include information about subject matter, specific techniques, the composition, or other idiosyncratic points to increase the viewers' understanding of the work. Refrain, however, from including too much of your own evaluation and point of view; allow the viewers the freedom to form their own.

Ultimately, as the Denver Art Museum guidelines for writing labels state, "gallery going is a leisure-time activity with no reward beyond the experience itself, and learning is low on the list of goals/expectations visitors bring with them. Our primary job is to help them find the experience rewarding." Further suggestions from the Denver Art Museum recommend that the visitors "should be able to make immediate use of labels so they get immediate positive feedback ('Yes, I see that!' 'Hey, did you notice that?')." An additional note advises that labels should not build upon each other; each one must stand alone.[6]

Lengths of museum labels vary. The following two examples illustrate a short exhibition label and a longer label for a work in a permanent collection. The first example is the information included on a short museum label of a work by Claude Monet that was part of his 1995 retrospective exhibition at the Art Institute of Chicago.

Cliffs and Sea, Sainte-Adresse, c. 1865
Black chalk on off-white laid paper
20.5 x 31.4 cm; 8 1/8 x 12 1/4 in.
The Art Institute of Chicago, Clarence Buckingham Collection (1987.56)

This drawing is one of five showing in sequence a sailboat running aground and capsizing. The series is Monet's earliest specific attempt to make time his principal subject.[7]

The second example is a longer label from a work in the permanent collection in the Leanin' Tree Museum of Western Art in Boulder, Colorado. The label discusses a large, breathtaking oil painting, *Land of Condor.*

Bill Hughes
(1932–1993)
Land of Condor
Oil, 1993

Spectacular mountain landscapes were favorite subjects of artist Bill Hughes. This magnificent scene is the last painting completed by Hughes before his untimely death. A close friend of the artist has related the story of going to dinner with Hughes on the last night of Hughes's life. The artist told his friend he had finished "the big one" and signed it that afternoon. Hughes died of massive heart failure that very night.

Hughes left a legacy of spectacular landscapes unmatched since the German artist Albert Bierstadt painted the American West. The major difference between the two was that Bierstadt painted real places, albeit with a romantic flair. Hughes never felt so restricted. *Land of Condor* is comprised of a montage of visual experiences by the artist in his travels throughout the West.

Hughes employed a unique procedure in painting his major works. He made preliminary sketches in pencil on cardboard. He then scored and folded the board so that it resembled a stage set. This gave him the perspective needed to visualize the scene before transferring it to canvas. The effectiveness of this is obvious in this masterful work. Note how the dark rocks at the right and giant palisades at the left bring the eye to focus on the center of interest: the tranquil lake at the bottom of the massive cirque. From the lake, the eye is carried up to the great, gray cloud bank and the splendor of the snow-blanketed peak in the distance. Only then does the viewer find the true message in the painting: the giant condor sailing gracefully over his domain, remote and secure, safely removed from mankind which has very nearly succeeded in eliminating him from the skies.[8]

Catalogue Entries: Some exhibitions, usually the larger ones, publish catalogues. Many of these catalogues contain essays about the individual works that are called **catalogue entries.** Although there is no formula for writing catalogue entries, here are some possibilities for inclusion in the essay about the work: a short analysis according to the elements discussed in Chapter Two, such as the principles of design and the elements of style; the work's history, including its various owners; information about the subject matter (if it is a portrait, details about the sitter are included); special circumstances under which the work was done; whether the work is part of a series; influences (for example, other artists, movements, trends, etc.) on the artist and this particular work; whether there were other versions of the work; whether photographs were used; bits of correspondence by the artist, other artists, or literary figures regarding the work; and quotes from the artist or others pertaining to the work. The following catalogue entry was written for the cata-

logue accompanying the 1988 exhibition of "The Art of Paul Gauguin," shown at the National Gallery of Art in Washington, D.C., and the Art Institute of Chicago. Entry 107 discusses the oil-on-canvas painting titled *The Haystacks* or *The Potato Field* done by Paul Gauguin in 1890.

> Along with *Landscape at Le Pouldu* (cat. 109) this painting is one of a series of landscapes executed by Gauguin during his stay at Marie Henry's auberge in 1890. The sites represented are either the gentle hills of the Breton hinterland or the picturesque coastline.
>
> These landscapes are characterized by a rhythmical conception of space powerfully organized in layers. This is especially true in this picture, where the various alternating bands of color, from the foreground that is handled as a decorative frieze to the sky with its raised horizon, are strongly differentiated. The peasant woman and her cattle moving across the foreground are reduced to flat, heavily contoured silhouettes with powerful contrasts of dark and light values; these in turn throw the variety of the middle ground into stark relief.
>
> At the center of the canvas stands the massive shape of the haystack, which has the same solid quality as its predecessor in *Farm at Arles* (cat. 59). Overtones of the broad spaces painted by van Gogh in 1888 are also present, with tiers of colors playing an important role in the front of the composition.
>
> This accomplished landscape originally belonged to the great collector Gustave Fayet. It is painted in the classic Pont-Aven style, which so strongly influenced the painters who gravitated around Gauguin, a style that reappears in many pictures by Emile Bernard, Meyer de Haan, Séguin, Filiger, and Verkade.[9]

APPROACHES TO ART CRITICISM*

Criticism, the term applied to expository and argumentative writing about art, means "evaluation or analysis of a work of art," not "condemnation" or "denunciation." Critical essayists often apply certain philosophies or theories to their writing. For example, people involved in politics usually view art with an eye toward some political message. People drawn toward psychology view art with an eye toward the psychological motivation of the author or the psychological implications of the art. You are probably already doing the same thing—applying your own interests to your viewing.

Following is a brief summary of several of the more popular approaches to art criticism. These approaches can be extremely complex and obscure, and this quick overview in no way pretends to capture any of them in their entirety. But at least a cursory understanding of the terms will enhance your appreciation and ability to write about art.

*Thanks to Theodore F. Wolff and George Geahigan for their excellent *Art Criticism and Education*. Urbana: University of Illinois Press, 1997.

DIARISTIC ART CRITICISM

Diaristic art criticism is the most relaxed and informal of all types of art criticism. Just as its name implies, it reads somewhat like an entry in the writer's diary, sharing the writer's observations and feelings about the works of art being viewed and discussed. The diaristic approach usually is written in the first person, using the pronoun *I*. In expressing his or her experience of the artwork, the skilled diaristic critic leans toward informality, perhaps even including bits of gossip and innuendo, as long as they do not ultimately distract from the main purpose of the essay. Although the writer's life and opinions might weave through the essay, it is vital that the writer not allow these personal elements to overshadow the artworks being discussed.

An excellent example of diaristic art criticism is Robert Rosenblum's 1980 essay, "Johns's *Three Flags*":

> The year was 1958 and I still remember the jolt of seeing *Three Flags* for the first time down at [Jasper] Johns's Pearl Street studio. I was hardly unprepared, having already been stopped in my tracks that January by Johns's first one-man show at Leo Castelli's, where what then looked like the most candid restatement of the Stars and Stripes suddenly ground the traffic of all American painting to a halt that made you stare and stare again. But even with that picture some months behind me, *Three Flags* almost literally bowled me over. For here, that red, white, and blue platitude, preserved for eternity as a flat painting, leaped out of the middle of the canvas like a jack-in-the-box, defying gravity and assaulting the viewer head-on. Especially for eyes accustomed to the murky, private labyrinths of color and shape in most painting of the 1950s, the strident clarity of *Three Flags* looked the way a C-major chord played by three trumpets might sound: a clarion call that could rouse the sleepiest spectator.[10]

Notice that although Rosenblum includes his personal reaction to the art, the paragraph is more about the art than it is about him.

FORMALISTIC ART CRITICISM

Very different from diaristic art criticism, **formalistic art criticism** focuses only on the objective aspects of a work of art, ignoring the subjective elements. Instead of the artwork's effect upon the writer, the reader is told about the elements of style (line, color, shape, value, and texture), the compositional devices (balance, repetition, and contrast), the materials and techniques, as well as other formal elements used in the work.

Clement Greenberg is one of the best-known and most dogmatic formalistic art critics of all time. The following critique of twentieth-century artist Fernand Léger's work demonstrates the basis for Greenberg's reputation:

> As far as I know, Léger's last complete masterpiece is the largest version of *Three Women*, also called *Le grand déjeuner* (1921), which is in the collection of the Museum of Modern Art, a picture that improves with time (and one which tends to be remembered as much larger than it actually is). Later on, Léger will secure

unity only by elimination and simplification, but here he secures it by the addition, variation and complication of elements that are rather simple in themselves. First, staccato stripings, checkerings, dottings, curvings, anglings—then a massive calm supervenes; tubular, nude forms, limpid in color and firmly locked in place, with their massive contours stilling the clamor around them—these own the taut canvas as no projection of a more earnestly meant illusion could.[11]

As you can see, Greenberg's concern is with shape, color, line, and compositional unity and variation—all formal elements of style and design. The writing assignment in Chapter Two requires you to engage in the formalistic approach to art criticism.

CONTEXTUALIST ART CRITICISM

Contextualist art criticism is a general term that covers several branches of art criticism, all relating to the art from the context of a particular discipline, such as psychology or sociology. The contextualist approach does not view the work of art in isolation, but, instead, explores its relationship to the rest of the world. Contextualist art criticism is more expansive and less limiting than the formalistic approach, yet it can fall into the trap of being too intellectually theoretical, forsaking the sensate aspect of the art. We will not attempt to cover all of the contextualist approaches but instead will focus on several of the most relevant ones.

PSYCHOANALYTICAL ART CRITICISM

Sigmund Freud's work in psychoanalysis at the beginning of the twentieth century opened up a new way to explain our psyches, as well as a new avenue for art interpretation and criticism. **Psychoanalytical art criticism** takes the writer beyond the obvious and into the subconscious. Psychoanalytical art criticism requires the writer to understand both psychoanalysis and art.

One of the most famous examples of writing about art through the psychoanalytical lens is Sigmund Freud's interpretation of Leonardo da Vinci's painting in the Louvre, *Madonna and Child with Saint Anne* (FIG. **1-2**). (Saint Anne was Mary's mother.) Freud writes:

Leonardo's childhood was remarkable in precisely the same way as this picture. He had had two mothers; first his true mother, Caterina, from whom he was torn away when he was between three and five, and then a young and tender stepmother, his father's wife, Donna Albiera. By combining this fact about his childhood with the one mentioned above (the presence of his mother and grandmother) and by condensing them into a composite unity, the design of *Saint Anne with Two Others* took shape for him. The maternal figure that is further away from the boy—the grandmother—corresponds to the earlier and true mother, Caterina, in its appearance and in its special relation to the boy. The artist seems to have

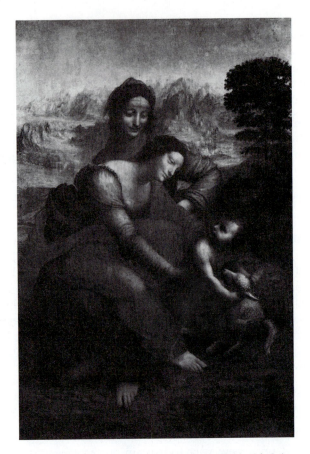

1-2 Leonardo da Vinci, *Madonna and Child with Saint Anne*, c. 1508–1513. Panel painting, 66 1/4" x 51 1/4". Louvre.

used the blissful smile of Saint Anne to disavow and to cloak the envy which the unfortunate woman felt when she was forced to give up her son to her better-born rival, as she had once given up his father as well.[12]

Clearly, according to Freud, the painting has psychological implications beyond its religious subject matter. And, interestingly, after the reader is exposed to his psychoanalytical theory here, it is nearly impossible to view the painting without considering this other level of meaning.

IDEOLOGICAL ART CRITICISM

Ideological art criticism is concerned with the ideas and values on which a particular political or social system is based. It deals with the artistic representation of those ideas and values. Obviously, ideological art criticism is

highly subjective. Our discussion will be limited to three of the major subdivisions: Marxist, feminist, and multicultural art criticism.

Marxist art criticism is concerned with social relationships and economic issues. Just as Karl Marx was interested in the struggle for power among economic classes, Marxist art criticism focuses upon the treatment of members of the underclass by those in power, pointing out the social injustices that class structures engender. You might view the sculptures of Duane Hanson through a Marxist lens. Your task would be to assess Hanson's treatment of the working class. Is his attitude one of respect or disrespect?

Some works of art lend themselves easily to Marxist criticism because the art itself is making a statement about the class struggle. In 1937, American artist Ben Shahn painted a mural for the school/community center in Jersey Homesteads, New Jersey. Jersey Homesteads, a planned community that housed Jewish garment workers, former eastern European emigrants, was a result of President Roosevelt's Resettlement Administration programs. In her article titled "Constructing History: A Mural by Ben Shahn" in *Arts Magazine* in 1987, Frances K. Pohl offers a Marxist slant:

> Shahn's mural was intended as a history of the town's residents, and of the country's Eastern European Jewish immigrants in general, documenting their arrival in the US, their employment in the crowded and oppressive sweatshops, and the improved working and living conditions obtained through union organizing and the programs of the Roosevelt administration. What appeared in the mural, however, was not a literal history, but one constructed out of a series of recorded historical events and personal memories, often reordered to convey with particular poignancy an ideal as much as a reality.[13]

Feminist art criticism, which began in the twentieth century, is based upon the sociopolitical philosophy that women deserve rights and opportunities equal to those of men. It approaches art from the female point of view—a relatively new vantage point, considering the patriarchal foundations that have dominated the majority of cultures for centuries. The feminist art critic infers the artist's attitude toward women and interprets the art accordingly.

Many works of art can be viewed through the feminist lens, although some works lend themselves more easily to the feminist approach than others. A seminal work in the feminist art movement is Judy Chicago's *The Dinner Party* (FIG. **1-3**), a multimedia installation piece conceived in 1979. *The Dinner Party* is composed of a large triangular table, covered with thirty-nine porcelain plates. Each plate represents a particular woman in history whose accomplishments have been significant, such as Sojourner Truth and Georgia O'Keeffe. In addition, handmade tiles bear the gold-scripted names of another 999 consequential women. Chicago designed each plate with the butterfly-vaginal imagery that was to become her trademark.

The feminist art critic would not focus a discussion of the piece upon its formal elements, but rather upon the feminist ideology of the piece. When

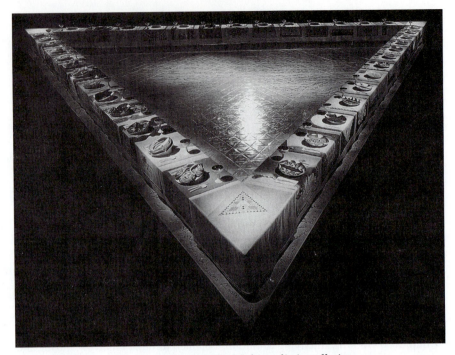

1-3 Judy Chicago, *The Dinner Party,* 1979. Multimedia installation.

formal elements are considered, such as the basic shape of the work, a triangle, they are interpreted through the feminist viewpoint. In this case, the triangle represents the goddess, the ultimate symbol of female power.

Lucy R. Lippard, an eminent feminist art critic, wrote an extensive article on "Judy Chicago's Dinner Party" for *Art in America.* The following is an excerpt:

> ... The cooperatively executed installation piece is an awesome incorporation of sculpture, ceramics, china painting, needlework and the history of women through Western civilization. One of the most ambitious works of art made in the postwar period, it succeeds as few others have in integrating a strong esthetic with political content. This success is in part due to the artist's feminist method of fusing process and product. Like Chicago's earlier work, and like the porcelain plates which are its focus, *The Dinner Party* radiates from a passionate core of belief. Its ripples expand from the sculpture itself, the hours of looking it requires and the personal and political associations it draws upon, out to the surrounding documentation that reflects its feminist structure, the books and events, to the mystique around it and its creator, out to the reality of its continuing image in the world and its prime goal—social change.[14]

Multicultural art criticism discusses the diverse ethnic and cultural orientations of people as depicted in art. You could view any work of art as a multiculturalist, but naturally, artworks that make statements (whether consciously or unconsciously) about the artist's and society's attitude toward

ethnicity lend themselves most easily to this type of criticism. The multiculturalist might deplore works of art that seem to denigrate people on the basis of race or culture or celebrate works that assist in furthering an acceptance of pluralism. The multiculturalist art critic might want specifically to point out the ethnic background of the artist as manifested in that artist's works. The following excerpt from Colette Chattopadhyay's essay in *Sculpture* about Betye Saar's work is a good example of multicultural art criticism.

> *Tangled Roots* explicitly approaches issues of derivation and multiplicity, deconstructing the premises of racial purity and polarity that are inherent to stereotypes. While the work undoubtedly carries autobiographic significance for Saar, who is as much white Irish and Native American as African American in heritage, it also forcefully critiques media-driven imagery. Shifting from the more didactic tactics of airing social grievances or lambasting cultural prejudices, the new works politically side-step the authoritative omnipresence of stereotypes by invoking the transformative powers of visual poetry.[15]

Luis Vigil's essay in Chapter Four, "American Myths, Patriotism, and Art," also demonstrates a multicultural approach.

Critical theories often cohabit. You may find the formalist and psychoanalytical approaches to be compatible. Marxist and multicultural criticisms often work well together because their philosophies overlap; both are concerned with treatment of the disenfranchised. The main thing to understand is that familiarity with these philosophies and theories will assist you in writing about art.

THE PROCESS FOR WRITING ABOUT ART

The process for writing essays and research papers about art is the same as the process for writing about any topic: **plan, draft, revise,** and **edit.**

PLANNING YOUR ESSAY

Planning your essay involves any of several **prewriting** strategies. You might begin by **brainstorming.** Many people use a **mind map,** which is a way of diagramming connections, pictured on the following page. The purpose of such an exercise is to free-associate ideas and begin the process of seeing the relationships among ideas.

Another brainstorming device is to **freewrite,** which is to set a timer for a certain number of minutes, say ten, and write for that length of time without stopping, without lifting pen from paper, without correcting grammar or spelling errors. Writer Bernard Malamud endorses this method: "The idea is to get the pencil moving quickly. [. . .] Once you've got some words looking back at you, you can take two or three—throw them away and look for others."[16]

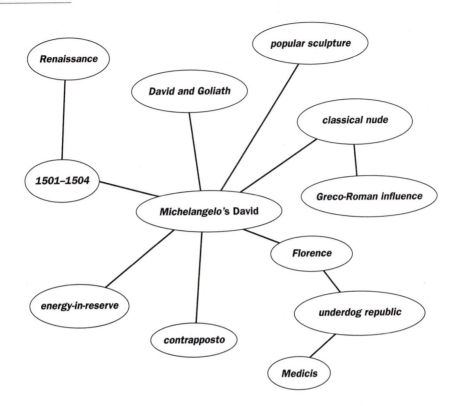

When you are beyond the prewriting stage, you will need a process for organizing your essay. The following are stages in the organization process.

CHOOSING A TOPIC: Your topic is the subject matter for your paper; it can be stated broadly in a few words. Your topic might be Michelangelo's *David* (FIG. **3-1**), or it might be Manet's use of light, or the cave paintings at Lascaux. There is a major difference between your topic and your thesis: Your thesis will state the point that you will make about your topic. For demonstration purposes, we'll use the topic of an essay in Chapter Three, "Strength in Stone: Michelangelo's *David*," throughout the discussion in this section.

POSING A RESEARCH QUESTION: Your **research question** is the question about the topic that the paper will answer. Posing a proper research question is a crucial step in the design of your essay because some research questions will lead you to a descriptive essay, some will lead you to an expository essay, and some will lead you into an argument.

For example, "What is the history behind the stone used to sculpt Michelangelo's *David*?" is a research question that will inevitably lead to a paper that is written in the descriptive mode of discourse because that information is readily available. No inference would be required on your part. It will also be a short paper.

The question "Who is the person represented in Michelangelo's *David?*" may lead to a descriptive or expository paper, depending on your answer. If your answer is that David is the biblical shepherd boy who slew the giant, Goliath, you are writing a descriptive paper because that answer is readily apparent to most people in our culture today. If, however, you answer that David, as a shepherd boy, represents the people, the underdog, or the republic of Florence, you have the makings of an expository paper—a paper that helps the reader understand the *David* in a way that he or she would probably not have understood without your help. The research question "Why is Michelangelo's *David* so beloved?" is likely to lead to an expository paper because no definite answer to that question exists. One can only speculate.

Be sure to ask only one research question. Asking more than one will lead to a disunited paper. Also, remember that a research question will never serve as a thesis. You will try to prove the truth of your thesis; you cannot prove the truth of a question.

RESEARCHING YOUR TOPIC AND TAKING NOTES: Hardly anyone can write an academic paper without sources, so you will probably need to collect some sources for your paper. Chapter Seven, "Writing the Research Paper," gives detailed information on finding sources through your campus library as well as the Internet.

After you have collected your resources, read them with your pen and highlighter. That is, highlight the interesting passages and write your reactions and thoughts in the margins as you read. If you are using borrowed books, use Post-it Notes to call out the interesting passages. We recommend that you take notes on index cards, one note per card. On each card, write a fact or a quote that you believe will be included in the paper. Be sure to note on each card the source from which you obtained the information as well as the page number. Later, you'll find that the index cards are easily shuffled and organized as your paper takes shape.

FINDING A THESIS: Your **thesis** is the answer to your research question. It articulates the main point of your paper, and it is, therefore, the most important sentence in the paper. A workable thesis will meet the following criteria:

◆ Answers the research question

◆ Is one complete, unified statement about the artist or artwork

◆ Is precise enough to limit the material

◆ Is general enough to need support

◆ Is defensible

◆ Is not too obvious

All of the preceding guidelines for a workable thesis are malleable to some degree. For now, though, it is best to adhere to them strictly in order to get a firm grip on a thesis that guides the writer into a well-focused paper.

Your thesis statement is also important because it determines your paper's mode of discourse. A narrative thesis will lead to a narrative paper; a descriptive thesis will lead to a descriptive paper; an expository thesis will lead to an expository paper; an argumentative thesis will lead to an argumentative paper. Consider the following examples:

NARRATIVE THESIS: David was a shepherd boy who became a hero to the Israelites.

DESCRIPTIVE THESIS: Michelangelo's *David* is a beloved work of art.

EXPOSITORY THESIS: Michelangelo's *David* is beloved because it illustrates what is best about ourselves.

ARGUMENTATIVE THESIS: Michelangelo's choice of moment in time in his representation of David is less effective than Donatello's.

IDENTIFYING THE COUNTERARGUMENTS: If your paper is argumentative, you must articulate your opponent's arguments in order to argue with them. Your opponent's arguments are your **counterarguments.** Like your own argument, they are controlled by a thesis and points of proof, which you will regard as the **counterthesis** and **counterpoints.** Your paper will **refute** the counterarguments. Identify what you believe to be the strongest arguments against the side that you will take.

ASKING THE PROOF QUESTION: After you have found a thesis, you must support or *prove* it. How do you do that? What constitutes support? One way to ascertain what sort of information will support your thesis is to ask a **proof question.** A proof question simply converts the thesis statement into a question, beginning usually with *how* or *why.* For example, if your thesis is "The *David* illustrates what is best about ourselves," a new question arises naturally in response to that statement: *"How* does the *David* illustrate what is best about ourselves?" This is your proof question, and answers to this question will support, or prove, your thesis. The proof question is a critical step in designing your essay because it provides a good test of whether you have a workable thesis. If you cannot answer the proof question, you need to rethink your thesis, which also requires that you rethink your research question.

DESIGNING YOUR POINTS OF PROOF: Your **points of proof** answer your proof question. They are the reasons why you think your thesis is true. Each point of proof must be general enough to require one or two paragraphs' worth of supporting facts, details, and examples but not so general that an entire essay would be required to support it adequately. Each point of proof should directly answer the proof question, but it will not, by itself, provide a complete answer. For example, if the proof question is "How does the *David* illustrate what is best about ourselves?" one answer could be "The story of David and Goliath, depicted by the sculpture, reminds us that we humans

are capable of extraordinary courage." This is not a complete answer to the proof question, but it is one partial answer. Together, your points of proof will fully support your thesis.

Be sure that each point of proof answers the proof question. You can be sure, in this way, that each point of proof supports the thesis and not some other idea. Sentences like "First we shall examine the biblical story of David," and "Then we shall look at Michelangelo's use of energy-in-reserve" are not points of proof. Rather than answer the proof question, they delay the task.

OUTLINING YOUR ESSAY: Most people find it helpful to organize their ideas in the form of an outline like the one that follows.

OUTLINE FOR ESSAY

I. Introduction

 A. Identify topic

 B. State thesis

 C. List of points of proof

 1. Point 1

 2. Point 2

 3. Point 3

II. Body (Developed Points of Proof)

 A. Point 1

 B. Point 2

 C. Point 3

III. Conclusion

WRITING YOUR ESSAY

Now that you have planned your essay, the next step is to begin writing. Remember that you will probably need to revise your essay several times before you arrive at a final version.

WRITING THE INTRODUCTION: Many people like to begin writing with the **introduction.** Others like to write the introduction later because they are more certain of what the introduction should say after they have written the body. Whichever method works best for you is acceptable. When you are ready to write the introduction, begin by identifying the work and the artist or, if the paper is more generally about a period or a movement, identify the movement, the time period, the place, and the artists involved. In other words, tell *who, what, when,* and *where.* (The *why* will come later.) It is important to stick to the facts at this juncture. Do not begin with a platitude or a

statement of universal truth or with an overly general expression such as "Throughout history ..." or "Artists have always...." As a rule, let your thesis be the first general statement you make. Sometimes the **research question** makes a nice transition from your introductory remarks to the thesis.

Next comes the **thesis.** This is the most important sentence in the entire essay so you want to construct it carefully. Be sure that the thesis is written in the appropriate mode of discourse.

The final part of the introduction is a list of your **points of proof.** Use transitional expressions such as "first," "second," and "finally" to help your reader see the relationship of the points of proof to the thesis and to each other. Without such clues, the reader will feel that he is reading several unrelated claims and will not understand their relationships to each other or that they are subordinate to the thesis. End the paragraph with the final point of proof. This type of paragraph is different from others in that you should resist the urge to tack on a summary statement because such a statement will only compete with the thesis. Nor should you tack on a transition sentence or a fact because any such sentence would only compromise the essay plan that you have laid out so carefully for your reader.

All of the essays in Chapters Three and Four, as well as the research papers in Chapter Seven, demonstrate the type of introduction described here.

ORGANIZING THE EVIDENCE: Before you begin writing the body paragraphs, gather the index cards on which you took notes to organize your evidence. Write your points of proof on separate index cards, one complete statement per index card, and lay them out side by side. Place each index card containing a fact on top of the point of proof that it supports. Continue to compile the evidence until you have enough to support each point of proof adequately.

WRITING THE BODY PARAGRAPHS: Well-written body paragraphs generally contain four qualities: **unity, adequate development, organization,** and **coherence.**

Unity, in paragraphs, is the quality of having only one main idea. Unity is best achieved by use of a **topic sentence** that makes a general claim. This claim will have to be supported by the evidence presented in the paragraph. Think of the topic sentence as the *thesis of a paragraph.* As such, it must be general enough to need support, yet narrow and specific enough to be supportable in the space of one paragraph.

Sometimes, when you have so overwhelmed your reader with evidence for your assertion that she has likely forgotten the point of all this information, a **concluding sentence** for the paragraph is in order. This sentence might restate the assertion made in the topic sentence, or it might speak of

the broader implications of the evidence offered in the paragraph and its connection to the thesis.

The following paragraph, excerpted from an essay by Guy Davenport, titled "Henri Rousseau," demonstrates the concept of paragraph unity:

> Rousseau, who said of Matisse's painting that if it was going to be ugly it at least ought to be amusing, was eminently a dramatic artist. His paintings have plots that range from the hilarious to the sublime. Before *La bohémienne endormie* [FIG. **1-4**] we are meant to feel the frisson of realizing that the gypsy is not asleep; the eyes are open a minim, watching the lion; the gypsy in terror is pretending to be dead, knowing that lions eat only live prey. Will the lion see through the ruse, or will it move on? There is no hope of help. Only the indifferent moon gazes down. The lion, like the cats of Paris, has raised his tail in curiosity. Will the gypsy ever again play Hungarian airs on that mandolin, or drink from that water jug? See how gay and bright the coat of the gypsy is! Are we not reminded of Joseph in Scripture, whose blood-stained coat of many colors was brought by his wicked brothers to his grief-stricken father, as evidence that "an evil beast hath devoured him"? Pity and terror! You must realize it all in your imaginations, messieurs et dames. For sentiment, could Bouguereau have done better?[17]

Adequate development is achieved by providing plenty of evidence for the single assertion you have stated in the topic sentence. Evidence consists

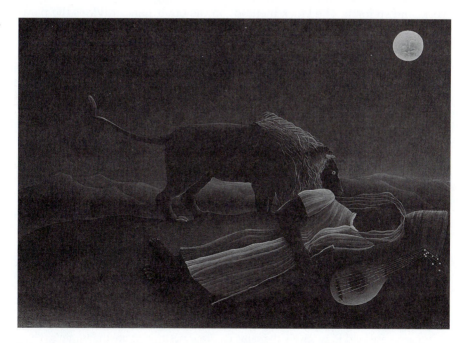

1-4 Henri Rousseau, *The Sleeping Gypsy*, 1897. Oil on canvas, 4'3" × 6'7". Museum of Modern Art, New York.

of specific details, facts, and examples. Assume that your audience is not going to believe a word you say unless you present specific supporting evidence. Count your general assertions. Then count your specific bits of evidence for each assertion. Your evidence statements should far outnumber your generalizations. All of the model paragraphs in this section demonstrate the quality of adequate development, even as they demonstrate unity and organization.

Paragraph **organization** is achieved simply by giving the details in a logical order. If you are describing something tangible, such as a sculpture or a painting, you might begin at the top and progress downward, or you might begin at the bottom and progress upward, or begin on the left and move to the right. Sometimes the logical order is chronological; sometimes it is from least important detail to most important detail, or vice versa. You must determine the logical order of the details of each paragraph and arrange the details accordingly.

Because comparison is a valuable tool in the study of art, it is particularly important to be able to organize a **comparison paragraph.** You might proceed in one of two ways, using either the **point-by-point method** or the **block method.** In the point-by-point method, you make a point about one work and a corresponding point about the other work. Then you make a second point about the first work and a corresponding point about the second work, and so forth. The block method, on the other hand, divides the paragraph roughly into halves, or blocks, and discusses the first work thoroughly before going on to the second work. The paragraph that follows, excerpted from an essay by Stephen Koch titled "Caravaggio and the Unseen," demonstrates the block method of comparison:

> I owe to a pleasant summer evening in Rome with the American abstract painter David Reed—Reed is a no less astute student of Caravaggio than Stella—confirmation of a simple observation which, once made, strikes me as being self-evident, but which quite inexplicably I have found nowhere in the literature. In the Galleria Doria in Rome hang Caravaggio's two earliest extant religious paintings. They were painted in the same year (1597) on the same commission, and used the same woman as a model. One is the *Repose on the Flight into Egypt.* Hanging directly beside it is a greater work, the *Magdalene Repentant.* In the *Repose,* the exhausted Virgin sits on a rock to the right of a serenading angel, holding her Child in the classic cradling embrace, her head tilted to our right. Her eyes are closed; she seems in fact to have fallen asleep; one of her hands (though the baby is still held firm) has slipped down slack in her lap. Hanging directly to the right of this picture is the *Magdalene.* She seems depicted from the model who served for the Virgin. She also is in the same pose. It is in fact almost exactly the same pose. She sits on a low stool. Her head likewise bends down to our right, not in exhaustion, of course, but in penance and pain. Most important, her arms are held in precisely the same cradling position as are the Virgin's. The difference, of course, is that she holds no child; she is, as it were, cradling a child not there. The arms are in precisely the classic maternal embrace; the crook of her left arm is in precisely the position to rest the baby's head, and the direction of

her eyes, which are not closed but half open, is directly into what would be a baby's upward-looking gaze. In short, the emblem of the prostitute's simultaneous penance and redemption is an absent child, whom she simultaneously embraces and grieves over.[18]

Coherence in paragraphs is the smooth progression from one idea to the next. One way that coherence is achieved is by the use of transitional expressions such as *for example, nevertheless,* and *however.* These expressions keep the reader from getting lost in the maze of evidence you are presenting. Some useful transitional expressions are listed next.

Additional idea: *and, also, in addition, too*

Alternative idea: *more importantly, furthermore, moreover, or*

Comparison: *similarly, likewise*

Contrast: *but, yet, however, on the other hand, conversely*

Numbered ideas: *first, second, third, finally*

Result: *so, hence, therefore, consequently, thus, then*

Exemplification: *for example, for instance, in fact*

Summary: *in short, on the whole, to sum up, in other words*

The preceding extract uses the transitional expressions *also, in fact, likewise, of course, but, most important, as it were,* and *in short.*

Repetition is another tool for bringing coherence to a paragraph. The third sentence in the extract, for example, repeats the phrase "the same": "They were painted in the same year (1597) on the same commission, and used the same woman as a model." Other repeated phrases in the extract include "in precisely," "the same pose," and "simultaneous."

Your reader has a difficult task, processing all of the information that you are delivering. You can assist your reader by providing these clues to the relationships among your ideas.

WRITING THE CONCLUSION: The conclusion is a very important part of your paper. It is your last chance to evoke a nod of approval from your reader as you reinforce your main idea. Do not waste the opportunity by merely repeating your thesis and points of proof. The reader has already read and been convinced of these points. On the other hand, the conclusion must not raise a new issue. How do writers, under these restrictions, reiterate their main ideas without repeating themselves? Conclusions need a controlling idea. Following are some ideas you might develop in your conclusion.

◆ Return to an illustration or anecdote written in the introductory remarks.

◆ Use a quote.

◆ Predict the future of the situation or issue.

◆ Tell the current status of the issue.

◆ Discuss the broader implications of the artist's work.

◆ Call your readers to action.

The following is a concluding paragraph of an essay by Ralph Ellison on artist Romare Bearden. The paragraph concentrates on the broader implications of Bearden's work.

> Bearden seems to have told himself that in order to possess the meaning of his Southern childhood and Northern upbringing, that in order to keep his memories, dreams, and values whole, he would have to re-create them, humanize them by reducing them to artistic style. Thus, in the poetic sense, these works give plastic expression to a vision in which the socially grotesque conceals a tragic beauty, and they embody Bearden's interrogation of the empirical values of a society that mocks its own ideals through a blindness induced by its myth of race. All this, ironically, by a man who visually at least (he is light-skinned and perhaps more Russian than "black" in appearance) need never have been restricted to the social limitations imposed upon easily identified Negroes. Bearden's art is therefore not only an affirmation of his own freedom and responsibility as an individual and artist, it is an affirmation of the irrelevance of the notion of race as a limiting force in the arts. These are works of a man possessing a rare lucidity of vision.[19]

Sometimes you can combine ideas while maintaining a unified, well-developed conclusion. The research paper in Chapter Seven titled "The Elgin Marbles: Saved or Stolen?" combines the ideas of the broader implications (the consequences to the reputation of the British Museum if it does not return the Elgin marbles to Greece) and a call to action (to return the marbles by the year 2004, in time for the summer Olympics).

After you have written your conclusion, look at your introductory remarks again. Do you perceive a shift in tone, attitude, emphasis, or even topic? If so, you will need to make revisions. The whole paper should work as a unit.

CITING YOUR SOURCES: If you have used sources in your essay in a way that obligates you to credit them, you must mark the necessary passages and create a list of works cited or a bibliography, depending upon which documentation style your professor requires. Chapter Seven gives detailed information on this step in the process.

WRITING A TITLE: Some writers create a title for their paper early in the process, saying it helps them narrow their topic and focus on the task. Others wait until they have finished the paper to compose a title. Your title may be an indication of the topic, such as "Gothic Nightmares in Romantic Painting." Or you might hint at the essay's thesis, as in "Nobility in Human Suffering in the Work of Théodore Géricault." Or you might mine your own paper for a particularly

apt turn of phrase or ask a question. Do give your essay its own title, not the title of the work of art it discusses. For example, "The Birth of Venus" will not do as a title for an essay about Botticelli's *The Birth of Venus,* although you might include the name of the work of art in the title, such as "Neoplatonism in *The Birth of Venus.*"

Notice that essay titles, when placed at the heads of essays, are not punctuated with quotation marks, italicized, boldfaced, underlined, or otherwise adorned. Capitalize only the first letter of the first and last words, any nouns, verbs, pronouns, adjectives, adverbs, and subordinating conjunctions. Titles of artworks contained in titles are underlined or italicized.

REVISING, EDITING, AND PROOFREADING YOUR PAPER

Good writing nearly always entails extensive revision. William Strunk, coauthor of *The Elements of Style,* writes, "Vigorous writing is concise. A sentence should contain no unnecessary words, a paragraph no unnecessary sentences, for the same reason that a drawing should have no unnecessary lines and a machine no unnecessary parts."[20] Such economy is rarely achieved without extensive revision. Another proponent of revision, Ernest Hemingway, once told an interviewer that he rewrote the ending of *A Farewell to Arms* thirty-nine times. When the interviewer asked him what the problem was, he replied "Getting the words right."[21]

Begin your revision by addressing the major issues of thesis and points of proof. If they need adjustment, much of your paper will change. Then examine your introduction and conclusion: look for changes in attitude, tone, main point.

Next, examine your sentences individually. Each sentence should be solidly constructed. Run-ons and fragments are very serious errors. Consult the "Handbook" section at the back of this textbook for advice on sentence construction. Try reading your sentences in reverse order, the last sentence first. This way, you're reading each sentence out of context and can look at the structure rather than be distracted by its meaning. This is also the time to consider sentence punctuation, especially of quoted material.

Finally, look at your words individually. Is each word chosen carefully and spelled correctly?

FORMATTING YOUR PAPER

See the sample essays in this book for a generally accepted, MLA-recommended format for college papers. You probably do not need a title page because they are generally for book-length papers with multiple chapters. If you need one, or if your professor prefers one, center the information on the page, as follows:

The Elgin Marbles: Saved or

Stolen?

by

Emily O'Connor

Art History 4030

Professor Esquivel

25 July 2000

Be sure to check with your professor for any special requests in the handling and packaging of your paper.

THE LANGUAGE OF ART
AND THE FORMAL ANALYSIS

The Language of Art	*Subject Matter*
	Formal Elements
	Principles of Design
	Medium
	Style or "Ism"
Writing the Formal Analysis	*Planning the Formal Analysis*
	Writing the Formal Analysis
Sample Formal Analysis Essay	
Revision Checklist	

Art is a type of symbolic expression. The artist, in creating that expression, makes choices, such as in what medium to work (for example, oil paints or clay), what size to make the work, whether to use bold or muted colors, or whether to make the work representational or nonrepresentational. Each choice communicates something from the artist to you, the viewer. In order for you to understand and translate that communication into writing, you must acquire a special art vocabulary. After you acquire the vocabulary, you are better able to *see* the work. Not only will the more obvious elements of the artwork be evident to you, but also the finer nuances, and you will be better able to interpret and analyze the work.

In this chapter, you will become acquainted with art terms and definitions that will be fundamental to your understanding of a work of art; they will help you make sense of what you are seeing because you will be able to apply words to your experience. This skill translates into credible writing about art, as demonstrated in the discussion of writing the formal analysis later in this chapter.

THE LANGUAGE OF ART

SUBJECT MATTER

One of the first questions that comes to mind when we initially view a work of art is "What is depicted?" We are wondering about the **subject matter.** *Subject matter* refers to the identifiable objects or ideas represented in the work. The ideas could refer to a story, an incident, or an event. The subject matter, for example, could be of everyday objects, such as oranges and apples, as depicted in a still-life painting. Or, at the other end of the spectrum, the subject could be a scene of great action and tumult, such as a ship caught at sea in a thunderstorm, as in Joseph M. W. Turner's painting, *The Slave Ship* (FIG. **2-1**) of 1840.

As well as asking "What is depicted?" we usually ask, "What does it mean?" The **meaning** or **content** is not always completely evident from looking at the work; additional research is sometimes required. When learning more about Turner's *The Slave Ship*, we come to realize that there is more to it than the drama of a ship in a storm. The scenario is based upon a real event in which a captain threw sick and dying slaves overboard because he was insured for losing slaves to the sea, but not to illness. The horror of this inhumane act is part of the content of the painting, part of what the artist wants to communicate and express through his work. Turner heightens the horror of this abomination, depicting the violence of nature by using steaming colors and tempestuous seas and by placing monstrous creatures in the same water into which the slaves are being tossed.

Noticing the **title** of a work can also enlighten us about the subject matter. The title of Turner's work tells us the nature of the ship, a slave ship. However, do be aware that occasionally a work becomes known by a shortened name or a nickname. In this case, the full title of the painting is *Slavers Throwing Overboard the Dead and Dying—Typhoon Coming On.* This complete title certainly gives us a more comprehensive picture regarding the subject matter and the content.

Another way in which the meaning of an artwork can be revealed is through **iconography.** Literally, *iconography* means "image or symbol writing." The symbolism can be **overt** or **hidden.** Overt symbolism is readily understood by most people. A Latin cross, for example, would usually be recognized as a symbol for Christianity. Hidden symbolism, on the other hand, is not as obvious. Hieronymus Bosch's *Garden of Earthly Delights* provides an example, with rats symbolizing lies and deceit and strawberries symbolizing sexuality. Often, additional research is required to interpret hidden symbolism.

In looking at a work of art and trying to determine its subject matter, we find that some works are easier to "read" than others. Some works have

2-1 J. M. W. Turner, *The Slave Ship*, 1840. Oil on canvas, 35 3/4″ × 48 1/4″. Museum of Fine Arts, Boston (Henry Lillie Pierce Fund).

objects that look like things we see in the "real" world, whereas others do not resemble anything we have ever seen. To explain the differences in art terms between these types of approaches, works are described as being **representational, abstract,** or **nonrepresentational** (or **nonobjective**).

Representational art portrays things perceived or represented in the visible world in recognizable form. Thus, a painting of a dog would look like a dog that we have seen or would expect to see in the natural world. The dog in fifteenth-century painter Jan van Eyck's *Giovanni Arnolfini and His Bride* (FIG. 2-4) is an example of representational art.

Abstract art, in the purest sense of the term, deals with extracting or "abstracting" the essence of a thing or image. In doing so, the artist makes forms recognizable as something from the natural world, although somewhat simplified or distorted. Very different from van Eyck's dog is the dog in Picasso's *Three Musicians* (FIG. **2-2**). There is just enough visual information to tell us that a dog is under the table. However, the body is stiff, the coat is reduced to toothpick-like lines, and the tail and pointed-eared head are

2-2 Pablo Picasso, *Three Musicians*, 1921. Oil on canvas, 6'7" × 7'3 3/4".
Museum of Modern Art, New York.

moved away to slightly different areas of the composition. This is hardly the
kind of dog we would expect to see in our neighborhoods, but it is an excel-
lent example of abstract art.

Nonrepresentational (or **nonobjective**) art goes one step further than
pure abstract art. Nonrepresentational art makes no reference at all to the
natural world of images. All identifiable subject matter has been eliminated.
The artist uses the elements of style and compositional devices (discussed
later in this chapter) to express his or her intent in the artwork. It is often said
that the formal elements *are* the subject matter. A pioneer of nonrepresenta-
tional art is twentieth-century artist Wassily Kandinsky, whose painting *With
the Black Arch No. 154* (FIG. **2-3**) essentializes this type of art.

For works that are representational or abstract, we would also notice into
what category or style of subject matter a work would fall. Is it biblical,
mythological, portrait, historical, landscape, or genre? (**Genre** refers to real-
istic paintings of representations of everyday life.) Identifying this factor
gives us a deeper understanding of the work itself.

2-3 Wassily Kandinsky, *With the Black Arch No. 154*, 1912. Oil on canvas, 74″ × 77 1/8″. National Museum of Modern Art, Georges Pompidou Center, Paris. Copyright ADAGP, Paris, 1993.

FORMAL ELEMENTS

The formal elements, also referred to as the *visual elements,* constitute the basic ingredients at the artist's disposal. The choices made as to which formal elements to use and how to use them ultimately determine what the work will be like in the end. The formal elements are line, color, value, texture, shape, space, time and motion, and sound and smell.

 Line: Technically, a line is a mark made by a moving point. Lines can create patterns, move our eyes through the composition, or describe or express emotions. Lines are not all the same; they can be thick or thin, short or long, straight, angular, or curved, hard- or soft-edged, similar or contrasting, horizontal, vertical, or diagonal, broken or unbroken, and dominant or subordinate. Lines can go in the same direction or in various directions. Lines can be contained within the edges of the shapes within the work, or they can be **contour** lines, which define the outlines of the shapes. Lines have intrinsically expressive meanings and are described in such terms as *calm, agitated, nervous,* or *gentle.*

Color: In discussing color, we must consider **hue,** which is the name of the color, such as red or green. Also note whether mainly **primary** (blue, red, and yellow) or **secondary** (green, orange, violet) hues are used. Twentieth-century painter Piet Mondrian reduced his color palette to only primary colors (with black and white) so that his paintings would appeal to people universally. Are **complementary colors** used? These are colors opposite from one another on the color wheel. The basic pairs are blue/orange, red/green, and yellow/violet. When used together, these colors intensify one another. Another aspect of color is its **intensity** or **saturation.** Simply put, how "violet" is the violet? How "orange" is the orange? The more pigment in the color, the more highly saturated or intense it is. Color also varies in warmth or coolness. Blues are cooler than reds, for example, and tend to subdue, thus affecting the mood of the work.

Value: Value has to do with the varying degrees of light and dark. In relationship to color, value distinguishes light from dark, as in the difference between "light" blue and "dark" blue. Light colors are "high" in value; dark colors are "low" in value. Sculpture is particularly affected by the direction and intensity of the light, thus the value. Note whether the gradations of light and dark are gradual or abrupt. When there is a strong contrast of light and dark, the artist is employing a device called **chiaroscuro.** Rembrandt frequently used chiaroscuro, which heightens the sense of drama in his works, such as *The Night Watch.*

Texture: *Texture* refers to the tactile aspect (**actual texture**) or to the *illusion* of the tactile aspect (**implied texture**). In regard to actual texture, consider whether the paint is applied in a smooth manner, whereby the eye can barely detect the presence of the brush. (Be aware that reproductions make it difficult to see this aspect of a painting; however, a **detail,** which is a close-up view of a small section of the work, can reveal this condition.) This smooth application gives the work an almost glassy, photographic look. A good example is van Eyck's *Giovanni Arnolfini and His Bride* (FIG. **2-4**). On the other hand, notice whether the paint is applied in thick daubs. If so, the artist is employing the technique of **impasto** (meaning "like a thick paste") and is working in a **painterly method.** Vincent van Gogh worked in this painterly method, and if you were able to run your hand quickly over the front of his paintings, you would clearly feel the roughness and the thickness of the paint on the surfaces. When considering actual texture, also note whether any different materials are introduced to the work. Pablo Picasso and Georges Braque experimented with textural variation when they glued pieces of newspaper to their paintings. In sculpture, notice whether the surface texture is smooth or rough. Nineteenth-century sculptor Auguste Rodin used both of these approaches in his very smooth work, *The Kiss,* as opposed to the craggy surface of his *Monument to Balzac.* **Implied texture** is not something you can physically feel, as in actual texture, but rather is purely a visual concern. *Giovanni Arnolfini and His Bride* also exemplifies implied texture. In Mr. Arnolfini's fur coat, you can detect the individual hairs; the

2-4 Jan van Eyck, *Giovanni Arnolfini and His Bride,* 1434.
Tempera and oil on wood, 32″ × 23 1/2″. National Gallery,
London.

"information" of the softness and "furriness" of the coat is conveyed to you
or "implied" to your sense of touch. Another example in that work is the
implied furry texture of the little dog's coat, waves and all.

Shape: *Shape* refers to an area that stands out from the space next to or
around it because of line, color, value, or texture. Line and shape are often
closely interrelated, although drawn contour lines are not necessary to create
shape. **Actual shapes** can be clearly and immediately seen by the eye. How-
ever, **implied shapes** might also exist in the work. A triangular shape, for
instance, could be visually suggested by the arrangement of figures, such as
in Raphael's Renaissance paintings of the Madonna, Child, and St. John. In
this case, the most stable of all geometric shapes, the triangle, also exempli-
fies the Renaissance characteristics of calm and orderly composition. There-

fore, shape can contribute to the meaning or stylistic tenets of a work. Note also whether the shape is simple or complex, regular or irregular.

Space: Space is concerned with either a two-dimensional or three-dimensional aspect of a work. In painting, a two-dimensional medium, space is concerned with the appearance of depth or flatness. Does the work remain a two-dimensional vision, or does it give the appearance of three dimensions? If the latter is true, certain pictorial devices can be used to create a three-dimensional sense of space. One of those devices is **linear perspective,** whereby all parallel lines and edges of surfaces receding at the same angle are drawn so that they converge at a single vanishing point. **Atmospheric** or **aerial perspective** creates the illusion of distance by decreasing the saturation of color and details and blurring the contour lines. **Foreshortening** is the technique of distorting an object or parts of an object that are at an angle to the picture plane, making them appear to extend backward or forward into space. **Overlapping** is also useful, wherein one figure or part of a figure extends over a part of another figure, creating a visual sense of depth. In three-dimensional sculpture and architecture, attention is cast on the space surrounding the piece and how the sculpture or building and that space mutually relate. In essence, the sculpture or building interacts with the space to create the whole work.

Time and **motion:** As our modern world is increasingly preoccupied with moving in the fast lane and with time getting away from us, it is not surprising that the notions of time and motion have become formal elements in our artwork. We have discussed two- and three-dimensional aspects of art. Motion is another element in the third dimension. Time, however, ushers in the fourth dimension. More recent mediums, such as photography, film, and video, deal with time and motion rather obviously. Paintings, such as Marcel Duchamp's *Nude Descending a Staircase,* (FIG. **2-5**) and sculpture, such as Umberto Boccioni's *Unique Forms of Continuity in Space,* depict figures who are rushing in a forward motion through time, their broken planes testimony to their hurried and fractured modern existence.

Sound and **smell:** Although sound and smell were not an issue with works of earlier centuries, contemporary mediums such as installation art and performance art bring in such new elements. Because there are no boundaries in these inventive mediums, the possibilities regarding the use of sound and smell are endless.

PRINCIPLES OF DESIGN

Design is the organization or the **composition** of the formal elements of art. The artist must decide not only which of the formal elements to use, but also how to arrange them. Design principles bring a certain sense of order to the work of art, pleasing our aesthetic sensibilities in the process. The most general principles used in design are the following.

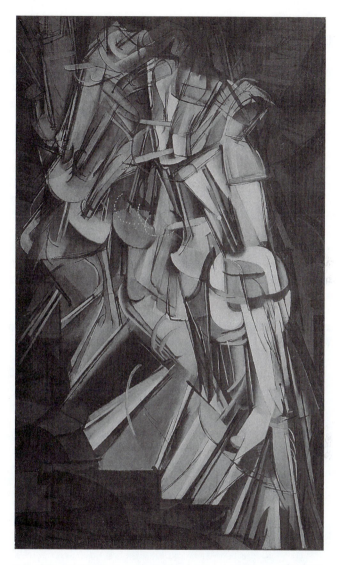

2-5 Marcel Duchamp, *Nude Descending a Staircase*, 1912. Oil on canvas, 58″×35″. Philadelphia Museum of Art (Louise & Walter Arensberg Collection).

Balance: Balance has to do with the distribution of masses in the work of art. If a line were to be drawn **axially** (down the middle of a work), would one side be a mirror reflection (with minor disparities allowed) of the other? If so, we have **bilateral symmetrical balance.** If this is not the case, then

asymmetrical balance exists in the work. **Radial balance** is another possibility, whereby the compositional elements radiate outward from or converge upon a central point.

Unity and variety: Unity is a condition or sense of oneness, of different elements and images belonging together and ultimately making up a coherent whole. Unity is created by the repetition of shapes, colors, textures, linear directions, and so forth. One of the most obvious examples of the use of repetition is Andy Warhol's *200 Campbell's Soup Cans*, (FIG. **2-6**) wherein he paints two hundred soup cans stacked in rows, all looking the same. Or do they? Upon closer inspection, we notice that Warhol has introduced variety by diversifying the kind of soup on the label, for example, vegetable, tomato, pepperpot. Variety provides interest and vitality, alleviating the visual boredom that can result from extreme unity.

Proportion and scale: Proportion and scale both have to do with size. *Scale* refers to the relative size of an object as compared to other objects of its kind. Scale deals with size in relation to some constant, often a human being, or to normal size, the size we expect something to be in the natural world.

2-6 Andy Warhol, *200 Campbell's Soup Cans*, 1962. Oil on canvas, 72″×100″. Private collection, photo courtesy of Leo Castelli Gallery, New York.

Proportion refers to the relationship in size of one part to another or of each part to the whole. If the head of a sculpted figure, for example, looks exceedingly large, it is "out of proportion."

Rhythm: Rhythm deals with the recurrence or repetition of identical or similar elements, such as lines, shapes, or colors that imply order and continuity. Rhythm can also be established through a reiteration of alternating elements. A good example is the alternating textures in the smooth and bunched-up treatment of the drapery in the marble statue titled *Three Goddesses* (FIG. **7-4**) from the Parthenon. Ultimately, the main function of rhythm is to move the viewer's eye through the composition.

MEDIUM

Medium (plural *media* or *mediums*) refers to the physical material or technical means that an artist uses for expression in his or her works. First, establish what major category the artist is working in, such as drawing, painting, sculpture, printmaking, mosaic, ceramics, computer graphics, collage, mixed media, fiber arts, installation art, performance art, photography, video/film, architecture. Then, discuss the materials or specific technique used, such as ink, pencil, oil paint, tempera, acrylic, fresco, gouache, watercolor, chalk, charcoal, clay, stone, wood, glass, metal, fiber, paper, sand, ice.

STYLE OR "ISM"

The notion of **style** in art encompasses both the **personal style** of the artist and the **period style** in which the work was done. The artist's personal style is defined by distinctive, recurring characteristics. We can look at the works of Matisse and easily recognize his personal style by the bold primary colors, arabesque patterns, and flattened space, which are repeated in the majority of his works. Another consideration related to style is the particular period style of the artwork. The concept of period refers to *time,* and it is safe to say that during most periods of time, artists have worked in fashions similar to one another. Works done during the Renaissance, for example, usually adhered to like tenets, such as rounded figures and three-dimensional space. However, it is also true that major, differing styles coexisted during some periods. In the fourteenth century, the Proto-Renaissance, many artists were beginning to work in the new Renaissance style, as established by Giotto. However, another group of artists went in a different direction, working in the Italo-Byzantine style, depicting flattened figures and two-dimensional space. Later, in the nineteenth and twentieth centuries, it was common for many styles, or **movements,** to coexist during a time period. Often the names of these movements ended in "ism," such as Impressionism,

Post-Impressionism, Abstract Expressionism, Dadaism, Surrealism, and so forth. Consequently, it is often asked, "What is the artist's 'ism'?" meaning "What is the period style or movement in which the artwork was done?"

THE FORMAL ANALYSIS

This section will instruct you in writing a formal analysis of a work of art. Be aware that a **formal analysis** is not the same thing as a **formal description.** When writing a formal description, focus only on *what* you are seeing. Mention the objects depicted in the work, as well as some of the formal elements and principles of design discussed in the previous section of this chapter, "The Language of Art." For example, the following sentence might be found in a formal description: "A woman in a bright scarlet dress arranges delicate yellow flowers in three blue vases, evenly spaced on a tilted tabletop."

A formal analysis, however, focuses not only on *what* is seen, but also on *why* it is there and *how* it is presented. In other words, you would discuss why the artist made the choices he or she did and how those choices affect the work. Instead of merely describing, you are moving into the arena of evaluating, inferring, and discussing meaning. A formal analysis might begin just as the descriptive example begins, but it would go on to delve more deeply: "A woman in a bright scarlet dress arranges delicate yellow flowers in three blue vases, evenly spaced on a tilted tabletop. The dynamic energy emitted from the intensity of her red dress is cooled by the blueness of the vases, as well as their symmetrical placement, only to be heightened again by the implied careening of the vases suggested by the slope of the table." The second sentence discusses the effect that these different elements have on one another and on the overall work.

PLANNING THE FORMAL ANALYSIS

In writing a formal analysis of a work of art, it is important that you have a visual of the work in front of you. Some assignments require that you go to a gallery or museum to see the work firsthand. Others, however, require you to select a color reproduction from an art history or art appreciation textbook. Be aware that reproductions are rarely completely true to the original.

Record the identifying information about the work, such as its title, artist, medium, dimensions, and current location. Then look hard and carefully at the work and take notes regarding the *subject matter* and *formal elements, principles of design, medium,* and *style,* as those terms have been explained in the preceding section.

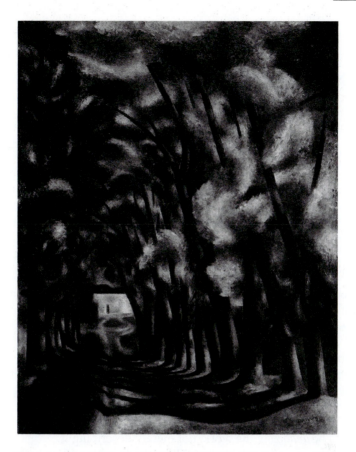

2-7 Andrew Dasburg, *Chantet Lane*, 1926. Oil on canvas, 74.9
cm × 59.7 cm. Denver Art Museum.

Decide which are the most important elements of the work. For example,
do you have enough notes to develop a discussion of line for the duration of
a paragraph? Could you develop a paragraph on color? shape? perspective?
iconography? Make decisions concerning upon which elements of the work
you will concentrate. You will find that some of the topics of discussion over-
lap. For example, in the following essay, a discussion of an element of the
subject matter, specifically the leaves of *Chantet Lane* (FIG. **2-7**), discusses
also the elements of color and shape.

Next, develop an outline of your formal analysis. Use the following tem-
plate:

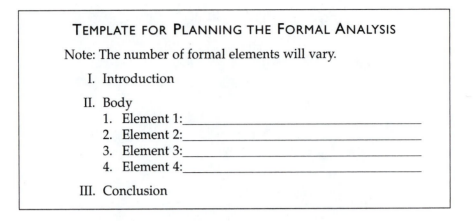

WRITING THE FORMAL ANALYSIS

The introduction of the formal analysis will identify the work of art, artist, medium, time period in which the work was produced, and often its location. The introduction might also give some biographical information about the artist and discuss some of the influences upon him or her. You might opt to describe your and other viewers' reactions to the work.

Each body paragraph should discuss some particular element of the work. Body paragraphs should always possess the qualities of *unity, adequate development, organization,* and *coherence.* These qualities of the well-written paragraph are elaborated upon in Chapter One. Remember as you write that you should be *analyzing* the work, not merely describing it.

The conclusion of your essay will probably discuss why the work is important. You might describe your personal encounter with the work, as Ron Baxendale does in the following essay, "*Chantet Lane:* A Post-Impressionist Walk in the American Southwest." You might also comment on how the work you are analyzing fits into the oeuvre of the artist (or does not). Or you might make a final assertion of why, based upon your discussion, the artwork works so well.

A SAMPLE FORMAL ANALYSIS ESSAY

Baxendale 1

Ron Baxendale II

Professor Noonan-Morrissey

Art History 201

20 April 1994

Chantet Lane: A Post-Impressionist Walk
in the American Southwest

Andrew Dasburg (1887-1979), who perhaps more than any other American painter willingly absorbed the influence of late-nineteenth-century French artists, took an Impressionist's love for the landscape, a *plein-air* approach, and a Cézannesque search for form and solidity to the American Southwest. Here--like Monet at Argenteuil, Pissarro at Pontoise, and Cézanne at L'Estaque--Andrew Dasburg could be found working out-of-doors near Taos or Santa Fe. In his 1926 American Post-Impressionist masterpiece *Chantet Lane,* an oil painting that rivals any French master's vision of the French landscape, Dasburg captures for the ages the remarkable beauty of the New Mexico countryside.

In the Denver Art Museum's *Chantet Lane,* Dasburg places the viewer at one end of a long tunnel of trees. Through the use of linear perspective we find ourselves positioned on the left side

Baxendale 2

of the road looking through this tunnel toward a
sunlit opening. The vanishing point, although not
precisely placed, lies within the brightly illumi-
nated adobe structure set along the horizon. By
making the vanishing point the brightest area of
the painting, Dasburg successfully draws our eye
down the road and into the distance. Locating the
opening in the lower left quadrant of the canvas
gives the artist a new angle from which to depict
an often symmetrical and balanced motif.

The use of linear perspective brings with it,
of course, the diagonal and the triangle, two com-
positional elements Dasburg uses to great advan-
tage. First, the line implied by the converging
green and yellow leaves above the roadway runs
from the painting's upper-left corner toward the
lower-right corner. This diagonal divides the
entire painting into two triangles. Second, two
diagonals are formed by the succession of tree
trunk bases that recede into the distance on each
side of the road. Moving toward one another, these
lines form a triangle in the lower portion of the
painting that directs our eye upward toward the
vanishing point. Likewise, the three visible
patches of blue sky in the upper portion of the
painting form a triangle that directs our eye

Baxendale 3

downward toward the vanishing point. This hour-
glass shape created by the two triangles just
identified quite inconspicuously centers our
attention on the adobe structure set in the sunlit
opening at the end of Chantet Lane.

Stretching the length of Chantet Lane, the two
rows of tree trunks, appearing almost regular in
pattern due to their uniform irregularity, resem-
ble the majestic colonnades of a Greek temple; in
fact, Dasburg's tree trunks are indeed columns--
long, tall, vertical shafts that gradually narrow
toward the top. This discussion of columnar,
cylindrical form brings to mind Cézanne's famous
remark that the painter should "treat nature in
terms of the cylinder, and the sphere, and the
cone" (de la Croix 864). As evidenced in *Chantet
Lane,* Cézanne's statement was one Dasburg took to
heart. While Dasburg's smooth use of line gives
hard, crisp edges to the tree trunks, line con-
trols shape while ignoring detail. But detail is
captured and communicated through the use of
color: upon closer examination, color informs us
that Dasburg's trees are not smooth cylinders, but
rather imperfect surfaces. Dasburg's varying
shades of brown, colors that play delicately over
a variety of tree trunk surfaces set at a variety

Baxendale 4

of angles, not only establish columnar shape
through light and dark but also reveal the rough
texture of vertically grained tree bark.

The rigid linear structure of the tree trunks
contrasts the loose, curvaceous leaves. Flowing
in, out, and around the trees' upper branches,
Dasburg's leaves hang like light, airy fragments
of cotton candy caught on sharp, pointed sticks.
These soft, fluffy clumps, although intended to
represent leaves, seem to also imply the presence
of unseen clouds in the blue sky blocked from
view. The curved shapes of the leaves, arms that
motion us to follow along down the roadway, direct
our attention once again down the lane toward the
adobe structure placed in the sunlit opening.
These swirling masses of leaves are constructed of
small rectangular brush strokes that impart a geo-
metric solidity not normally associated with the
sinuous, delicate quality of leaves; but these
brush strokes, along with heavy impasto, do impart
a texture very much associated with thick foliage.

Dasburg's choice of colors for his leaves--warm
yellow-orange with touches of red and cool green
with a few traces of yellow--captures and defines
detail, just as did brown hues in his tree trunks.
Once again, we touch upon another Cézanne idea

Baxendale 5

obviously of great importance to Dasburg: if all
we see is color--the fleeting screens of color
that the eye takes in--then "color alone must give
depth and distance, shape and solidity" (de la
Croix 864). Through his use of color, Dasburg sug-
gests the many layers of individual leaves that
recede into space.

Because light enters the painting from the
right, the tree trunks cast shadows to the left
that lie horizontally across the roadway. These
shadows, as does the bright sunlight that shoots
in between the trees, fall into ruts and depres-
sions that define the dirt road's undulating sur-
face and texture. Texture is again enhanced by
Dasburg's short rectangular brush strokes dis-
cussed earlier in relation to his green and yellow
leaves. Using brown hues similar to those in the
tree trunks, Dasburg suggests the rough, pebble-
strewn surface of the dirt road. The alternating
light and dark stripes of sunlight and shadows
offer themselves as steps or rungs of a ladder by
which the viewer can climb through the dark alley-
way toward the opening in the distance.

Although impressive in its use of color to
establish depth, shape, and solidity, Dasburg's
Chantet Lane is above all an exercise in contrast.

Baxendale 6

Not only do light and dark, looseness and rigid-
ity, and verticals and horizontals oppose one
another, but also the colors yellow and green pro-
vide contrast between hot and cold, summer and
fall, and sunshine and shade.

With all this now said, the next time we find
ourselves in front of Andrew Dasburg's *Chantet
Lane* we will have reason to look more deeply at
an artist who has strong connections to the
Impressionists through contact with their work; an
artist who so admired the work of late nineteenth-
century French masters that he made their tech-
nique his own; an artist who, the equal of a
Monet, Pissarro, or Cézanne, lived and worked in
our midst painting the beauty of nature found in
our own seemingly commonplace surroundings.

From March of 1994 to May of 1995, the Denver
Art Museum exhibited its French masters collec-
tion. Among works by Daumier, Degas, Bouguereau,
Rodin, Gris, and Braque, works by Renoir, Monet,
and Pissarro were included as well. In an adjacent
room hung Andrew Dasburg's *Chantet Lane,* framed by
the connecting passageway. Viewers standing in
front of the Monets and Pissarros could, and often
did, turn to gaze at *Chantet Lane* through the open

Baxendale 7

doorway. The power of the work was inescapable.
Andrew Dasburg could not have been in more appro-
priate company.

Works Cited

de la Croix, Horst, and Richard G. Tansey. *Gard-
ner's Art Through the Ages.* San Diego: Har-
court, 1986.

Although the author of the preceding formal analysis chose to include quotes in his essay, that is not a requirement of a formal analysis. The bulk of the essay focuses on the elements discussed in the "Language of Art" section of this chapter. Ron Baxendale looks at the artwork with incisive eyes, as is appropriate in a formal analysis.

REVISING, EDITING, AND PROOFREADING YOUR PAPER

Use the following checklist to be certain that your paper is ready for submission. Consult the "Handbook" section at the end of this book for guidance in issues of sentence structure, grammar, punctuation, mechanics, and style.

REVISION CHECKLIST

☐ Introduction contains specific information about the artwork, including the name of the work, the artist, time period produced, medium, and location.

☐ Introduction develops a brief description of the artist's life or influences, the style in which the artist worked, or reactions to the work.

☐ Each body paragraph discusses one element of the artwork.

☐ Body paragraphs are unified, adequately developed, organized, and coherent.

☐ Conclusion develops a discussion of the importance of the artwork, the writer's reaction to the work, how the work fits into the artist's oeuvre, or why the artwork succeeds.

☐ Sentences are well constructed. There are no run-ons or fragments.

☐ Sentences are correctly punctuated.

☐ Words are correct and well chosen.

☐ Title is appropriate.

☐ Paper is properly formatted.

3

WRITING THE EXPOSITORY ESSAY

Planning the Expository Essay

Topic Suggestions *What Is the Appeal of the Artwork (or Artist)?*
How Does One Artwork Compare to Another?
How Do Certain Elements of the Art Contribute to Larger Concepts?
What Caused the Artist to Make Certain Choices?

Sample Expository Essays *Organizing the Comparison-Contrast Essay*

Revision Checklist

At the heart of the expository essay about art is an *inference*. In other words, the writer posits a theory about the art and then supports that theory with facts. There are many approaches to expository writing. You might theorize about the causes or effects of some artistic movement or event. You might theorize about a particular artwork's meaning, or, if the meaning is not at issue, you might infer the artist's reasons for making certain choices. You might explain viewers' reactions to the artwork. You might also compare one work of art to another in order to support your inference.

Of particular interest in this chapter are one professionally written essay and three examples of student essays. Each demonstrates a particular approach to expository writing. In the essay titled "Strength in Stone: Michelangelo's *David*," the author theorizes about the reasons for the sculpture's universal appeal. The first student essay, "Gothic Nightmares in Romantic Painting," demonstrates the comparative approach. The second

student essay example, "Don't Worry, Be Happy: Minoan Art and Architecture," examines environmental influences upon Minoan art. The third student essay, "Nobility in Human Suffering in the Work of Théodore Géricault," infers the reasons for the artist's choice to idealize his figures. Students who read these essays will find themselves in possession of an increasingly clearer idea of the nature of exposition and of the various approaches to expository writing.

PLANNING YOUR ESSAY

Before you write the expository essay, it is best to spend some time planning and sketching an outline. A general process for planning essays is described in Chapter One. The following is a further description of the process, more specifically as it applies to writing the expository essay.

1. Choose a topic. Isolate one remarkable element of the artwork or technique of the artist that you find intriguing. Consider the length of the essay and narrow your topic accordingly. A two- or three-page essay cannot discuss Renaissance art in depth. Nor would that amount of space allow for a deep discussion of Michelangelo's body of work, or even of one piece—Michelangelo's *David* (FIG. **3-1**). The essay presented later in this chapter discusses just one aspect of the *David*—its universal appeal.

2. Pose a research question. Be certain that your research question will lead to an expository essay. Following are four research questions, each of which stands a good chance of leading to an expository essay on art.

 ◆ What is the appeal of the artwork (or artist/s)?

 ◆ How does the artwork (or artist) compare to another?

 ◆ How do certain elements of the art contribute to larger concepts?

 ◆ Why did the artist make certain choices?

 There are other possible research questions, naturally, that will lead you into exposition. If you are in need of guidance, however, avail yourself of the preceding suggestions. Additionally, beginning on page 60 are numerous examples of specific research questions based upon the four generally stated ones above.

3. Formulate a thesis. Your thesis answers the research question you have posed. The thesis statement is so important in the planning process that it would behoove the reader to pause at this juncture to contemplate the nature of the expository thesis. A workable thesis usually possesses the following qualities:

◆ Answers the research question
◆ Is one complete, unified statement about the artist or artwork
◆ Is precise enough to limit the material
◆ Is general enough to need support
◆ Is defensible
◆ Is not too obvious

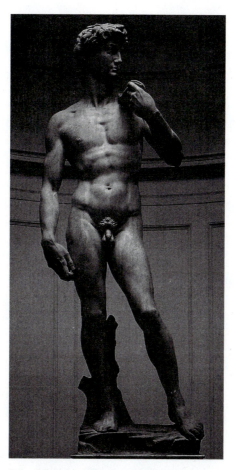

3-1 Michelangelo, *David*, 1501–1504. Marble sculpture, 14′3″ high. Galleria dell' Accademia, Florence.

Using the preceding guidelines, perform the following exercise.

EXERCISE: FAULTY EXPOSITORY THESES

All of the following theses are faulty. Imagine that the writer has observed in his introductory remarks that Michelangelo's *David* is an appealing work of art. The research question that arises from that observation is "What is the appeal of Michelangelo's *David*?" The thesis should answer that research question.

Use the preceding guidelines for a workable thesis to determine the problem(s) with all of the following expository theses. After you have determined the problems, compare your answers to those on the opposite page.

1. Michelangelo's *David* is an appealing work of art.

2. Michelangelo's *David* is an appealing work of art for three reasons.

3. This paper will analyze the appeal of Michelangelo's *David*.

4. The popularity of Michelangelo's *David* lies in its enormous appeal.

5. The appeal of Michelangelo's *David* can be understood through analysis.

6. Michelangelo's *David* symbolizes the concerns of humanity.

7. David killed Goliath and cut off his head.

8. Michelangelo's *David* was carved from an unlikely slab of stone.

9. Michelangelo's *David* helps us understand ourselves.

10. The *David* reveals Michelangelo's egocentric nature.

ANSWERS TO EXERCISE: FAULTY ANALYTICAL THESES

1. The thesis does not answer the research question. It merely repeats what has already been established in the introduction.

2. This sentence typifies the most common faulty thesis among beginning writers. The first half of the sentence repeats the mistake of thesis 1. The second half of the sentence merely anticipates the points of proof. The effect is that the thesis has been skipped and the writer has moved straight from the research question to the points of proof. The result will be an essay that develops three disparate ideas without a stated common bond. Furthermore, the thesis is indefensible in that there are many more than three reasons for the *David*'s appeal.

3. This sentence does not make a statement about the work. It is not a thesis but rather a statement of purpose, which is usually unnecessary. If a statement of purpose is necessary, it should not replace the thesis.

4. The sentence is circular.

5. The sentence does not make a statement about the work. It is also imprecise. What understanding will we come to after we have analyzed the work? Answer that, and you will have a thesis.

6. The thesis is too broad. The concerns of humanity are too numerous to be enumerated and developed in one essay.

7. The thesis is too specific; it needs no proving; it is a fact. And it is too obvious.

8. The thesis will not lead to an expository essay. Such a thesis will result in an essay written in the descriptive mode of discourse, or perhaps a narrative mode.

9. The thesis has potential but is still too broad. What specific understanding of ourselves does the sculpture help us to gain?

10. The thesis is indefensible.

4. Articulate a proof question. Convert the thesis into a question beginning with *how* or *why*.

5. List the points of proof. Give at least two answers to the proof question or however many are required to answer the proof question adequately.

If you are writing about Michangelo's *David*, your essay plan might look like the following:

EXPOSITORY ESSAY PLAN

MICHELANGELO'S *DAVID*

Choice of topic:
The popularity of Michelangelo's *David*

Research question:
What is the appeal of Michelangelo's *David*?

Thesis:
The *David* illustrates what is best about ourselves.

Proof question:
How does the *David* illustrate what is best about ourselves?

Points of proof:
1. The biblical story of David and Goliath reminds us that we are capable of extraordinary courage.

2. The artistic devices of *energy-in-reserve* and *contrapposto* dramatize the potential power of a human being.

3. The sculpture strikes a perfect balance between the real person and the ideal person, which helps us envision ourselves as ideal.

You may want to construct an outline for your essay, now that you have assembled the main points. An outline of the paper on Michelangelo's *David*, as planned in the preceding box, follows:

OUTLINE FOR EXPOSITORY ESSAY

MICHELANGELO'S *DAVID*

I. Introduction
 A. Introductory remarks: The *David* is a popular work of art.
 B. Thesis: The *David* is popular because it illustrates what is best about ourselves.
 C. List of points of proof:
 1. The biblical story of David and Goliath reminds us that we are capable of extraordinary courage.
 2. The artistic devices of *energy-in-reserve* and *contrapposto* dramatize the potential power of a human being.
 3. The sculpture strikes a perfect balance between the real person and the ideal person, which helps us envision ourselves as ideal.
II. Body (Development of each point of proof)
 A. Point of proof 1: The biblical story of David and Goliath reminds us that we are capable of extraordinary courage.
 B. Point of proof 2: The artistic devices of *energy-in-reserve* and *contrapposto* dramatize the potential power of a human being.
 C. Point of proof 3: The sculpture strikes a perfect balance between the real person and the ideal person, which helps us envision ourselves as ideal.
III. Conclusion

A SAMPLE EXPOSITORY ESSAY

Following is an essay that developed as a result of using the recommended process. Notice that the research question ("What is the appeal of Michelangelo's *David?*") and the proof question ("How does the *David* illustrate what is best about ourselves?"), although necessary to the planning process, are not physically present in the final version of the essay.

STRENGTH IN STONE: MICHELANGELO'S *DAVID*

BY NANCY NOONAN-MORRISSEY

Michelangelo's marble statue *David*, sculpted from 1501 to 1504 and housed in Florence's *Galleria dell'Accademia*, is a work of art that virtually everybody knows and loves. It was initially

intended to be placed high up on one of the exterior apse buttresses of the Cathedral of Florence, but the Florentine citizens insisted that it instead be placed at ground level so that it could be enjoyed by all at close range. People from cities and towns far and wide came to Florence to see the *David*, this mesmerizing figure that Michelangelo had sculpted from stone. They immediately were drawn to the work, to its sheer force of genius, as we still are today. Travelers planning their first "Grand European Tour" are sure to include a sojourn to Florence to see the *David*. We react to it like no other piece of art. It makes us cry. It makes us gasp. It makes some of us fall silent. It stops us in our tracks. But one thing it does *not* do is leave us untouched.

Thesis Ultimately, we realize that one reason we are so drawn to the *David* is that it illustrates what is best about us as human beings. First, the well-known story behind the sculpture, the *Points of* biblical theme of David and Goliath, speaks to our hope that *proof* we would face seemingly unconquerable foes as bravely as David did. Second, the artistic devices of *contrapposto* and *energy in reserve* dramatize the potential power of a human being, as David readies himself to meet Goliath. Finally, by striking the perfect balance between the real and the ideal person, the *David* helps us to envision ourselves as ideal.

First point The story of David and Goliath from the first book of Samuel, chapter 17, in the Hebrew Bible, appeals to our own aspirations of bravery. David, a shepherd boy of Bethlehem, first came into the service of his people through his musical talents. The king of the Israelites, Saul, was terrified of the approaching Philistines and commanded his servants to find him a skilled harpist who could soothe his nerves with beautiful music. David was selected. Soon David learned of the challenge given to the Israelites by a Philistine shock-trooper named Goliath, who, reportedly ten feet, nine inches tall, evoked terror in his enemies. Goliath shouted, "Choose you a man for you, and let him come down to me. If he be able to fight with me, and to kill me, then will we be your servants: but if I prevail against him, and kill him, then shall ye be our servants and serve us" (1 Sam. 17:8–9). David, although still only a boy, volunteered to fight Goliath in the name of God, while all of the other Israelites ran away. Goliath was fully armed, with metal armor, spears and javelins; David, however, refused the armor offered to him by Saul because he was not used to its heaviness. His weaponry consisted of five smooth stones and a sling. When Goliath saw his puny enemy, he disparaged David and delivered a dark threat: "Come to me, and I will give thy flesh unto the fowls of the air, and to the beasts of the field" (1 Sam.

17:9). Undaunted, David broke into a run, placed a stone in his sling, and struck the Philistine in the forehead, causing Goliath to fall to the ground. David then took the giant's own sword and killed him, cutting off his head and sending the Philistines fleeing in fear. David's unflappable bravery, when combined with his self-confidence and pride, catapulted him beyond the range of what is average and expected and into the realm where anything is possible. Thus, a shepherd boy becomes a hero, and our own need to hear of brave deeds, in order to envision ourselves capable of them, is satisfied.

Second point

Working in the style of the Italian Renaissance, Michelangelo draws upon the devices that had been developed by the Greeks and Romans many centuries earlier. A sense of weight-shift, or *contrapposto*, is applied, making the marble seem more like a real human being, as the body subtly rotates around the flexible axis of the spine. Michelangelo also uses the principle of *energy in reserve*, depicting the narrative at the point just seconds before the figure changes from one of potential energy to one of kinetic energy. Instead of the figure's being firmly and flatly planted on the ground, David's left foot is lifting up, the heel not touching the ground at all. David seems ready to confront Goliath, poised as he is at the exact moment before he runs at the giant. *Energy in reserve* is also apparent in Michelangelo's handling of David's body. One senses blood pulsing through the veins, pumping up this shepherd boy, about to trigger the adrenaline rush that will transform courageous intent into decided action. As we see his body revving up, we realize he is not going to back out; his bravery will propel him forward, a human being in his most noble moment. The head of David also portrays *energy in reserve*. The face, with its deeply grooved brow and its far-reaching gaze, shows a storm brewing beneath the surface, ready to be unleashed. Furthermore, the deep-set eyes and the furrowed forehead reveal this young man's concentration in the moments before his attack. The shock of hair on the head of *David* is presented as a deeply carved, tousled mass of pent-up energy, with thick, twisting plaits, wired to spring loose the moment David lunges forward.

Third point

Not only has Michelangelo used the ancient devices of *contrapposto* and *energy in reserve* to dramatize the potential power of a human being, but also he harkens back to the concepts of antiquity, particularly the Greek focus on the Golden Mean, to create a perfect balance in his *David*. This balance pulls together the dichotomies of the real and the ideal, more specifically, the real person and the ideal person. As human beings, we grapple with developing and integrating these two elements so that we are a healthy whole. David is depicted here as

a real shepherd boy, not some idealized, remote, godlike figure. Although the musculature is powerfully articulated and rather godlike, he is still portrayed as a young man who has not fully grown into his limbs. David also conveys a sense of real, honest-to-goodness human fear by the look in his eyes and the tension in his body.

The real and the ideal are also exemplified in the blending of the physical and intellectual prowess of this young shepherd. His body has clearly benefited from years of climbing the hills around Bethlehem, tending his father's sheep. The ancient Greeks revered nature and working outdoors, placing a great amount of importance on the development of the human physique. But as a people, they did not admire those who were all brawn and no brain. Equally important to physical development was advanced intelligence. So it is with the *David*, as he conjures up his physical strength and pairs it with intelligent planning.

Conclusion As we viewers cast our eyes upon the *David*, we come to the realization that David was just an ordinary human, but one with extraordinary vision and determination as well as extraordinary physical and intellectual abilities, a human whose courage surpassed the level of the ordinary. Ultimately, the *David* invites each of us to ask this question: "If this simple shepherd boy could accomplish such heroic deeds, then who's to say I can't, too?"

TOPIC SUGGESTIONS FOR EXPOSITORY ESSAYS

The list of possible topics is endless when it comes to writing about art, but not all research questions will lead you into an expository essay. The following questions, stated generally, are likely to lead to exposition.

- ◆ What is the appeal of the artwork (or artist/s)?
- ◆ How does the artwork (or artist) compare to another?
- ◆ How do certain elements of the art contribute to larger concepts?
- ◆ What caused the artist to make certain choices?

You might find some of the following suggested research questions helpful in choosing a topic for your expository essay. Keep in mind that in exposition, no absolute answer is available: You are expected to speculate.

WHAT IS THE APPEAL OF THE ARTWORK (OR ARTIST)?

- ◆ What is the appeal of the choppy application of paint in Impressionism?
- ◆ What is the appeal of Louise Bourgeois's sculptural works in an age of women's liberation?

- What is the appeal of the handling of fabric in the *Three Goddesses* from the Greek Parthenon?
- What is the appeal of large, everyday objects in Claes Oldenburg's works, such as the Philadelphia *Clothespin?*
- What is the appeal of Turner's handling of light and color in his paintings?
- What is the appeal of unexpected combinations in Robert Rauschenberg's combine paintings?
- What is the appeal of the mother/child subject matter in Mary Cassatt's paintings?
- What is the appeal of the human element of Dorothea Lange's photograph, *Migrant Mother, Nipomo, California?*
- What is the appeal of shape in Robert Smithson's *Spiral Jetty?*
- What is the appeal of repetition in Andy Warhol's silk screens of Marilyn Monroe?
- What is the appeal of abstraction in African sculpture?
- What is the appeal of empty space in Japanese compositions?

How Does One Artwork Compare to Another?

- How does the treatment of space in the Greek *Parthenon* compare to that in the Roman *Pantheon?*
- How do the neoclassical elements of David's painted, reclining figure of *Madame Récamier* compare to those elements of Antonio Canova's sculpted, reclining figure of *Pauline Borghese as Venus?*
- How does the Minoan approach to architecture, as shown in their palaces, compare to the Mycenaeans' in their citadels?
- How does Rembrandt's use of light compare to Poussin's?
- How do the churches of the Romanesque period compare to Gothic churches in terms of height and light?
- How does Cimabue's use of space in his Uffizi *Madonna Enthroned* compare to Giotto's use of space in his Uffizi *Madonna Enthroned?*
- How does the exterior decoration of Christian cathedrals from the Middle Ages compare to the exteriors of Islamic mosques from the same time period?
- How does the war theme on Maya Ying Lin's *Vietnam Memorial* compare to the treatment of war on the Roman *Column of Trajan?*
- How does the color palette of van Gogh's early works, for example, *The Potato Eaters,* compare to the color palette of his later works, such as *The Night Café?*
- How do George Segal's twentieth-century painted plaster sculptures compare to the painted polyester and fiberglass sculptures of twentieth-century artist Duane Hanson?
- How does the mood of Matthias Grünewald's *Crucifixion* panel from the Isenheim Altarpiece compare to the mood of its *Resurrection* panel?
- How does Helen Frankenthaler's use of color and shape in her painting, *Bay Side,* compare to that usage in Ellsworth Kelly's *Red Blue Green?*

HOW DO CERTAIN ELEMENTS OF THE ART CONTRIBUTE TO LARGER CONCEPTS?

◆ How do the facial and body gestures in Rubens's *The Rape of the Daughters of Leucippus* contribute to the Baroque nature of the painting?

◆ How does Leonardo's use of *sfumato* contribute to the mood of the *Mona Lisa*?

◆ How does the placement of the different images on the *Palette of Narmer* contribute to the Egyptians' concept of "horror vacui"?

◆ How does Georgia O'Keeffe's use of color contribute to the overall sensuousness of her paintings?

◆ How do the elements of nature contribute to Frank Lloyd Wright's design of *Fallingwater?*

◆ How do the concepts of existentialism contribute to the meaning of Munch's *The Scream?*

◆ How does Ribera's use of light in *The Martyrdom of St. Bartholomew* contribute to the sense of drama in the painting?

◆ How does Kandinsky's use of line and color contribute to the explosive quality in so many of his paintings?

◆ How do the sense of expression and the use of diagonals contribute to the Hellenistic character of the ancient Greek sculpture *The Laocoön Group?*

◆ How does the young woman's kicking off her shoe contribute to the Rococo essence in Fragonard's *The Swing?*

◆ How does Picasso's depiction of the figures in *Les Demoiselles d'Avignon* contribute to the Cubist treatment of time?

◆ How did Cézanne's respect for geometry contribute to his painting style?

◆ How does the use of fur contribute to the sense of contradiction in Meret Oppenheim's *Object?*

◆ How do the hand gestures contribute to the meaning in many statues from India?

◆ How does the element of music contribute to Paul Klee's *Twittering Machine?*

WHAT CAUSED THE ARTIST TO MAKE CERTAIN CHOICES?

◆ What caused the Assyrians to employ the technique of double aspect relief in their sculpted *Lamassu* figures?

◆ What caused Manet to depict the seated female figure nude while the other figures were clothed in *Le Déjeuner sur l'herbe?*

◆ What caused the Mannerists to crowd and elongate their figures in their paintings?

◆ What caused the Egyptians to include an extra chamber called the *serdab* in their pyramids?

◆ What caused van Gogh to use the color yellow so predominantly in so many of his paintings?
◆ What caused the Greeks to stop clothing their sculpted male figures in the Age of Colonization?
◆ What caused Picasso to create the Cubist style in his paintings?
◆ What caused Nicola and Giovanni Pisano to move away from the Italo-Byzantine style, which was so popular in the late thirteenth and early fourteenth centuries?
◆ What caused Rosalba Carriera to depict herself in her self-portraits so differently from the way she depicted her aristocratic clientele in formal portraits?
◆ What caused the Impressionist style to be replaced by the various styles of the Post-Impressionists?
◆ What caused the inhabitants of the Neolithic Anatolian settlement of Çatal Hüyük to include so many shrines within their dwelling structures?
◆ What caused the Greeks to have so many varied shapes to their pottery?
◆ What caused so many painters, such as Artemisia Gentileschi, to follow Caravaggio's style in the seventeenth century?
◆ What caused the public to be so affronted by Courbet's *The Stone Breakers* in the nineteenth century?
◆ What caused the American artists of the "Ashcan School" to use so many dark, drab colors in their paintings?

TEMPLATES FOR PLANNING THE EXPOSITORY ESSAY

Now that you have chosen your topic, begin organizing your ideas. Use the following template to assist you.

EXPOSITORY ESSAY PLAN

1. My topic: _____
2. My research question: _____?
3. My thesis:_____
4. My proof question: _____?
5. My points of proof: (Fill in at least two blanks.)
 1. _____
 2. _____
 3. _____
 4. _____
 5. _____

Now use the following template to outline your own expository essay.

EXPOSITORY ESSAY OUTLINE

I. Introduction

 A. Introductory remarks (briefly): _____

 B. Thesis_____

 C. List of points of proof: (Fill in at least two blanks.)

 1. _____

 2. _____

 3. _____

 4. _____

 5. _____

II. Body: (Development of each point of proof)

 (Copy your points of proof from C above; there should be at least two.)

 A. Point 1: _____

 B. Point 2: _____

 C. Point 3: _____

 D. Point 4: _____

 E. Point 5: _____

III. Conclusion

SAMPLE EXPOSITORY ESSAYS

Following are three examples of college student essays. All three exemplify an expository mode of discourse as well as the form recommended throughout this book. Rachel Gothberg, the author of the first essay, has noticed that Fuseli's *The Nightmare* (FIG. **3-2**) and Goya's *El sueño de la razón produce monstruos (The Sleep of Reason Produces Monsters)* (FIG. **3-3**) are similar in that they are both from the Romantic period and they both are interested in nightmares as an avenue for exploring the subconscious. But how are the artists' attitudes toward their subjects different from each other? That is the essential question that the author strives to answer in "Gothic Nightmares in Romantic Painting."

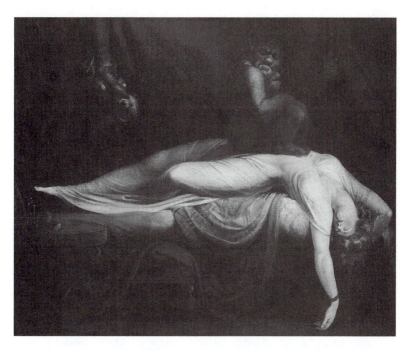

3-2 Henry Fuseli, *The Nightmare*, 1781. Oil on canvas, 40″ × 50″. Detroit Institute of the Arts.

3-3 Francisco de Goya, *The Dream of Reason*, from *Los Caprichos*, c. 1794–1799. Pen and sepia drawing, 8″ × 5″. Prado, Madrid.

Gothberg 1

Rachel Gothberg

Professor Heydt-Stevenson

Humanities 4102

14 March 1999

Gothic Nightmares in Romantic Painting

During the Romantic period, there was a
revival of interest in Gothic art and ideas.
Through their Gothic paintings, Henry Fuseli and
Francisco Goya were among the first artists to
explore the human subconscious and the darkest
recesses of the human mind. Fuseli's *The Nightmare*
and Goya's *El sueño de la razón produce monstruos*
(The Sleep of Reason Produces Monsters) are both
disturbing pictures that show people having night-

Thesis mares. Although they are similar in subject, they
differ in attitude toward the release of subcon-
scious desires inherent in sleep. Henry Fuseli
conveys the frightening idea that although the

Points of deepest desires of the subconscious are suppressed
proof in order to follow the expectations of society,
the unexplored areas of the subconscious that are
able to be kept secret and hidden in the
waking hours resurface as monsters in sleep. Goya,
on the other hand, shows that these dark areas of
the mind, when combined with reason, can be man-
ageable and even positive.

Gothberg 2

Fuseli combined contemporary notions about women's nightmares with his own fantasies to create an erotic yet frightening depiction of the relationship between sleep and the unconscious mind. Dreams, especially those of women, had been the subject of many theories. Some people believed that nightmares are caused by the menstrual cycle; others believed that they come from women's unconscious desire to be raped and controlled by men. It was the belief of some that getting married would stop the nightmares (Powell 53).

In Fuseli's painting, a woman wearing a virginal white gown reclines beneath a strange creature, which is often referred to as an incubus. The woman is lying in an exaggeratedly sexual position that leaves her vulnerable. Because of the way her head falls so far back and her arms lie limply on the ground, she looks as though she has fainted or died. Her face does not show that she is resting peacefully; rather her features are strained, and she appears to be frowning as if something were tormenting her.

Because an incubus is believed to sit on or have intercourse with women while they are sleeping, they are associated with attributing nightmares to innocent victims. In Fuseli's painting,

First point

Historical context

Dreamer

Dream creatures

Gothberg 3

the dark incubus, who in some versions wears a mask, rests in a fetal position, weighing upon the woman's breast just as the nightmare weighs upon her mind. By his position and his bizarre appearance, the incubus resembles the frightening and watchful gargoyles that perch upon Gothic architecture. Therefore, in Fuseli's painting the woman's sexual desires, which she had been able to suppress during her waking hours, have now been freed in the form of the incubus and partake in her dark fantasies.

Most likely the horse in the background is a play on words and meanings. A mare is a female horse, but it is also an evil creature that causes night*mares*. The horse, or mare, as it peers through the curtains into the woman's bedchamber, subtly informs the viewer that the scene is of a nightmare and that the woman is in fact sleeping rather than dead. The mare's flowing mane suggests that she has just burst into the quiet room, and with her arrives the manifestation of the woman's unconscious desire, the incubus. Literally and symbolically, the nightmare has now burst in and burdens the sleeping woman's once-peaceful rest. The woman is a victim of her own unconscious desires; she can neither eliminate nor act upon

Gothberg 4

her urges but can only suppress them, and there-
fore she will always be vulnerable to them.

Second point

Goya's artwork deals with the same dark urges,
but his come out in society both during the day
and night. He believed that these urges do not
need to be repressed if they can be combined with

Historical context

reason. The Enlightenment had held that reason
should direct the actions and thoughts of human-
ity; however, this ideal was not evident in Goya's
society. Spain was troubled by the Napoleonic
wars, the corrupt church, and the horrifying
Inquisition, which bred sin, violence, and greed.
If reason had been used against these problems,
society could have been made safer and more pro-
ductive, but unfortunately, reason was ignored,
and the situation escalated out of control. In a
series of etchings, *Los Caprichos,* people are
shown as haggard and disgusting. Their features
are combined with those of animals in order to
show the dark, wild aspects of humankind.

Dreamer

Goya makes the importance of reason clear with
his work, *The Sleep of Reason Produces Monsters,*
which was the frontispiece of *Los Caprichos.* The
print shows a man who has fallen asleep on his
work table while creatures of the night surround
him in a nightmarish frenzy. The caption beneath

Gothberg 5

the engraving reads, "Imagination abandoned by rea-
son produces impossible monsters; united with her,
she is the mother of the arts and the source of
their wonders." In other words, while reason is
sleeping or is inactive, it is unable to control
the monsters that lie within the mind, but imagi-
nation and reason together are the source of art.

Goya believed that art is a combination of
reason and unreason and that nightmares and the
imagination are linked (Eisenman 78). The man in
The Sleep of Reason Produces Monsters is most
likely the artist himself. The figures that sur-
round him are those of his imagination--the cre-
ative, unreasonable side of his art. The artist,
who has unwillingly fallen asleep while working,
rests uncomfortably on his work table with paper
and writing utensils nearby. He has chosen not to
go to bed for the night and allow sleep to over-
come him, just as most people do not generally
choose to let reason abandon them and thereby
allow themselves to be overcome by the potential
evils of the mind. The man, therefore, represents
not only Goya and art, but also reason itself.

Dream creatures

The cats, owls, and bats that surround the
sleeping man convey the idea that superstition is
created by the mind when logic is absent. The lynx

Gothberg 6

that rests in the lower right-hand corner mimics the sleeping man, his paws crossed in the same manner in which the man's arms are folded. The use of animals acquiring human traits and vice versa is a theme throughout *Los Caprichos* that shows how humans are reduced to animals when they allow their urges to go unchecked. In this instance, the lynx is more aware of his surroundings and the evils of the mind than is the sleeping man, which can be seen in the lynx's alert facial expression. Another cat, dark and half-hidden by the man's body, lurks in the background. Nightmares and cats are predators of the night with wide and watchful eyes, waiting to attack their prey when least expected.

Because owls are symbols of folly, Goya repeatedly used them throughout the *Los Caprichos* prints in order to make a strong statement against foolishness (Eisenman 78). The owls seem to taunt the man; they are perched upon his body, and one even holds a writing instrument in his talons, which again attributes human traits to animals, but also shows the importance of this part of the mind in the creation of art. Owls are birds of prey that seek out and attack defenseless victims, just as without reason, individuals are defense-

Gothberg 7

less against foolish behavior. The bats, although they are mostly just dark shadows in the background, are nonetheless significant because they represent blind ignorance, which is anathema to rationalism (Eisenman 78).

Conclusion Fuseli and Goya both explored the intricacies of the human mind in their nightmarish pictures. According to Fuseli's painting, it is necessary to repress these individual urges, usually sexual or violent, to fit into society; however, when such urges and desires are repressed, a great burden is placed on the mind, which allows the desires to escape the defenseless sleeping mind in the form of nightmares. Goya, who takes a different view in *The Sleep of Reason Produces Monsters*, believes that there would be no creativity or imagination without the subconscious and that the most magnificent things, such as art, come from the ability to combine these unconscious thoughts and emotions with reason. When reason is abandoned, however, the dark areas of the subconscious make man selfish, irrational, and cruel, so that he resembles demons or animals. The mysteries of the mind will never be solved, but Fuseli and Goya provide interesting interpretations in their artwork of the miraculous subconscious.

Gothberg 8

Works Cited

Eisenman, Stephen F. *Nineteenth Century Art: A Critical History.* New York: Thames, 1994.

Powell, Nicolas. *Fuseli: The Nightmare.* London: Penguin, 1973.

ORGANIZING THE COMPARISON-CONTRAST ESSAY

When using the comparison-contrast approach, be specific about the elements you are comparing. For example, the question "How does *The Nightmare* compare with *The Sleep of Reason Produces Monsters*?" is too open-ended. Everything there is to say about both paintings could be in an essay that asks such a broad, vague question. One purpose of the research question is to help you narrow, focus, and eliminate material. "How do the two paintings compare in attitude toward the unconscious mind?" is a more specific question and will lead to a more focused paper.

For a comparison-contrast essay to be successful, you must point out the differences in things that appear similar, or similarities in things that appear different. For example, if you write an essay that shows that a landscape is different from a cityscape, you have wasted your time. Your audience already knows they are different. If you write an essay showing that Picasso's cubism is similar to Braques's cubism, you have made the obverse mistake. Contrasting *The Nightmare* against *The Sleep of Reason Produces Monsters* works only if your audience cannot readily see the difference in the artists' attitudes toward the unconscious.

Comparison-contrast essays usually fall into one of two organizational patterns: the block pattern or the point-by-point pattern. The block pattern would discuss one work of art and then the other. The point-by-point pattern would discuss one point of comparison between the two works of art, then the next point of comparison, and so forth. The two patterns are outlined next, using Fuseli and Goya to demonstrate.

Rachel Gothberg's essay, "Gothic Nightmares in Romantic Paintings," employs the block pattern. The same information, however, could be reorganized into the point-by-point pattern. Not every essay can adhere to these patterns slavishly. Still, it is a good idea to adhere to the pattern as closely as possible.

Standard Block Pattern	Standard Point-by-Point Pattern
I. Opening Paragraph	I. Opening Paragraph
A. Occasion	A. Occasion
B. Thesis	B. Thesis
C. Projected Organization	C. Projected Organization
1. Fuseli	1. Historical Context
2. Goya	2. Dreamer
II. Body	3. Dream Creatures
A. Fuseli	II. Body
1. Historical Context	A. Historical Context
2. Dreamer	1. Fuseli
3. Dream Creatures	2. Goya
B. Goya	B. Dreamer
1. Historical Context	1. Fuseli
2. Dreamer	2. Goya
3. Dream Creatures	C. Dream Creatures
III. Conclusion	1. Fuseli
	2. Goya
	III. Conclusion

The author of the following essay noticed the idyllic setting of the island of Crete, which led to this research question: "How does the natural openness of the island of Crete contribute to Minoan art and architecture?" The essay strives to answer that question.

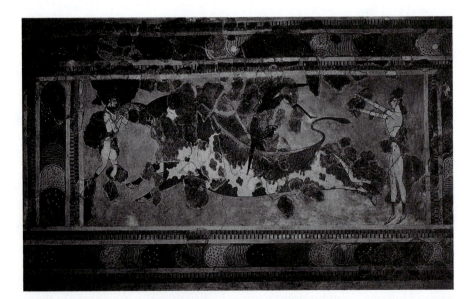

3-4 *Toreador Fresco*, from the Palace at Knossos, Crete, c. 1450–1400 B.C.E. Fresco, 32" high, including border. Archeological Museum, Herakleion.

Coffelt 1

Donald Coffelt

Professor Buchner

Art Appreciation 111

29 October 1998

Don't Worry, Be Happy:

Minoan Art and Architecture

The Minoans lived during the Bronze Age on the
beautiful island of Crete, which was surrounded by *Thesis*
water on all sides. This setting is reflected in
the Minoans' themes of ease and relaxation in
their art and architecture. Because of their
island location, the Minoans could see if enemies *Points of*
were approaching from any direction; because they *proof*
could defend themselves so easily, they were
unthreatened, resulting in the openness of their
architecture. The temperate climate also fostered
a love of the outdoors, which is also reflected in
the Minoans' art.

Unthreatened by enemies, the Minoans adopted a
sort of "don't worry, be happy" philosophy. Conse- *First point*
quently, they built their largest structures,
called *palaces*, with several entrances and many
roads leading to them, welcoming visitors. They
did not feel the need for massive, defensive walls
surrounding the palaces, either. The palaces were
constructed around a large, open courtyard, and
it was here in the open where many of their

Coffelt 2

activities took place. The Minoans' Palace at
Knossos is the most well-known and best-preserved
example of such a structure.

Because the courtyard was an important part of
the building, the Minoans took great care to deco-
rate the surrounding walls, several stories high,
with beautiful architectural features, such as
columns and painted motifs. They left their exte-
rior walls relatively simple because they wanted
people to "come on in." This approach to decorat-
ing the interior walls more elaborately than the
exterior is called *introverted* architecture,
interesting in itself because the Minoans, as a
people, were anything but introverted.

The Minoans, in their open, relaxed ways,
believed in living life with certain creature com-
forts. They installed toilets and bathtubs in the
palaces, highly unusual for such ancient times.
They also put skylights in the roofs, allowing
sunlight and fresh air to sweep through the
palaces, opening up their architectural structures
to the outside even more.

Second point When it came to decorating their palaces with
art, the Minoans' love of the outdoors was unmis-
takable. One example is the famous *Toreador Fresco*
from the palace of Knossos. This shows several
slim, acrobatic figures gracefully engaged in

Coffelt 3

bull-leaping; the lively contours give off a sense
of energy compatible with the outdoorsy, athletic
habits of the Minoans. Another example is the
frescoes on the walls of the throne room at Knos-
sos that picture delicate flowers, seeming to sway
in the open breeze. The frescoes also depict
griffins, mythological animals with the bodies of
lions and heads of eagles. The animals are shown
seated outside and relaxed, not at all fearful for
their lives in this peaceful culture.

So, from how they built their structures to
how they decorated them with art, the Minoans made
an unmistakable stamp of their carefree attitudes:
their openness to life and love of nature, beauty,
and a graceful way of living.

Speculating about causes works well in analysis; it obligates us to make an inference based on facts. For example, the following essay speculates about the causes of Théodore Géricault's choices in his depiction of suffering people. The research question might be "What caused Géricault to idealize suffering people?" The student has based her inference on facts. In this paper, Rachel Gothberg's inference has become the thesis, and the facts upon which the inference was made have become the support for the thesis.

The paper is structured the way that this book recommends, but the author has opted to take what we will call a "time-out" paragraph after the introduction. The time-out paragraph serves to give the reader the necessary mental image of Géricault's *The Raft of the Medusa* (FIG. **3-5**) so that the subsequent analysis will be easier to follow.

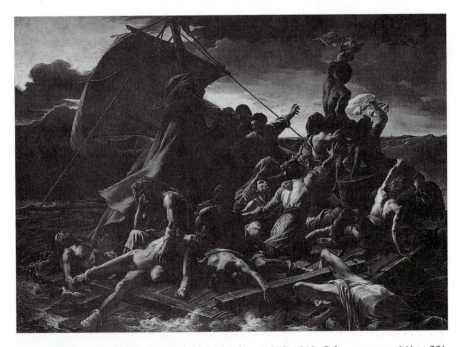

3-5 Théodore Géricault, *The Raft of the Medusa*, 1818–1819. Oil on canvas, 16′ × 23′. Louvre, Paris.

Gothberg 1

Rachel Gothberg

Professor Heydt-Stevenson

Humanities 4102

21 April 1999

Nobility in Human Suffering

in the Work of Théodore Géricault

The Romantic movement in art was a reaction against the restrictive Neoclassical style and often emphasized the natural human rights of all people. Neoclassicism frequently contained patriotic and upper-class subject matter, whereas the Romantic artists, Théodore Géricault in particular, focused on the idea that the nobility of humans does not depend upon whether they are of high status or power, but rather upon each individual's inner self, which can be seen in how personal hardships are handled. In two of his works, *The Raft of the Medusa* and *Portrait of an Insane Man*, Géricault makes the statement that there is an inherent nobility in human suffering, regardless of social class, political standing, or ethnic background. *The Raft of the Medusa* physically and morally idealizes people who have suffered terribly, and *Portrait of an Insane Man* presents survivors of mental illness as having dignity.

Thesis

Points of proof

Gothberg 2

The shipwreck of the *Medusa* in 1816 was a hor-
rific event in which many people died and through
which many more suffered.

Géricault was extremely careful to portray the
event with accuracy. In order to do so, he went
to morgues and hospitals to sketch the dead and
dying; he launched a raft in the ocean to observe
its movements and also used live models, posed in
the same way as the passengers on the real raft
had been. Many preparatory sketches to the paint-
ing were also made in order to create the best
effect in the final composition. His careful stud-
ies can be seen in the realistic depiction of the
chaos that occurred on the raft. Géricault por-
trayed the bodies as strewn all over the raft in
every imaginable position and with different emo-
tional reactions. At the back of the raft, a man
is unexcited by the rescue soon to come. He has
abandoned all hope and sits facing backward as if
looking toward the past rather than toward the
future. Several dead or dying bodies surround him;
one man who has been partially cannibalized and
another who has died and is hanging from the raft
only by a foot caught between the boards are among
the most shocking depictions. In the shadow of the
sail, another figure has his hands placed on his
head in deep despair. Toward the front there is

*"Time-out"
paragraph*

Gothberg 3

more excitement because a rescue ship has been
spotted in the distance, and many occupants strug-
gle to gain its attention. The weaker individuals
strain their bodies to reach out to their saviors,
while the stronger ones join together to help sig-
nal the far-off ship.

Although Géricault accurately portrays the con-
fusion on the raft, he does not portray the physi- *First point*
cal bodies in a realistic manner; the figures are
in idealized form, much like Greek gods, and
unlike figures who have undergone great suffering.
The actual bodies would have been in wretched con-
dition: thin from hunger and wounded by the fights
and storms that overcame many of the occupants.
Géricault's bodies look healthy and strong. Even
the figure of the dead man who lost half of his
body to cannibalism seems to be robust. His body
does not appear limp and lifeless in that the
strong musculature can still be seen, especially
in his arm, which looks as though he is going to
pull it out of the water at any moment.

The facial expressions of the men also support
the idealized form. None of their faces reflects
the horrors that they have endured; rather they
show composure and stature. After so much care was
taken to determine how the bodies actually looked,
Géricault must have made a conscious decision not

Gothberg 4

to portray the bodies in the most deplorable con-
dition. This was most likely an attempt to portray
the passengers of the raft as heroic survivors
rather than as gruesome murderers. These people
had lived through a terrible ordeal and could do
nothing but try to survive, a feat that only 13
of the 148 passengers accomplished.

The moment that Géricault chose to paint indi-
cates another way in which he represented the raft
survivors as heroic. He does not portray the point
at which the lifeboats deserted the makeshift
raft, nor the horrific scenes of murder (the
strongest were killing the weakest for food), nor
any of the other disturbing moments that took
place during the twelve days that the raft drifted
on the seemingly endless ocean. Géricault,
instead, chose the event when nearly all the sur-
vivors came together one last time in order to
flag down the distant rescue ship. His preparatory
drawings were done of different, more violent
moments, but he abandoned these for the very dra-
matic moment just before their rescue. Most of the
surviving men are reaching out toward the ship
with hopeful looks, and two men wave their cloth-
ing while being held up by other men in an
attempt to draw the most attention. In this

Gothberg 5

moment, all the figures on the raft were equally
heroic.

Géricault focused not only on historical
events, but also on irregular subject matter. Dur-
ing the Neoclassical period, a painting of an *Second point*
insane person would never have been accepted, but
in the Romantic period, Géricault dared to take
his subject matter to extremes. He did a series of
portraits of people suffering from insanity, all
of whom further exemplify courage through great
torment. The people are not portrayed by Géricault
as threats to society, but rather as spirited,
misunderstood people with deep emotions. His *Por-
trait of an Insane Man* shows a normal-looking,
lower-class man who has suffered many hardships.
The man has a solemn expression on his face; he
shows little emotion except for his eyes, which
reveal his sadness. His clothes appear to be
fairly well kept, and he seems to be in good con-
dition. Géricault has portrayed the insane gentle-
man as a proud peasant rather than as a menace to
society, which evokes pity from the viewer. Géri-
cault, himself, may have also been treated for
mental instability, which would have given him a
greater understanding for the suffering of the
mentally ill.

Gothberg 6

Géricault was trying to gain the compassion of the viewer for outcasts of society. The insane portraits, as well as *The Raft of the Medusa,* show all kinds of people whose suffering has been great but who became heroes for their ability to survive.

REVISING, EDITING, AND PROOFREADING YOUR PAPER

Use the following checklist to be certain that your paper is ready for submission. Consult the "Handbook" section at the end of this book for guidance in issues of sentence structure, grammar, punctuation, mechanics, and style.

REVISION CHECKLIST

☐ Thesis statement is clear and present. It makes an inference about the art. It is narrow and specific enough to be adequately supported in the space of the paper but general enough to need support.

☐ Points of proof are clear and present. Each answers the proof question. Each is narrow and specific enough to be supported adequately in one to three paragraphs and general enough to need support.

☐ Introduction contains specific details. It leads the reader to the thesis; it does not lead the reader to believe that the essay will be about something it is not about.

☐ Essay adheres to the essay plan set out in the list of points of proof.

☐ Body paragraphs are unified (containing *one* topic sentence), adequately developed (containing evidence in support of assertions), organized, and coherent (containing appropriate transitional expressions).

☐ Conclusion finds a way to solidify the paper's main point without resorting to mere repetition of thesis and points of proof. Conclusion is unified and developed. Conclusion does not bring up any new issues.

☐ Sentences are well constructed. There are no run-ons or fragments.

☐ Sentences are correctly punctuated.

☐ Words are correct and well chosen.

☐ All quotations use acknowledgment phrases.

☐ Sources are correctly cited in text.

☐ Title is appropriate.

☐ Essay fulfills requirements specific to assignment, such as length and subject matter.

4

WRITING THE ARGUMENTATIVE ESSAY

Topic Suggestions

Planning the Argumentative Essay

Writing the Introduction
Thesis
Constructive Arguments
Refutations
Body Paragraphs

A Sample Argumentative Essay

Revision Checklist

The essential difference between the argumentative essay and the expository essay is that the argument engages directly in refutation. The arguer disagrees with a particular view or interpretation of a work of art or a movement in art. The arguer's job, then, is not only to defend his or her opinion but also to refute someone else's opinion.

CHOOSING A TOPIC

For your argumentative essay, choose a topic that is controversial. Your professor, textbook, and class discussions will alert you to some existing debates in the art world, but new issues in art are constantly arising. Be on the lookout for such topics as you read newspapers, magazines, and journals.

You must also find an opinion against which to argue. Such an opinion must be held by someone who is both rational and your intellectual equal. Arguing against a weaker opinion compromises the strength of your own. Your professor may suggest an opinion to refute, or you may need to find credible opponents on your own through library research. You might consult Chapter Seven of this book, "Writing the Research Paper," for advice on finding essays and articles on art, particularly opinionated ones. Or perhaps one of the topic suggestions listed next will be workable.

TOPIC SUGGESTIONS

In debate, arguments are based upon **propositions,** statements that may be either defended or refuted. You might defend or refute any of the following propositions:

◆ Art in public places, such as Richard Serra's *Titled Arc*, should be placed wherever the artist feels is appropriate to the artwork, without regard to public opinion.

◆ There is always a woman's sensibility present in women's art.

◆ I. M. Pei's glass entrance pyramid to the Louvre is completely discordant with the Louvre and, thus, is an abomination and should be removed.

◆ Without Cézanne, Cubism would not have been born.

◆ The twentieth-century restoration of the Sistine Ceiling destroyed Michelangelo's original intent.

◆ Leonardo used himself as the model for the Mona Lisa.

◆ Artemisia Gentileschi's art strongly reflects the effect of her rape by Agostino Tassi.

◆ After 1950, Willem de Kooning's artistic career began its never-ending decline.

◆ Classical style painting requires more talent than the Abstract-Expressionist style and, therefore, is superior.

◆ Sexually explicit art exhibitions, such as the Brooklyn Museum of Art's "Sensation," should be censored.

◆ Video art is as valid a medium as sculpture.

◆ The Greeks were more artistic architects than the Romans.

◆ Picasso's work conveys an attitude of misogyny.

◆ Representational painting is superior to nonrepresentational painting.

◆ Craftsmanship has become unimportant in art.

◆ Delacroix was correct when he argued with Ingres that color is more important than line in art.

◆ The untrained style of Grandma Moses cannot be considered fine art.

◆ William Blake's art is good enough to stand on its own, not merely as accompaniment to his poetry.

PLANNING THE ARGUMENTATIVE ESSAY

INTRODUCTION

We recommend that students organize their introductory paragraphs to include the counterthesis, counterpoints, thesis, and points of proof. Such an introduction gets the essay off to a strong start: the reader understands

immediately the issue under debate, what your opinion is, how you will support your opinion, and against whom you are arguing. Constructing your introduction in this manner also keeps you focused and organized.

Your introductory remarks will identify the work(s) of art you are writing about, the artist(s), and the issue in contention. Next, write what your opponent thinks and why. These are the **counterthesis** and **counterpoints**. Be as specific as possible about who said (or wrote) what, and when and where they wrote it.

In a short paper, your introductory remarks, counterthesis, and counterpoints should fit into one paragraph. When writing longer papers, however, you may need more space, perhaps one paragraph each, to establish each element: the issue in contention, the counterthesis, and the counterpoints.

THESIS

If the statement of the issue in contention, the counterthesis, and the counterpoints comprise a full-bodied paragraph in their own right (six or seven sentences), begin a new paragraph for your thesis and points of proof. Use a transition to ease the shift from counterthesis to thesis and to cue the reader that a change in attitude is coming. Something as simple as the word *however* at the beginning of the thesis will sometimes suffice. At other times, a whole sentence is in order.

The thesis must be in your own words; this is not the time to quote or paraphrase a source. This is *your* argument. You must be the person to make all the major assertions. Your sources will corroborate what you say, but you must not let them speak for you. Like the thesis of the expository essay, the thesis of the argumentative essay fulfills the following criteria:

- Is one complete, unified statement about the issue in contention
- Is precise enough to limit the material
- Is general enough to need support
- Is defensible
- Is not too obvious

To the preceding list, add two more criteria specific to the argumentative thesis:

- Answers the charge made in the counterthesis
- Makes a statement with which an educated, intelligent, and rational person could disagree

The following exercise is designed to assist you in developing the ability to assess the workability of argumentative thesis statements. The exercise is based upon the issue discussed in the sample essay found later in this chapter: a Smithsonian exhibition called "The West as America," which generated controversy because of its overtly political stance. Use the preceding guidelines to perform the exercise.

EXERCISE: FAULTY ARGUMENTATIVE THESES

Use the preceding guidelines to determine the problems with the following argumentative theses. Assume that the counterthesis is "The Smithsonian should not have exhibited 'The West as America.'" After you have determined the problems, compare your answers to those on the opposite page.

1. The Smithsonian exhibition was interesting.

2. The Smithsonian exhibition was interesting for three reasons.

3. This paper will argue for the Smithsonian's decision to exhibit "The West as America."

4. The Smithsonian exhibition was very well attended.

5. The Smithsonian exhibition was the most important exhibition of the century.

6. The Smithsonian exhibition embraced multiculturalism.

7. If viewers understood the art and the historical context better, they would agree with the Smithsonian's decision to exhibit "The West as America."

8. Detractors of the exhibition are simply being narrow-minded.

9. Multiculturalism is a valid concept, if viewers would open their minds to it.

10. Art simply reflects the social influences of the time in which it was conceived.

ANSWERS TO FAULTY ARGUMENTATIVE THESIS EXERCISE

1. The thesis doesn't answer the charge made in the counter-thesis. In fact, this is not an argumentative statement. Few people would argue that the exhibition was uninteresting.

2. The thesis has the same problems named in answer 1. Adding "for three reasons" does not solve the problems. The thesis is also indefensible because there are more than three reasons why the exhibition was interesting.

3. The thesis is really a statement of purpose. It tells what the paper will do, but not what it will say.

4. The thesis is a fact, not an arguable statement.

5. The thesis is indefensible. No amount of research will prove that this exhibition is the "most important" of any time period.

6. The thesis is a fact, not an arguable statement.

7. The thesis assumes that opponents are uneducated and that simply presenting them with the facts will persuade them. You must assume that your opponent possesses the same facts that you possess but interprets them differently. An additional problem with this thesis is that it will lead to a descriptive paper.

8. The thesis resorts to name-calling and assumes that opponents are not rational. A strong argument takes on an educated, rational, intelligent opponent.

9. The thesis is not about the issue in contention. This thesis will lead to an argument about multiculturalism instead of an argument about the exhibition at the Smithsonian.

10. This thesis is not arguable. No rational, educated person would disagree with it. Besides, like thesis 9, this thesis is not about the issue in contention.

POINTS OF PROOF

Your points of proof should answer the proof question—the question that the thesis provokes. In argument, there are often two proof questions: (1) Why do you believe what you believe? and (2) Why don't you believe what your opponent believes? For example, in response to the thesis statement in the essay "American Myths, Patriotism, and Art" (presented later in this chapter), a critical reader will naturally have two questions:

1. Why do you believe the Smithsonian was right to show the exhibition?

2. Why don't you believe (with your opponents) that the Smithsonian was wrong to show the exhibition?

The answers to the first question are the author's **constructive arguments;** the answers to the second question are the author's **refutations** of the counterpoints.

You must state your own points of proof. Do not quote or paraphrase a source for this task. This is *your* argument, not your sources' argument.

Your points of proof are mini-theses; each will serve as the thesis of one section of the body of the essay. Each must make a claim that needs support and, therefore, cannot be too specific. Points of proof are *reasons why* you think what you think, not facts. Also, the point of proof cannot dodge the responsibility of making a point, as in the sentence "First we shall look at the subject matter of frontier art." After you have looked at the subject matter of frontier art, what conclusion will you come to? The answer to that question will be your point of proof.

TEMPLATE FOR ORGANIZING THE ARGUMENTATIVE ESSAY

To organize your thoughts, fill in the blanks of the following template, keeping in mind the following instructions:

◆ Your thesis must oppose the counterthesis. Both the thesis and counterthesis can't be true at the same time. This advice may seem too obvious to mention, but a surprising number of first attempts at formulating the argumentative thesis result in the mistake of ignoring the counterthesis.

◆ Organize your refutations in the same order as your counterpoints. In other words, your first refutation should refute the first counterpoint and so forth.

◆ Your paper might be more persuasive if you place your refutations before your constructive arguments. If so, arrange your points of proof accordingly.

◆ Your strongest point of proof should be your last one.

ARGUMENTATIVE ESSAY PLAN

I. What My Opponent Believes (Counterthesis): _____
 A. Why my opponent believes it (Counterpoints):
 1. _____
 2. _____
 3. _____
 4. _____

II. What I Believe (Thesis): _____
 A. Why I believe it (Constructive Arguments):
 1. _____
 2. _____
 3. _____
 B. Why I think my opponent is wrong (Refutations):
 1. _____
 2. _____
 3. _____

Following is the plan for the essay "American Myths, Patriotism, and Art."

ARGUMENTATIVE ESSAY PLAN
"AMERICAN MYTHS, PATRIOTISM, AND ART"

I. What My Opponent Believes (Counterthesis):
The Smithsonian should not have exhibited "The West as America."
 A. Why my opponent believes it (Counterpoints):
 1. The exhibition was an assault on the nation's founding and history.
 2. The exhibition presented an imbalanced view of history.
II. What I Believe (Thesis):
The Smithsonian exhibition was admirable and necessary.
 A. Why I believe it (Constructive Arguments):
 1. History needs correction.
 B. Why I think my opponent is wrong (Refutations):
 1. Engaging in public discourse and inviting feedback confirm our founding and history.
 2. Imbalance is not inherently wrong.

The following essay outline results from the preceding essay plan:

OUTLINE FOR ARGUMENTATIVE ESSAY
"AMERICAN MYTHS, PATRIOTISM, AND ART"

I. Introduction
 A. Identification of issue in contention: Smithsonian exhibition
 B. Counterthesis: The Smithsonian should not have exhibited "The West as America."
 C. Counterpoints:
 1. The exhibition was an assault on the nation's founding and history.
 2. The exhibition presented an imbalanced view of history.
 D. Thesis: The Smithsonian exhibition was admirable and necessary.
 E. List of points of proof:
 1. Constructive argument: History needs correction.
 2. Refutation of counterpoint 1: Engaging in public discourse confirms our nation's founding and history.
 3. Refutation of counterpoint 2: Imbalance is not inherently wrong.
II. Body (Development of points of proof)
 A. History needs correction.
 B. Engaging in public discourse confirms our nation's founding and history.
 C. Imbalance is not inherently wrong.
III. Conclusion

WRITING THE BODY PARAGRAPHS

Well-written paragraphs for the argumentative essay contain the same qualities as those for the expository essay: *unity, adequate development, organization,* and *coherence.* Use the following template to organize each body paragraph of your *constructive arguments:*

BODY PARAGRAPH: CONSTRUCTIVE ARGUMENT

Constructive argument: (Fill in the blank with one point of proof.)

Evidence: (Fill in at least two blanks.)

 1. _____
 2. _____
 3. _____
 4. _____

Note: You may have more than one paragraph's worth of support for one constructive argument. For example, in "American Myths, Patriotism, and Art," the author finds it necessary to divide his first point of proof into two paragraphs because the evidence naturally subdivides into two categories. You may divide your support into as many paragraphs as you need, but do be sure to head each paragraph with a topic sentence—a sentence that summarizes the paragraph.

Use the following template to organize each body paragraph of your *refutations*:

BODY PARAGRAPH: REFUTATION

Restate the counterpoint: _____

Evidence for counterpoint: (optional)

1 _____

2 _____

3. _____

Your refutation statement: _____

Evidence for your refutation: (Fill in at least two blanks.)

1 _____

2. _____

3. _____

4. _____

Note 1: The counterpoint may be easily understood and stated in one sentence. If that is the case, head your paragraph with the counterpoint and proceed immediately to refute it without beginning a new paragraph. However, if the counterpoint needs to be explained in a bit of detail, you might allot a whole paragraph to it and then begin your refutation in a new paragraph.

Note 2: You may have more than one paragraph's worth of support for your refutation statement. If that is the case, break your evidence into separate paragraphs, but do be sure to begin each paragraph with a topic sentence—a sentence that summarizes the paragraph.

A SAMPLE ARGUMENTATIVE ESSAY

The following is an essay that argues about the validity of a Smithsonian exhibition that sparked several controversies regarding multiculturalism, the tenuousness of revising history to suit ideological fads, and the responsibility of federally funded museums to present balanced views. The author has defended his point of view as well as refuted the opinion of his opponent.

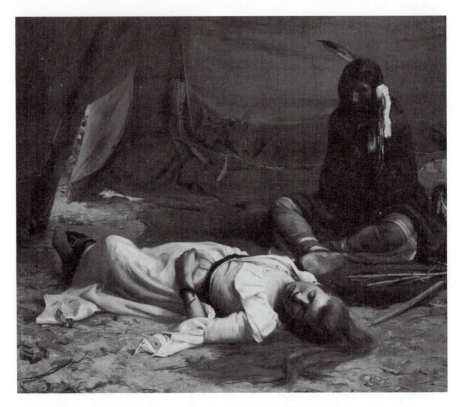

4-1 Irving Couse, *The Captive*, 1892. Oil on canvas. Photo courtesy of Association of Administrators and Consultants, Irvine, California.

Vigil 1

Luis Vigil

Professor Pemberton

Art History 412

7 November 1993

American Myths, Patriotism, and Art

"The West as America: Reinterpreting Images of the Frontier, 1820-1920" was an exhibition at the National Museum of American Art, Smithsonian Institution, from March to July of 1991. On exhibit were hundreds of paintings, sculptures, prints, and photographs that offered evidence that the myths behind American expansionism--manifest destiny, in the vernacular of the times--found their way into the art of the American West. The exhibitors published a catalogue containing essays that establish the artists' complicitness in sugarcoating the cruel fact of European conquest and expansion. Labels for the works interpreted the art from the specific political point of view that is multiculturalism. The exhibition engen- *Counterthesis*
dered the ire of the *Wall Street Journal*, among
others, who called the exhibition "an entirely *Counterpoint 1*
hostile ideological assault on the nation's found-
ing and history" (qtd. in Gulliford 207). Many *Counterpoint 2*
objected to the exhibition's unbalanced, flagrant promotion of a "politically correct" point of view.

Vigil 2

Thesis

However understandable the objections to the exhibitors' revisionist agenda, in truth the Smithsonian did the admirable and necessary job of assembling the proof of the multiculturalists' contention that much American frontier art puts a glossy cover on an ugly chapter of American his-

Constructive argument

tory. History needs the occasional correction, and the fact that such corrections are discussed pub-

Refutation 1

licly only proves that the principles upon which this nation is founded are still in force. Fur- thermore, the exhibition's detractors are right in

Refutation 2

saying that the exhibition was unbalanced, but not in their assumption that imbalance is inherently wrong.

Constructive argument

When a version of history proves incorrect, we must correct it. History is written from the point of view of the winners. In the case of American history, we have for several hundred years taken the version told by the conquerors of the land as the essential truth. But winners will occasionally justify and rationalize their actions, and Ameri- can artists have been complicit in those rational- izations. For example, an oil painting by William S. Jewett is titled *The Promised Land--The Grayson Family, 1850*. The title of the painting, as well as the portrait of the father, mother, and child, composed in the triangle typical of so much reli-

Vigil 3

gious Renaissance art, gives Christian overtones
to the westward movement. Irving Couse's *The Cap-
tive* [FIG. **4-1**] depicts a white woman, lying
unconscious on the dirt floor of a tepee before
the Indian who has presumably kidnapped her. She
looks seductive in her unconsciousness, and her
captor stares at her, his gaze seeming to rest on
her breasts. Such images of Native Americans
allowed white people to justify the removal of
hostile Indians who would prevent settlers from
reaching the "promised land" of the West.

Examples of art as propaganda for expansionism
abound. William Fuller's painting *Crow Creek
Agency, Dakota Territory, 1884* portrays the peace-
ful coexistence of Native Americans and whites. In
fact, there was little coexistence. As wards of
the government, Native Americans had to be fed,
clothed, and sheltered. Children were schooled in
English and urged to forget their native language.
Many natives resisted assimilation and clung to
their tribal heritage. Fuller's blue skies, orga-
nized white buildings and factories, scattered
tepees and quiet, clothed Native Americans, stand-
ing still, hat in hand, reassure the viewer that
the taming of the West was the best thing for
everyone. However, the myth, as glorified in so
much art of the American West, contradicts real-

Vigil 4

ity. What can possibly be wrong with recognizing
and correcting that false impression?

Many patrons of the Smithsonian objected to
the exhibition on the grounds that the museum is
taxpayer-supported and therefore not supposed to
antagonize the citizens. The task of correcting
our view of art, however, belongs to a museum. The
word *museum* derives from the Muses of Greek
mythology who inspired and enlightened. Given the
year, 1992, which was the 500th anniversary of
Columbus's so-called discovery of America, and the
fact that America was just coming off the Persian
Gulf War, patriotism was running high. But the
philosophy of multiculturalism was also gaining
momentum. Debate was in the air. The Smithsonian
would have been remiss not to organize the exhibi-
tion. Besides, because the Smithsonian receives
roughly $300 million each year in federal funds,
it has a particular responsibility to engage pub-
lic discourse, which it did, not only in present-
ing the art and the fresh and controversial inter-
pretation of it, but also in inviting viewer
responses. Hundreds of visitors who toured the
exhibition stood in line to write comments that
expressed their reaction to the show--an unprece-
dented level of audience involvement. Many of the
comments expressed resentment toward what they

Vigil 5

felt had been a bludgeoning with a multicultural instrument. One visitor called the exhibition "revisionist bulljive." Another wrote, "How nice! According to your connotations the world is filled with racist white males and their hapless victims. Grow up!" Not all of the comments were negative, however. One visitor wrote, "Finally, an art exhibit that is truly interpretive and relevant, especially given the uncritical nationalism of the times. More!" (qtd. in Gulliford 206). The point is that inviting feedback was an act of democracy, an upholding of a real tenet, not a myth, of our civilization.

Was the exhibition unbalanced? Of course it was. It made no attempt to reconcile the increasingly polarized versions of American history. And why should it? Does a museum have to present the point of view of slave owners even as it exhibits African-American art? Does a museum have to present the point of view of George III alongside the American version of the American Revolution?

Refutation 2

The Smithsonian has done a great service to lovers of art as well as lovers of America. It has not annihilated the art, in the style of fascist book burners, or demolished it in the fashion of the Bolsheviks who destroyed so much of Russian art and architecture to erase the memory of the

Vigil 6

czars. The Smithsonian has preserved frontier art and placed it in a historical context that makes sense. For that we should be grateful.

Works Cited

Gulliford, Andrew. "Exhibition Reviews." *The Journal of American History* 23 (1992): 199–207.

REVISING, EDITING, AND PROOFREADING YOUR PAPER

Use the following checklist to be certain that your paper is ready for submission. Consult the "Handbook" section at the end of this book for guidance in issues of sentence structure, grammar, punctuation, mechanics, and style.

REVISION CHECKLIST

- ☐ Thesis is clear and present. It makes an argumentative statement about the art—a statement that a rational, intelligent, educated person might disagree with. The thesis is narrow and specific enough to be adequately supported in the space of the paper but general enough to need support.
- ☐ Introduction contains specific details. It leads the reader to the thesis; it does not lead the reader to believe that the essay will be about something it is not about. The introduction contains a counterthesis and counterpoints, and it clearly identifies opponents.
- ☐ Points of proof are clear and present. Each point answers the proof question. Each point is narrow and specific enough to be supported adequately in one to three paragraphs but general enough to need support.
- ☐ Points of proof include refutations of all the counterpoints.
- ☐ Essay adheres to the essay plan set out in the points of proof.
- ☐ Body paragraphs are unified (containing one and only one topic sentence), adequately developed (containing evidence in support of topic sentences), organized, and coherent (containing appropriate transitional expressions).
- ☐ Conclusion finds a way to solidify the paper's main point without resorting to mere repetition of the thesis and points of proof. Conclusion is unified and developed and does not bring up any new issues.
- ☐ Sentences are well constructed. There are no run-ons or fragments.
- ☐ Sentences are correctly punctuated.
- ☐ Words are correct and well chosen.
- ☐ All quotations use an acknowledgment phrase.
- ☐ Sources are correctly cited in text.
- ☐ Title is appropriate.
- ☐ Essay is properly formatted.
- ☐ Essay fulfills requirements specific to assignment, such as length and subject matter.

WRITING THE ESSAY EXAMINATION

Study and Review Tools	*Study Checklist* *Mind Map* *Flashcards*
Exam-Taking Strategies	
Sample Essay Examination	

PREPARING FOR THE EXAMINATION

Most art appreciation and art history students are called upon to write essay examinations in class. Knowing how to prepare for such examinations and how to approach the task of writing the essay exam will lead to success.

◆ Know the material: Preparing for an art history exam is an ongoing process. Reviewing the material on a weekly basis is integral to your exam-taking strategy.

◆ Create review tools:

1. **Study checklists** such as the following are often useful.

STUDY CHECKLIST: ART HISTORY

Materials:
- ◆ Gardner: pages 878–1013 ✓
- ◆ Rosenblum: pages 14–84 ✓
- ◆ Writing about art: pages 105–113 ✓
- ◆ Lecture notes: 10/25–11/30 ___

Subjects:
- ◆ Romanticism ___
- ◆ Neoclassicism ✓
- ◆ Historical context ___
- ◆ Jacques-Louis David ✓
- ◆ Francisco de Goya y Lucientes ___
- ◆ Henry Fuseli ___
- ◆ William Blake ___
- ◆ Jean-Auguste-Dominique Ingres ___

2. **Mind map summary sheets** can help you visualize connections. Use varied shapes and colors to help you remember.

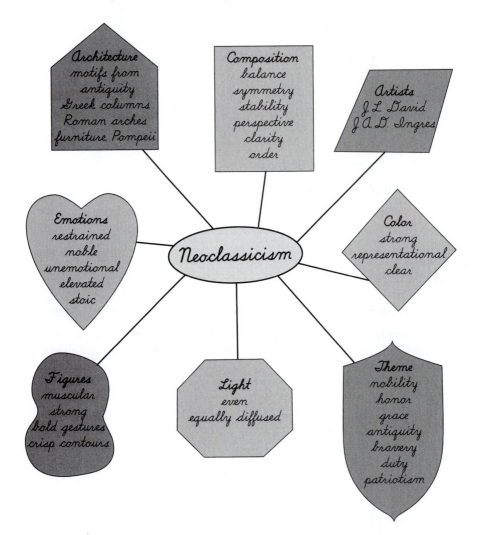

3. **Flashcards** such as the one that follows are particularly useful in preparing for both the slide identification and essay parts of an exam. You might use various colored cards to help you remember an art-work's category. For example, use blue cards for the Neoclassical style and yellow for the Baroque. Another technique that has been used successfully involves pasting a photocopy of the illustration from your textbook on the front of the card and printing all of the verbal infor-mation on the back.

FRONT OF FLASHCARD

BACK OF FLASHCARD

Oath of the Horatii

Jacques-Louis David

1784

Neoclassicism

Three Horatius brothers will defend Rome vs. the Albans. Themes of honor and bravery. Elements of antiquity: architecture, clothing. Symmetry; bold colors; controlled emotion.

The act of creating the flashcards reinforces your memory of the facts, and then using them to review the material just before the test gives your short-term memory a quick booster.

◆ Plan a strategy.

1. Do a dry run: make up your own essay test and then take it.
2. Ask the instructor what to expect.

TAKING THE EXAMINATION

BEFORE YOU BEGIN WRITING

◆ Pay attention to verbal directions given as the test is distributed. A surprising number of students stop listening as soon as they have the test in their hands and thus miss important instructions and hints.

◆ Scan the whole test immediately.

◆ Evaluate the importance of each section.

◆ Decide how much time to spend on each section.

◆ Read the directions *slowly.*

◆ Jot down memory aids in the margins.

PREPARING TO ANSWER THE ESSAY QUESTION

◆ Underline key terms, as exemplified in the following sample essay question.

<u>Identify</u> the two paintings shown and <u>name</u> the artists who painted them. Also <u>identify</u> the date the art was produced. <u>Compare</u> these two works. In doing so, <u>discuss</u> how they reflect their particular styles/periods and the differences between the two. Also <u>include</u> the narrative behind each work.

◆ Create a quick outline of your answer. The following outline would work for the preceding essay question.

> I. Identify paintings, artists, styles, dates.
> II. Narrative
> III. Differences
> A. Theme
> B. Emotions
> C. Composition
> D. Figures
> E. Color
> F. Architecture

◆ Know your audience. Although your professor is obviously the person who will be reading your essay, it will behoove you to think of your reader as someone who is not as well versed as your professor. If you think of your reader as someone who does not already know the material, you will explain your answer more carefully and patiently.

WRITING THE ESSAY

◆ Get to the point quickly. Skip the mindless introduction, such as "There are many interesting facets to this difficult question."
◆ Stick to the point of the question.
◆ Answer the whole question. Many essay questions have more than one part.
◆ Stay specific. Every time you write a general statement, take time to include specific details that illustrate the generalization. For example:

```
David's Neoclassical painting has relatively con-

trolled emotion: the style is objective, unemotional.

Although the women are sad and concerned, they are not

wildly weeping or throwing themselves around.
```

◆ As you write, leave space to add more material.

A SAMPLE ESSAY EXAMINATION QUESTION AND ANSWER

Question:

Identify the two paintings shown and name the artists who painted them. Also identify the date the art was produced. Compare these two works. In doing so, discuss how they reflect their particular styles/periods and the differences between the two. Also include the narrative behind each work.

5-1 Jacques-Louis David, *Oath of the Horatii*, 1784. Oil on canvas, 11′ × 14′. Louvre, Paris.

5-2 Francisco de Goya, *The Third of May, 1808*, 1814. Oil on canvas, 8′ 8″ × 11′ 3″. Prado, Madrid.

Answer:

Student Name: Thilo Frieman

Oath of the Horatii by Jacques-Louis David was painted in the Neoclassical style in 1784. It depicts a story from ancient Rome and shows the moment at which the Horatius brothers are taking a vow to their father to represent Rome in a battle against the Albans.

The Third of May, 1808 by Francisco Goya was painted in the Romantic style in 1814. It depicts the day in Spain when the invading French soldiers rounded up and gunned down the Spanish people who were fighting for their freedom.

These two works are very different for many reasons. First, the theme behind the narratives is different. Although both works deal with war, Goya's theme is the horror and brutality of war, whereas David shows the nobility and bravery of war.

Second, the emotions shown are very different. David's Neoclassical painting has relatively controlled emotion: the style is objective, unemotional. Although the women are sad and concerned, they are not wildly weeping or throwing themselves around. Goya shows us men in complete agony and fear, which was common in Romanticism, a style that is graphic and emotionally provocative.

The compositions in these two paintings also differ. In David's work, we see a very organized and symmetrical composition: the father is in the center, with the brothers on the left and the women on the right. The main figures, the brothers and the father, form an implied triangle (as in Renaissance paintings). In Goya's painting, the figures who are being executed are unorganized and frenzied, huddled together in a mass. However, the French executioners are placed on a diagonal, as are their bayonets, heightening the composition's dynamism and emotion.

The approaches to the figures in these two works are also quite different. David made his figures very classical, with well-articulated musculature and ancient Roman clothing, as seen in the robes and sandals. Goya, on the other hand, put his figures in the simple clothing of common people of the times, emphasizing the horror that this could happen to anyone.

The colors of Goya's painting, which are mainly dark and somber, are used to emphasize the terror of the event. The viewer's eyes are drawn to the figure with the brightest clothing, and on his face we see panic and fear. His body is surrendering, but we see that his situation is hopeless, as indicated by the dead bodies lying at his feet. The colors of David's work are bright and bold. The red of the clothing

implies strength and courage, reinforcing the ancient Roman theme of bravery in battle.

Architecture is also used differently in these two works. David has included architectural elements from ancient times, with the Greek columns and the Roman arches. The only architecture in Goya's work is the church in the background, which is in the dark and not being noticed by anyone. This ignoring of spirituality only heightens the theme of humankind's inhumanity to humankind.

BEFORE TURNING IN THE EXAM

Save a few moments at the end of the writing period to relax and reread your answer. Use the remaining time to improve connections among your ideas. Add any pertinent additional information that will improve your essay.

WRITING THE EXHIBITION REVIEW

A Sample Exhibition Review

Visiting the Gallery or Museum
Written Material at the Exhibition
Audio Program
Moving through the Exhibition

Organizing Your Material

Writing the Introduction
Writing a Working Thesis
Developing a Controlling Idea for
Your Introduction
Ending the Introductory Paragraph
with a Thesis

Writing the Body Paragraphs

Writing the Conclusion

Writing a Title

Revision Checklist

This chapter will teach you how to write an art review, which is an evaluation of a show or exhibition at a gallery or museum. The art show might be a one-time display of an artist's (or several artists') work. Or, an exhibition can be a *visiting* one, meaning that it will be shown for only a short time before being dismantled and moved to another location. It is also possible to write a review of a permanent collection within a museum, using many of the same guidelines. Generally speaking, the terms *show* and *exhibition* can be used interchangeably. *Gallery* and *museum*, although also sometimes used interchangeably, can have slightly different meanings. Both words refer to establishments for exhibiting art objects, but a museum is more formal, more of an institution for preserving, as well as exhibiting, artworks. A gallery is usually smaller than a museum, and often its works are available for purchase. Also be aware that the term *gallery* can refer to any of the display rooms within a museum.

AUDIENCE AND PURPOSE

The person who writes an art review is referred to as an **art critic.** As an art critic, you have the job of reviewing an exhibition for a reading audience whose members fall into one of two categories: (1) They are considering whether or not to attend the exhibition, or (2) They are unable to attend the exhibition and are counting on the intelligent writing of the reviewers to bring the essence and some of the details of the exhibition to them.

An art critic engages in criticism, which involves the writer's personal opinion. However, in writing art criticism, do not be lulled into thinking that stating what you personally think of the work or the exhibition is enough. Art criticism demands that you analyze the works and the exhibition carefully and then defend your responses with solid evidence based upon a knowledge of art terms and concepts. A well-known art critic, Michael Fried, writes of the challenge of writing art criticism:

> I wrote with a sense of acute difficulty. I felt I saw [Anthony] Caro's sculptures clearly, even presciently, but found it almost impossible to put that vision into words. Welcome to art criticism.[1]

Notice that Fried says he found it "almost" impossible. However, he *was* able to write his critique after some further serious looking and thinking, so it wasn't impossible after all, just challenging.

The critic's obligation is to evaluate the merit of an exhibition. To do this effectively, you must ask questions: What did the artists or the exhibition organizers set out to do, and why? Did they meet their goals? If not, why not? If so, how? What is the exhibition's essence and its theme or style? (Keep in mind that there could be more than one theme or style.) Are all of the works shown by the same artist or by several artists? If there are works by different artists, what are the factors that tie them together? For example, are all of the works done in the same style, such as Abstract Expressionism? Or do they all express a similar theme, such as social oppression? Are they all from the same era, for example, the early twentieth century, or from the same geographic region, such as Russia?

If the style of the art on exhibit has been enduring and popular, such as Impressionism, assume that your audience is somewhat familiar with the essence of the style but might be in need of some reminders of the particulars. If the style, on the other hand, is relatively new, or not well known, such as Fluxus or Performance Art, give a more thorough explanation of the elements of that style so that your audience can understand your criticism.

Because unsupported judgments are not acceptable in art criticism, you must *prove* that your assessment is a valid one by supplying evidence. For example, critic Malcolm Jones wrote the following paragraph in a *Newsweek* review of an exhibition of Walker Evans's photographs:

> No matter how iconic Evans's images have become, their disturbing power remains undiminished. The portrait of Allie Mae Burroughs [FIG. **6-1**], a

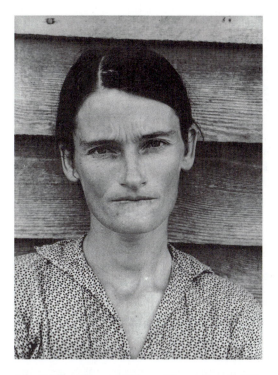

6-1 Walker Evans, *Alabama Tenant Farmer Wife*, 1936, black and white photo, Harry Ransom Humanities Research Center, University of Texas at Austin.

sharecropper's wife, is one of the last century's most unnerving works of art—and one of its most complicated. This is even more remarkable because it is one of the quietest, simplest-looking pictures imaginable. Evans keeps his angle as straight on as a passport photo, using available light that barely casts a shadow. The illusion is that the camera isn't there. But that was his genius: to take a picture with so few prompts that the viewer stares a little harder. Then you begin to notice the worry lines in her forehead, the way she bites her lower lip, the severity of her countenance. You sense something trapped about this woman, but also something resolute. Staring straight into the camera, she almost dares you to stare back. Your curiosity aroused, you want to see deeper, but at the same time, you feel uneasy, as though you've trespassed on someone's privacy.[2]

To say, as Malcolm Jones does, that an artist's work has "disturbing power" is a strong claim that requires support. Jones immediately provides a specific example, the photograph of Allie Mae Burroughs. He then supplies the details of the camera angle and the use of light to reveal even finer points: the worry lines in her forehead and the way she bites her lower lip. By providing examples and concrete details for your opinions, you will support your judgments and validate your opinions, as Jones does here.

As a good reviewer, adjust your expectations appropriately. It would be unreasonable to review an exhibition of "the best of local high school art" and complain that the work is "amateurish." This goes without saying; the artists *are* amateurs. The art, however, can still be judged on its formal elements and principles of design.

A final point to keep in mind in writing art reviews is the importance of being honest. View the exhibition with an open and analytical mind before arriving at a carefully considered opinion. Do not be swayed by whether or not your opinion will be "popular." Not everyone will agree with your opinion, but if you think it through and carefully support it, your endeavor in art criticism will be a successful one.

A SAMPLE REVIEW

There is no better way to get a sense of how to write an art review than to read a good one written by a professional critic. The following is a review of the exhibition "Degas: Beyond Impressionism" by Karen Wilkin for *ARTnews*. It is quite instructive in the art of art review writing. First, Wilkin assumes that her reading audience is interested in more than just a light, entertaining article and will not be deterred by the intellectual aspects of the material. She strikes an effective balance by not going into too much pedantic detail, yet providing enough scholarly insights to keep the reader's interest. She supports her claims with specific detail. She demonstrates familiarity with the subject matter and offers insights and examples. Ultimately, Wilkin delivers an honest, carefully considered opinion.

KNAVERY, TRICKERY, AND DECEIT

BY KAREN WILKIN

Edgar Degas (1834–1917) is one of those rare artists whose work, though easily recognized by even casual museumgoers, remains enigmatic and unpredictable. This month, "Degas: Beyond Impressionism" opens at the Art Institute of Chicago, and it remains on view through January 5. Organized by the National Gallery in London, where it debuted last spring, the exhibition offers a chance to rediscover the artist through the work of his last active decades, from the 1890's to about 1910. The sharply focused, impeccably chosen exhibition encompasses painting, works on paper, and sculpture. It proves that the more we know about this familiar figure, the more mysterious and contradictory he seems. Degas was the quintessential *flaneur*-painter—not just a passive spectator but someone who, like Baudelaire's "painter of modern life," bore witness to the public spectacle of 19th century Paris. A con-

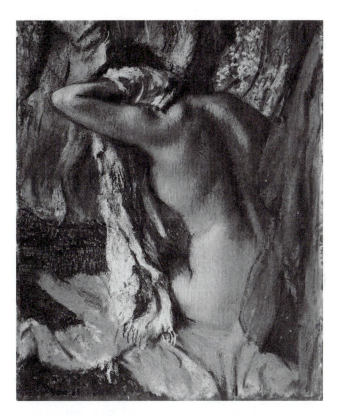

6-2 Edgar Degas, *After the Bath,* c. 1890–1893. Pastel, Norton Simon Foundation, Pasadena, California.

noisseur of appearances, he was also obsessed with themes of astonishing intimacy. And the contrasts multiply. A fluent painter and original colorist, he also produced some of the most provocative sculpture of the past century. A brilliant draftsman, owner of a pitiless eye that extracted essential contours from seemingly random encounters, he also experimented with photography as a way of interpreting the world. Reactionary in his politics and social attitudes, he was radically innovative in his art, but at the same time profoundly attached to the excellences of the past, even to the highest values of the Academy—Ingres, no less than Delacroix, was one of his heroes.

Indeed, paradox seems to have been at the heart of Degas's approach, perhaps even consciously. It is explicit in some of the show's most double-edged works, such as the Courtauld Institute's fiercely stroked pastel, *After the Bath, Woman Drying Herself* (ca. 1895–1900), or the Philadelphia Museum of Art's glowing red canvas of the same title (ca. 1894–96). Confronted by these dispassionate yet deeply felt, immediate yet carefully calculated images, I kept thinking of something that the notoriously acerbic painter wrote when he was a very young man: "A picture is something that requires as much

knavery, trickery, and deceit as the perpetration of a crime. Paint falsely, and then add the accent of nature."

Degas's later work reveals this prickly, hard-to-categorize master at his most audacious and most private. On display here is the best kind of "old man's art," with all the authority and contrariness, simplicity and intensity that mark the late achievements of supremely talented artists who live a long time. Think of the careworn Rembrandt's last, emotionally naked self-portraits, or the wheelchair-bound Matisse's joyous *papiers collés.*

Far from suggesting that age enfeebled their authors, these works transcend the esthetic norms of their moment, and present a wholly personal, utterly assured summing-up of a lifetime's preoccupations. The loose, aggressively scribbled pastels of Degas's last years, with their unraveling planes, tense forms, and superheated color, seem to defy everything we know about traditional rendering of the figure. Yet Degas was no seeker of novelty for its own sake—the late dancers and nudes link seamlessly with the tradition of Delacroix and Titian. They also point to the future. Picasso's Blue and Rose Period figures are deeply indebted to Degas's bathers, and so are Matisse's incisive translations of the human body into expressive two-dimensional drawing.

In 1886, when the last Impressionist exhibition was held, Degas, aged 51, had another 31 years to live. During that time, he produced paintings, works on paper, and sculptures of startling rigor, intensity, and frankness—and of surprising abstractness, both intellectual and formal. As Richard Kendall, this exhibition's curator, meticulously documents in his informative catalogue text, the aging Degas relied more and more on memory and early drawings as sources, no longer attending the ballet performances and rehearsals that were points of departure for his first pictures of dancers. This automatically imposed a liberating distance from a constraining actuality. And Degas's late practice of tracing and repeating particular figures with alterations, shifts, additions, or subtractions intensified this freedom.

The exhibition presents ample evidence of Degas's serial methods. There are groups of dancers that differ only in the amount of space they occupy or in the dominant color of the picture, as in the kindred works *Red Ballet Skirts* (ca. 1897–1901, Burrell Collection Glasgow) and *Three Dancers in Yellow Skirts* (ca. 1899–1904, Cincinnati Art Museum). There are bathers who differ only in the position of their arms or in their settings, such as the pastels *After the Bath, Woman Drying Herself* (ca. 1890–95, the National Gallery, London) and *After the Bath* (ca. 1890–93, Norton Simon Foundation, Pasadena) [FIG. **6-2**]. There are precedents, from ancient Greece to Degas's contemporary, Rodin, for creating "new" figures by attaching different limbs to replicated torsos, but the notion of working in series is uniquely modern. Think of Cézanne returning over and over again to Mont Sainte-Victoire, of Monet to his haystacks, or of Kenneth Noland to his concentric circles.

In London, "Degas: Beyond Impressionism" began with a capsule overview of what Kendall calls "the years of transition"—the late 1880's.

Present here, among other works, were the Art Institute of Chicago's cele-brated *Millinery Shop* (ca. 1879–84), composed as economically as a Japanese print, and the stunning *Hélène Rouart in Her Father's Study* (ca. 1886–95, National Gallery, London). One could also find an aristocratic, arrogant self-portrait in pastel (ca. 1895–1900, Fondation Rau pour le Tiers-Monde, Zurich), a depiction of the aged artist, silver beard neatly trimmed, gazing at himself (and the viewer) with cool detachment.

Afterward the show concentrated, as Degas did, on a more circumscribed set of themes, mostly dancers and women who seem unaware of being observed at their toilette. Placed alongside the occasional sculpture, these sequences of drawings, oils, and finished works on paper make Degas's thought processes come alive. Bronzes of unstable dancers and bathers wrenching themselves out of massive armchairs, paired with strangely flat-tened pastels of similar motifs, underline how Degas's urgent modeling of real mass in his sculptures subtly informed the contours of his drawings—and vice versa.

The intimacy and directness of these works erase the century that sepa-rates us from them. Unlike Degas's earlier pictures, with their unexpected viewpoints and layered, boldly cropped compositions, his later images are deceptively straightforward. For these are complicated private dramas ani-mated by a sense of imminence. The gestures and poses here are those of transition, not completion; they suggest not timelessness but the fleeting moment.

They are enlivened, too, by Degas's vigorous, overscaled touch. Thick caressing contours define and model in a single assured swoop, in opaque smudges and layers of color applied in rapid scrawls and spikes—these rhythmic gestures stay very much on the surface, but also create potent illu-sions of weight. It all looks spontaneous, yet the radiant pastels were achieved by a laborious sequence of putting down color, spraying with fixa-tive, waiting for it to dry, and attacking once again. In the same way, the firm contours of the drawings often resulted from a complex process of tracing and recycling poses refined to essentials.

Thanks to the exhibition, it's possible to follow this thrifty reuse of figures studied in the nude. Degas traces the image of a woman, sometimes months or years after the initial pose, gives her a costume, companions, a setting and then traces the whole again, adjusting space and shifting colors—and so on. The illusion of an immediate response to observed reality is an eloquent fic-tion, the product of "knavery, trickery, and deceit," just as the "reality" being observed was itself a fiction. The intimacy of the boudoir in the Philadelphia Museum's *After the Bath, Woman Drying Herself* (ca. 1894–96), for example, was evoked in the studio, like a stage set, through the cunning deployment of a copper tub, a padded chair, and some drapery. "The artist," Degas said, "does not draw what he sees, but what he must make others see."

It is surprising that these remarkable late works have generally attracted less interest than the pictures Degas made in the late 1870's and '80's, when

he was closest to the Impressionists. ("Degas: Beyond Impressionism" is the first exhibition dedicated to his late work.) This lack of attention was true even in Degas's lifetime, since after the last Impressionist exhibition, he showed infrequently, horded his works, and increasingly refused to allow all but a circle of intimates into the studio, thus giving rise to rumors about reclusiveness, misogyny, and even blindness.

Yet Degas's desire for privacy was longstanding. "It seems to me," he wrote around 1856, "that today, if the artist wishes to be serious—to cut out a little original niche for himself, or at least preserve his own innocence of personality—he must once more sink himself in solitude." And the painter, a sought-after dinner guest who entertained and dined out frequently until the very end of his life, was no recluse.

The question of Degas's eyesight is more complex, and the subject of much scholarly discussion. The cliché that he began to make sculpture because he could no longer see well enough to draw or paint is nonsense, easily disproven by the chronology. What is true is that Degas seems to have had serious eye problems as early as in his 30's, including a hypersensitivity to light that compelled him to wear dark glasses. His vision later deteriorated—he apparently lost the sight in one eye and was understandably frightened of becoming blind—but he continued to work until his late 70's.

Such issues aside, the cumulative effect of "Degas: Beyond Impressionism" is to make us see this difficult, well-known artist in a new light. He appears, more than ever, as a stubborn, irreducible individual who shrugs off the labels usually attached to him. Rather than the ingratiating "Impressionist painter of ballet dancers" of popular perception, he proves to be tough, complex, *odd*. At 22, Degas wrote, "There is much courage indeed in launching a frontal attack upon the main structure and the main lines of nature, and cowardice in approaching by facets and details: art is really a battle." It was a battle that he won.[3]

In her review, Wilkin holds forth the idea that Degas's late works are not works on the wane, but rather are as vital and novel as his earlier works. While including some information about Degas's persona and style, Wilkin steadfastly remains focused on the exhibition, deftly interweaving Degas's historical points into her discussion of the works on hand.

VISITING THE GALLERY OR MUSEUM

Your review will be written after you have visited an exhibition at a gallery or museum. Not every student has the opportunity to view a blockbuster art exhibition in a major museum in order to write the art review. However, most college towns have smaller galleries with local or visiting

shows that still provide ample opportunity to learn to write a review. In addition, university fine arts departments often have a gallery with exhibitions.

WRITTEN MATERIAL AT THE EXHIBITION

You will discover that there are several types of written materials to assist your viewing experience at the exhibition. In a small show, particularly a solo show of one artist's work, a **pamphlet** or **card** describing the artist's technique and style and including an *artist's statement* is often on hand. A larger exhibition usually has a **brochure** available. Generally, the brochure gives you information about the artists' backgrounds, the style or "ism" in which they were working, some historical information about the times in which the works were done, and possibly some mention of other major artists who were working at the same time or in the same style. In addition, most significant exhibitions have larger **catalogues** available for purchase. These scholarly catalogues, printed in book form, expand upon the information included in the brochure and provide reproductions of the works in the exhibition. Many museums furnish study rooms within the exhibition to facilitate your examination of the catalogue during your visit. If you are able to purchase the catalogue or find it in your college library, delay reading very much of the text until you have recorded your major ideas and opinions so that you are not unduly influenced. Also, as you move through the exhibition, be sure to read the valuable information that is sometimes written right on the walls or displayed on panels throughout.

AUDIO PROGRAM

Nowadays, larger exhibitions often have audio programs available. They are relatively inexpensive to rent (generally around $5) and are well worth it. With a cassette player worn around your neck, you are able to listen to the recording about selected works as many times as you desire. Do, however, view all of the works in the exhibition, not just the ones discussed on the tape.

MOVING THROUGH THE EXHIBITION

While visiting the exhibition, take your time. Look at each work carefully and read the accompanying text. When you reach the end, return to the beginning and revisit selected works on which you would like to focus in your review. Take thorough notes; write down the specifics about the works you wish to discuss, including the title, artist, date, dimensions, medium, and any other helpful information provided on the museum label. Note the name of the show's curator. Also note the formal elements and your own responses while you confront the works. Write in pencil because many

museums do not allow note-taking in pen. A Palm Pilot is also a useful tool. As soon as you leave the exhibition, write or tape record any additional thoughts or observations you have about the exhibition.

ORGANIZING YOUR MATERIAL

The second step in writing the review is to organize your notes into categories. You might use index cards, as advised in Chapter One. If you did not glean ample information about the major categories (listed next) from the written materials attendant to the exhibition, additional research might be required. Make decisions about which elements or categories you will emphasize. Although by no means exhaustive, the following is a list of the more common categories discussed in reviews:

◆ Theme
◆ The artist(s)
◆ A description of some of the works in the exhibition
 Subject matter
 The formal elements
 The principles of design
 The mediums used by the artist(s)
◆ The style or "ism" of the artist(s)
◆ What makes the work unique
◆ Comparable and influential artists
◆ The social influences on the art
◆ Historical references
◆ How the exhibition is displayed

WRITING THE INTRODUCTION

The introduction of the review is particularly important because it determines whether or not the reader's attention is caught sufficiently to compel him or her to read the rest of your review. The introduction is often a good place to include specific information about the exhibition, such as its title, location, and dates.

There are many ways to write an introduction, not all of which, obviously, can be covered here. Therefore, what follows is advice on writing an introductory paragraph that is versatile enough to be applicable to nearly any art review and potentially interesting enough to launch a provocative essay instead of a standard, predictable one.

Your introduction should meet the following criteria:

◆ Use specific names, times, and places.
◆ Have a sense of organization.

◆ Develop a controlling idea.
◆ Express an opinion.

WRITING A WORKING THESIS

Review your notes and decide what you can say generally about the exhibition as a whole. What opinion statements do your notes already support? You are developing a **working thesis,** not a final one. It is acceptable to say something rather vague at this stage, like, "The exhibition was good for the most part, but there were a few problems." It does not have to be an elegant statement quite yet: the most important thing is to *write it down.*

DEVELOPING A CONTROLLING IDEA FOR YOUR INTRODUCTION

The controlling idea is simply a main idea that the introductory paragraph develops. Ideas for introductory paragraphs are often in short supply for the beginning art critic, which is why so many introductory paragraphs lack unity and development. It will be useful to study the following examples of introductory paragraphs.

THE HISTORICAL INTRODUCTION

> "The Big One"—a colleague's term—of the fall season was the Jackson Pollock retrospective at the Museum of Modern Art. Proof that this was *the* show to see—or be seen at—came from the parade of international art world heavies (and the occasional movie star) at MOMA's Friday morning viewings; but apart from its chic, the Pollock show was essential because of its sheer excellence. The course of a short, intense career was presented through a thoughtfully chosen, elegantly presented selection of canvases, works on paper, prints, and a couple of sculptures—everything from laborious, essentially student efforts to gritty early works, to the astonishing, radiant poured paintings of Pollock's all-too-brief peak periods (about 1947 to 1950), to the desperate struggles of his last years. It was Pollock warts and all, with full weight given to the painter at his best. Wall texts that repeated old half-truths couldn't diminish the impact of this brilliant show; neither could the hokey facsimile (*sans* floor) of the painter's Springs studio.[4]

The preceding introductory paragraph is from a review by Karen Wilkin for the *Partisan Review* and concentrates on one idea: the history of the artist's work through his entire life. Mention is given even to Pollock's artworks done as a student, as well as to those done in his final period. As she points out in the first sentence, the exhibition is a **retrospective,** which means that it encompasses the lifetime work of the artist. In this review (as well as many others) the critic's opinion is expressed in the final sentence of the first paragraph because this is often the most logical place for it. Wilkin declares this a "brilliant show," beyond being compromised by a few of the show's weaknesses.

Other introductory paragraphs dealing with a historical element might focus on the history of a certain type of work shown in the exhibition, such as presidential portraits or a particular theme of art, such as the recumbent female nude. When recounting the history of an artist or artwork, select strong verbiage and avoid the overly broad or clichéd opening. Wilkin refers to a specific time frame by clearly writing, "The course of a short, intense career was presented …"

THE UNPOPULAR OPINION

> The exhibition called "Erotic Art" at the Sidney Janis Gallery has come and, in effect, has gone, leaving behind it no sensation more vivid than the faint, stale stirring of the air following a mass yawn. Such is the situation, at any rate, on the day after opening, when this is being written. And although people may line up to see the show, enfevered by the promise of forbidden delights served up with intellectual sanction, the only thing that can happen, surely, is that the yawn will spread.[5]

In this opening paragraph in a review for the *New York Times*, John Canaday admits that he is anticipating that a large number of people will come to the exhibition with great expectations, attracted by the salacious subject matter. However, he stands outside of popular opinion to say that the exhibition is a bore. Another possibility is to disagree with other critics' opinions of the exhibition.

THE ANALOGY

> As slippery, agreeable and conventional as an ad man at a client's party, Rosenquist nevertheless makes us aware of his attitudes in his big chopped-up ads and billboard sections. He persistently presents a picture of hare-brained non-involvement, sneaking in his comment so quietly that we are never certain we have not made it up for ourselves. His is a world of inescapable superficiality.[6]

In the preceding paragraph from a review in *Artforum*, critic William Wilson compares artist James Rosenquist with an unctuous ad man at a cocktail party. When you are writing a review, ask yourself what the art or artist you are reviewing is *like*. Of what does it remind you? If an answer to this question comes to mind, you might make use of an analogy in your introduction.

WHAT I EXPECTED VERSUS WHAT I GOT

This idea is quite versatile. You may have expected to enjoy an exhibition for several reasons (list them) but instead find that you did not enjoy it. The body of the essay will show why you did not enjoy the exhibition. On the other hand, you may have had a predisposition not to enjoy the exhibition for various reasons (list them), but instead you did enjoy it. The following opening paragraph in another *New York Times* review by John Canaday illustrates his disappointment.

Just exactly why I was foolish enough to think that "Young Italians," a new exhibition at the Jewish Museum that opened last week to run all summer, might offer something both solid and fresh, I'm sure I don't know. Pure old-fashioned association of ideas with words, I suppose—"young" suggesting freshness, and "Italians" reminding you that some pretty wonderful things have happened on that peninsula over the centuries. "Young Italians," indeed. It is just another obvious show dominated by fashions thin in the first place and now mostly on the wane, stuff we are already getting tired of because it never offered much substance although it still poses as "vital" and, God help us, "avant-garde."[7]

THE COMPARISON

In reviews of exhibitions that showcase the works of more than one artist, the introductory paragraph might include a comparison of the different artists. Keep in mind that if the exhibition is large, with many artists, you cannot compare all of the artists. The following introductory paragraph of a review in *Artforum* by Robert Pincus-Witten compares three artists showing at the Noah Goldowsky Gallery.

Three sculptors of notable talent fill out the restrained space of the Goldowsky front room. Two of them, Walter de Maria and Mark di Suvero, are familiar enough to be, in the present review, almost overlooked. By far, the freshest figure is a newcomer from the West Coast called Richard Serra. In the face of the current trialogue, Serra appears to link certain of the effete literary qualities of de Maria to the male principle of di Suvero. Of the three, Serra provides the most exciting contrasts of medium and literary undertone.[8]

Another use of comparison in the introductory paragraph would be to compare the artist's works done in one style in the exhibition to works done in another style.

THE FIRST IMPRESSION

The introductory paragraph is an excellent place for the writer to discuss the initial impact that the show had on him or her. The following introductory paragraph was written by Julia Pitts for *Ceramic Review:*

I am still trying to work out why this year's "Setting Out"—the Craft Potters Association's (CPA) annual selected exhibition of ceramics graduates—struck me as such a convincing show. It had its weaknesses like any mixed exhibition, but it grabbed me from the start as I walked past the window on a routine lunch-time visit to Contemporary Ceramics, the gallery of the CPA in London's West End. Susan O'Bryne's (Edinburgh College of Art) three-some of fleeing zebra placed in the window literally stopped me in my tracks; a combination of perfect positioning and a sensitive use of clay—an expressive, delicate patchwork of layers making up the galloping creatures.[9]

STRENGTH OF THE ARTIST

Alice Neel, who showed a group of portraits at the Graham Gallery, has a striking ability to get down what it is that is quick and aware and also spe-

cific in a human gaze. She concentrates on that riveting and elusive mobility which passes from the look in the eyes to the tension of cheeks and mouth, and goes after it with a style that is above all functional.[10]

The preceding introductory paragraph by Jane Harrison Cone for *Artforum* pulls us into the review by focusing on a characteristic strength or ability of the artist. Cone states that Neel's idiosyncratic expertise in capturing a human gaze makes this artist's work unique.

THE QUESTION

Another technique in writing your introductory paragraph is to pose a question or two to the reader. Be sure, however, that the questions are relevant to the body of the article and that they will be answered in the body. The following review about a major retrospective of Aubrey Beardsley was written by Jed Perl for a 1999 issue of *The New Republic:*

> The centenary of Aubrey Beardsley's death in 1898 did not pass unnoticed. In London last fall, the Victoria and Albert mounted a major retrospective; and quite a few new books have appeared, among them a monograph by Stephen Calloway, who organized the V&A show, and a new biography by Matthew Sturgis. Still, I find it difficult to escape the impression that this centenary has come and gone without much more than a whimper. Could it be that Aubrey Beardsley, who was a scandal in the 1890's and a sensation in the 1960's, is humdrum in the 1990's? Could it be that this master draftsman's deliciously unsettling conjugations of sexual daydream, theatrical fantasia, and near-abstract visionary design have lost their appeal?[11]

There are many possible controlling ideas for introductory paragraphs, of course. The preceding suggestions are intended to give you some ideas for development.

ENDING THE INTRODUCTORY PARAGRAPH WITH A THESIS

You have already sketched out a working thesis. Now refine it and fit it to the introductory remarks that precede it. For example, if your working thesis says, "The exhibition was good for the most part, but there were a few problems," and your introductory remarks compare the works of several artists exhibiting in the show, your revised thesis might say something like, "Although the New York Gallery's show is a bit uneven in the choice of works by the three exhibiting artists, it still manages to display a strong sense of energy via the vibrant colors and dynamic lines in the majority of the works."

This is no time for weak, unimaginative writing, such as "The exhibition was interesting," or "I liked the show." To give your thesis life, try telling what effect the art in the exhibition had on you. For example, you might write, "The exhibition brilliantly achieved its intended effect of overwhelming the viewer by the power of its bright colors and their unconventional use."

If you noticed that your reaction seemed to be similar to the reactions of other visitors to the exhibition, discuss what effect the works seemed to be having on those other visitors. One of the authors recalls visiting Andrew Wyeth's much-publicized exhibition of his "Helga Pictures" at the National Gallery in Washington, D.C. Much hullabaloo surrounded this show because Wyeth had closeted these paintings for years; they were unknown to anyone (including Wyeth's wife) except the model, Helga, and Wyeth himself. There was a great deal of speculation in the press regarding Wyeth's exact relationship to the model and his reasons for sequestering the paintings. Consequently museum-goers, planted in front of the works, were actually muttering comments aloud, often to themselves. This situation would have made it easy to note their reactions and include them in your final thesis statement, such as "The exhibition was stimulating for the candor of the artist, as well as for the voyeuristic reactions it provoked in its viewers." Granted, not every exhibition turns the gallery into a salon all abuzz, but you might strike up conversations with fellow viewers and note their opinions and points of view.

The main thing to remember is that you must make only one evaluative statement about the exhibition, or else you will have given yourself more than one thesis to support.

There are more types of introductions than the ones recommended here, of course. Some introductions are only one or two sentences long; others are two or three paragraphs long. Some begin with the thesis rather than end with it. Another type of introduction never states a thesis explicitly but instead implies one. Any introduction is correct if it leads to a strong, focused, coherent review.

WRITING THE BODY PARAGRAPHS

Decide which categories your review will emphasize and then write a body paragraph for each. To refresh your memory, the major categories are theme, the artist(s), a description of some of the works in the exhibition (including subject matter, the formal elements, principles of design, and medium), the style or "ism," what makes the work unique, a comparison to other artists or works, the social influences on the art, the historical reference, and how the exhibition is displayed.

Keep in mind that well-written body paragraphs usually have four characteristics: *unity, adequate development, organization,* and *coherence.* The following is a discussion of the major categories, including some sample body paragraphs from professionally written reviews:

THEME

Exhibitions usually have a basic theme, the glue that binds the artworks. The title of the exhibition often hints at the theme, such as "Women in White,"

"Gardens by the Impressionist Hand," or "The Royal Art of Benin." The following excerpt from a review by Edward M. Gomez in the *New York Times,* titled "An Abstractionist Maintains the Faith in a Skeptical Era," discusses theme in the paintings of the "self-described third generation Abstract Expressionist" Louise Fishman on view at the Cheim and Read Gallery in New York City. After a trip to eastern Europe, Fishman produced a group of somber tableaus.

> Honoring Jewish themes of survival and remembrance in mood and title, they [the tableaus] use unfussy, rectilinear arrangements of broad brushstrokes to whisper hauntingly for attention through nearly transparent washes of dark color. Subsequently, Ms. Fishman said, she found that her art "loosened up"—but she worked at freeing up her touch, too.[12]

THE ARTIST(S)

Including some information about the artist, especially if he or she is not well known, sometimes enhances the understanding of the reader. For example, when twentieth-century American sculptor David Smith began making large metal sculptures, it was helpful for the viewing and reading audiences to know that he was also an automobile welder, thus his comfort level and adeptness in working with metal.

Avoid supplying too many details about the artist's life, as fascinating as they might be, particularly if you are writing a short review. Stick to the facts most germane to the review. Keep in mind that you are writing a review, not a biographical research paper on an artist. If they are on topic, quotes from the artist can also be included. The following excerpt is from the Boulder, Colorado, *Daily Camera.* The review by J. Gluckstern discusses the exhibition of mixed-media works of Jason Lujan:

> Prominent iconographic forms include painted eagles and fleets of B-52 bombers. The B-52s refer to Lujan's childhood living near a military base, where, according to his statement, fly-overs were so regular that even church services were routinely paused to allow the planes to pass. And as an American Indian, Lujan has some understandably ambivalent feelings toward this ubiquitous symbol of American military might.[13]

Without belaboring the point, Gluckstern has shown the relevance of the background information to the artwork itself.

DESCRIPTION OF WORKS

Because you, the writer, are the eyes of the reader, it is important that you offer descriptive samples of some of the works in the exhibition. Obviously, you do not have the space in the review to discuss every piece of art in the show, so choose a few pieces that are particularly compelling or indicative of the style of the artist or artists. Refer to Chapter Two, "The Language of Art and the Formal Analysis," and look at the artwork in the show in terms of

subject matter, formal elements, principles of design, medium, and style. Focus on some of the most salient points of these aspects. You might compare different works in the show, as Roger Green does in the following review from *ARTnews*. The review critiques the screenprints of American artist Jacob Lawrence, on exhibit at Detroit's George N'Namdi Gallery.

> Among other noteworthy works were the screenprint, *Man with Birds*, from the series "Hiroshima" (1983), and the earliest work on view, *Workshop* (1972), a colored lithograph. The unusually harrowing *Man with Birds*, portraying a survivor of the Hiroshima blast, draws emotive power from strident colors and ragged line quality. *Workshop*, portraying builders working harmoniously at a construction site, is much more painterly than any of the screenprints, featuring shaded passages with irregular textures.[14]

Specific words, such as "strident colors" and "ragged line quality," give the reader a visual sense of the expressiveness of the Hiroshima theme in *Man with Birds*. Green's pointing out the painterly approach in *Workshop* helps the reader to picture the effect of paint building up in this work as well as to envision the subject matter of the construction workers at their job.

SUBJECT MATTER

Writing about subject matter in a work of art answers the questions "What is depicted?" and "What does it mean?" In the following *Time* review of an Henri Matisse retrospective, Robert Hughes discusses subject matter, including the aspect of meaning:

> Matisse was the heir to an entire, and in his time still viable, tradition of European painting. *Conversation* [FIG. 6-3] is, on the one level, an intimate interior—the painter in his pajamas chatting with Mme. Matisse in her chair. But its hieratic grandeur irresistibly puts you in mind of an Annunciation, with angel (though wingless) and Madonna.[15]

THE FORMAL ELEMENTS

The formal elements are the basic components with which the artist creates the work. The formal elements are line, color, shape, value, texture, space, time and motion, and sound and smell. Like Roger Green, the reviewer describes these elements in the work and their effect on the work. Refer to the discussion of the formal elements in Chapter Two and write a paragraph on each element you have chosen to discuss. The following two excerpts from reviews—the first discussing line, the second discussing sound and space—are examples of how to write paragraphs about the formal elements in your review.

Line: The following paragraph from a review by Harry Cooper in *Artforum* animatedly compares Jack Tworkov's use of line to Willem de Kooning's:

6-3 Henri Matisse, *Conversation*, 1908–1912. Oil on canvas, 69 5/8″ × 71 3/8″. Hermitage Museum, St. Petersburg.

With their scraped and spattered ink, the drawings look at first like pure homage [to de Kooning]. But while de Kooning's line carves up the surface like a high-powered jigsaw, Tworkov's strokes are something more, well, French. They skip along and lift off the surface gently, and the shapes keep a respectful distance from the edge, weakening the abstraction by suggesting a figure floating on a ground.[16]

Sound and space: The following excerpt from a review by Shannen Hill in *African Arts* discusses an installation exhibition by nine artists called "Thirty Minutes" and highlights sound as an integral part of the work. The theme of the exhibition, installed at the Robben Island Museum in Cape Town, South Africa, arises from the fact that visits with inmates at Robben Island Prison were limited to thirty minutes:

[Lionel] Davis's installation most directly captures the demands of the space; as a former inmate, he experienced the thirty minutes first hand. His *Untitled* records repressed words, distilled expression, and the intrusions of neighboring sounds and monitored language that bore upon the prisoner and visitor. At the center of the cubicle, a black face on a rope-bound pedestal wears a white plaster mask without a mouth. As Davis describes it, the ensemble reflects his experience of pretending that conditions were bearable so visitors would not worry. The tension of that performance was

heightened by the sounds that engulfed him, given presence here in the graffiti-scrawled walls surrounding the head. Fellow prisoners shouted to be heard; multiple languages competed, each monitored by a warden who restricted the topics of conversation. The interaction of components in this piece jars the viewer, leaving sorrow over the presence of too many words unspoken amid so many said.[17]

The preceding paragraph also refers to the concept of space, another formal element. As Hill mentions, the installation "most directly captures the demands of the space." Installation and performance pieces are situated in a particular physical space, which interacts with the more solid pieces of the work, as well as with sound.

PRINCIPLES OF DESIGN

Design refers to the composition of the formal elements, using the principles of design: balance, unity and variety, proportion and scale, and rhythm. The following body paragraph from a review of Tom Duncan's work by David Ebony in *Art in America* discusses the principle of scale:

> The witty play on scale—things are proportioned to a child's point of view—in *At Waverley Station* is present in most of the work and is used to ironic effect in a wall piece called *In Memory of John F. Kennedy*. This sincerely felt tribute to JFK is a twist on the familiar image of the president's small son saluting his murdered father's funeral procession. Here, a gigantic John-John towers over a miniature flag-draped coffin being pulled up Pennsylvania Avenue by teams of tiny toy horses.[18]

THE MEDIUM

What is the medium in which the works are done? Medium refers to the physical material used in the work. Is it sculpture, painting, drawing? Is it made of stone, oil paints, pencil?

The following review by Katy Siegel in *Artforum* discusses an exhibition of Frank Stella's works and generously describes the medium:

> The strangest [relief] was *Severambia*, 1996, a curving, free-standing fiberglass wallpainting that looks like *Titled Arc* after a thorough graffiti hit; Kenny Scharf comes to mind as much as Fabian Maraccio. In this piece, as in the huge paintings on canvas (his first since the '70's) like *Das Erdbeben in Chili* (Earthquake in Chile), 1999, Stella uses an elaborate technique to get the paint on. First, he amasses a certain amount of printed material, much of it produced by master printer Ken Tyler. Some of these abstractions are computer generated, often deriving from organic forms like smoke rings (a new signature) and soap bubbles. With these materials Stella then creates roughly half-scale collages that are photographed and projected onto a surface. Finally, scenery painters meticulously reproduce the projections, but even that's not simple: while some of the dots, lines and splotches are painted directly, others are cast in acrylic and laminated onto the final work. *Severambia* shifts uneasily between illusion and 3-D reality.[19]

THE STYLE OR "ISM"

What is the artist's personal style? What is the particular **period style** of the artwork? By naming the style, movement, or "ism," you are imparting a great deal of information to the reader who is knowledgeable about the different art styles and movements. However, to be sure that each and every reader understands, it is helpful to discuss briefly a few tenets of that particular "ism" or period style in which the artist is working. In the following review from *The New Republic*, titled "Our Dadaist," Jed Perl views Robert Gober's retrospective at the Hirshhorn through the lens of the famous twentieth-century "ism" of Dadaism, in which Gober is working:

> Gober comes closer than any other contemporary artist to rekindling the original spirit of the Dadaists; I suppose that a sneeze comes to mind when I think of Gober's work because his bizarre inventions remind me in some general way of Marcel Duchamp's object *Why Not Sneeze?* from 1921, a small metal cage filled with marble cubes. In the last fifty years, smart-alecky Dadaist gestures have become such a standard art-world marketing strategy that it can be a pleasant shock to come upon an artist such as Gober who occasionally dreams up weird stuff that really is weird [...]. Dadaism is self-reflexive, adolescent in its intense, angry, grand self-absorption, and sometimes almost pre-adolescent in its abstracted fascination with play.[20]

As you can see, Perl points out some of the principles of Dadaism and shows the reader how Gober fits in.

UNIQUENESS

What makes the artist's work unique? Another review in *The New Republic* by Jed Perl titled "Theory for Gallerygoers" discusses the unique aspects of Wes Mills's drawings at the Joseph Helman Gallery:

> Mills is a kind of fundamentalist; and a somewhat humorous one. He has taken drawing apart, and he presents the component parts (a scratched line here, a shaded form there) as such quizzically isolated images that his interest in an inviolate essence can seem a slightly oddball pursuit. I expect that Mills invites such thoughts. He is the most talented among a slew of younger artists who have come of age at a time when nobody can even begin to agree as to whether there are any basics or fundamentals to art, and they have responded by glorifying the fly-weight, the hardly-there, the shadowy trace. I think that Mills gives some real drama to this kind of chic whispery nihilism. If Mills is being embraced by a small but growing group of artists and gallerygoers, it is because he makes something of their uncertainties, of their sense that art is too embattled to be anything but cagey and elusive.[21]

In describing Mills as a "humorous fundamentalist" and "slightly oddball," Perl portrays a unique artist. Mills's medium, drawing, is a fluid one, not conducive to being "taken apart"; however, this is exactly what Mills

does. Furthermore, the fact that Mills, in Perl's estimation, stands out among a group of contemporary artists reinforces the uniqueness of this artist and his talent.

COMPARABLE AND INFLUENTIAL ARTISTS

Does the artist's work remind you of other artists' work? Was the artist influenced by other artists? By drawing such parallels, you are giving the reader further insights and visual images upon which to draw while trying to imagine the works you are describing. Obviously, you must not choose obscure artists for comparison because your reference will not be known by most readers. A review by Alisa Tager in *ARTnews* makes a good comparison of Robert Rauschenberg's traveling exhibition to another twentieth-century artist:

> Many of the works in this show were previously unexhibited and unpublished. Including paintings, sculpture, works on paper, and photographs, it was a celebration of both diversity and consistency. Each of Rauschenberg's artistic tangents reveals his capacity for exposing and creating meaning. His tiny "fetishistic" assemblages have the poignant poetry of Joseph Cornell's boxes, with an added mischievous or obsessive twist. The black monochromatic collage paintings are both sublime and spiritual, with an unanticipated move toward alchemy. This same notion of transformation and transcendence is apparent in his photogram collaborations with Susan Weil, as well as in his gold paintings.[22]

Here, Tager is referring to the glass-fronted wooden boxes filled with found objects, which became Cornell's calling card and which were certainly known to Rauschenberg, as well as to most art review readers.

Another example of referring to other artists' work appears in the following column written by Theodore F. Wolff in the *Christian Science Monitor*. The column discusses the work of twentieth-century print artist Käthe Kollwitz.

> Although compassion was her primary response to life, she was also capable of venting her frustration and rage at war, poverty, political murder, and any other form of inhumanity—and without recourse to the highly idiosyncratic or flamboyant distortions used by Otto Dix, George Grosz or Picasso when they were most angry or passionate. Kollwitz, in fact, never deviated very far from direct physical description, from taking full advantage of the way people and things actually looked, and then using that information to fashion images that remained profoundly and specifically "human" even while serving as powerfully effective moral or social icons.[23]

Here, Wolff compares Kollwitz not to one artist, but to three, who were working in a similar way. This comparison gives the reader an even greater number of images to think about in relationship to the artist's work, thus broadening the reader's comprehension.

6-4 Käthe Kollwitz, *The Mothers*, 1919. Lithograph, 17 3/4″ × 23″. Philadelphia Museum of Art.

SOCIAL CONTEXT

What are the social influences on the art? Art is not created in a vacuum, but, instead, emerges from a particular time and place. Thus, it is a product of all the pulses of society that are beating at the time of its conception. Further-more, some art is created with a deliberate social intent, designed to bring a particular message to the viewer and, perhaps, to change the viewer's opin-ion. By providing some social insights about the works, you, as a writer, can expand the reader's understanding. When evaluating a work or an exhibi-tion with a social intent, consider the impact the message would have had upon the viewers at the time the work was done as well as contemporary viewers. A good example of writing about the social context of an exhibition is an *Art in America* review titled "Wilhelmine Berlin." Franz Schulze, art critic and professor of art, discusses an exhibition at the Jewish Museum in New York titled "Berlin Metropolis: Jews and the New Culture, 1890–1918":

> Yet the exhibition, which reviews the cultural role played by the Jews and non-Jews who lived in Berlin during the Wilhelmine era, succeeds in con-veying a story as complicated and multilayered as it is enlightening. The show does not shrink from references to German anti-Semitism, and it leaves no doubt about its organizers' awareness of the horrors of the Hitler years that followed. But it offers heaps of information, much of it little

known to the American public, to demonstrate the richness of Berlin's artistic atmosphere at the turn of the 20th century and the contributions made to it by Jews, and also by Gentiles connected with them in one significant way or another.[24]

Schulze is direct in discussing the show's references to the antisemitism that dominated Germany during the early twentieth century and Hitler's subsequent rise to power. We can scarcely look at German art from those times without recalling what was occurring socially, culturally, and politically—influences that are recognized and understood by most readers.

HISTORICAL REFERENCE

In longer reviews, it is sometimes pertinent to include some discussion about what was occurring historically at the time the works being discussed were done. An excerpt from *Smithsonian* by Bennett Schiff is titled "Titian: Art's Venetian Lion." In reading about the renowned painter Titian and his place in Renaissance art, it is important that the reader understand what was occurring at the time in Venice, as opposed to Rome or Florence, the centers of Renaissance art.

> Venice at the turn of the 16th century was still at the height of its powers, a unique republic in a region dominated by principalities, where a well-allied pope commanded from Rome. Founded, according to legend, in the marshes in A.D. 421, it had lasted for more than a thousand years, a wealthy and proud society, a colonial power, the fulcrum for trade between East and West.[25]

So even though the center of Renaissance artistic developments was not Venice, Venice rivaled its Italian counterparts as a power to be reckoned with, both politically and artistically. This setting allowed Venice's artist, Titian, to flourish as well as any Florentine or Roman artist at the time.

EXHIBITION DISPLAY

How is the exhibition as a whole displayed? How are the individual pieces displayed? These questions might not enter the consciousness of the museum visitor, but our enjoyment of the exhibition can be greatly affected by this component. Who is the curator? Numerous factors go into the decisions made by the curator in charge of organizing the show. Some of them include:

- What color to paint the walls
- Which pieces to put in which rooms
- What kind of lighting to use
- Whether to separate the works of different artists or to mingle one artist's works with another's
- Whether to display different mediums (e.g., paintings, sculpture, ceramics) together or to put them in different areas
- Whether or not to group similar themes

◆ How close together to hang or display the works
◆ Whether to place works chronologically or to mix earlier works with later ones

The following excerpt is from Karen Wilkin's review, "Knavery, Trickery, and Deceit," of an exhibition of the works of Impressionist painter Edgar Degas at the Art Institute of Chicago. The review in its entirety appears earlier in this chapter.

> Afterward the show concentrated, as Degas did, on a more circumscribed set of themes, mostly dancers and women who seem unaware of being observed at their toilette. Placed alongside the occasional sculpture, these sequences of drawings, oils, and finished works on paper make Degas's thought processes come alive. Bronzes of unstable dancers and bathers wrenching themselves out of massive armchairs, paired with strangely flattened pastels of similar motifs, underline how Degas's urgent modeling of real mass in his sculptures subtly informed the contours of his drawings— and vice versa.[26]

Here Wilkin points out the curator's decision to group different mediums according to their shared theme: females, going about their daily personal grooming and dance practice. In this case, bronze sculpture is intermingled with pastels (a chalklike medium on paper). As the reviewer points out, a mutual benefit is derived from this decision, with the three-dimensional modeling in the sculpture affecting the lines of the pastels and vice versa. Had these works not been paired with one another, this exciting synergistic effect would not have been brought to the viewer's attention, and the further insight regarding Degas's process would not have been revealed. Fortunately, good curatorship prevailed!

———

In each of the preceding examples of body paragraphs, the reviewer expresses an *attitude* about the artistic element under discussion. Jed Perl calls it a "pleasant shock" to find in Robert Gober an artist who "occasionally dreams up weird stuff that really is weird." Shannen Hill claims that Lionel Davis's installation "most directly captures the demands of the space." Franz Schulze asserts that an exhibition at the Jewish Museum "succeeds in conveying a story as complicated and multilayered as it is enlightening." Having made such claims, the reviewers then proceed to support them with specific facts.

Merely describing these elements without expressing judgment of them will not suffice, nor will expressing judgment without describing.

WRITING THE CONCLUSION

The conclusion is of utmost importance in a review. It is your last opportunity to convince your reader of your insights and opinions and to give your

reader a sense of satisfaction. Save some arresting comments for the conclusion.

When it comes to writing conclusions, like introductions, there are innumerable possibilities. This book cannot possibly cover them all, but it offers enough suggestions to guide students through most situations. Your conclusion should meet the following criteria:

- ◆ Use concrete imagery.
- ◆ Offer more than mere repetition of the points already covered.
- ◆ Develop a controlling idea.
- ◆ Give the reader a sense of closure.

The concept of the controlling idea is quite important. Without a controlling idea, conclusions become a hodgepodge of general, abstract, repetitious, and unrelated statements, and it would be a shame to attach such a conclusion to an otherwise scintillating review. Because controlling ideas can be a challenge to conceive, following are several examples of concluding paragraphs.

THE HISTORICAL CONCLUSION

Sometimes a thumbnail history lesson, as it pertains to the works or artist in question, is in order. Historical conclusions can also make a statement about the artist's place within an artistic movement or a more personalized statement about the artist's own career history.

The following paragraph concludes a 1964 review by critic John Canaday for the *New York Times*. The Museum of Modern Art exhibition showed the works of Max Beckmann, and Canaday discusses Beckmann's own stylistic evolution through his history, as well as through social history.

> I have always felt, in spite of efforts to feel otherwise, that at the end of the war in 1945 Beckmann became a stylist, rather than a painter who expressed himself through a style. By 1950, the man in the self-portraits is once again dapper and jaunty. The fortunate boy who painted himself in Florence has indeed become father to the man, and the paintings of the last years have a way of revealing an unwelcome degree of artifice in even the best of Beckmann. But in this best there remains an emotional record of three decades of social history not approached in the work of any other painter who witnessed it.[27]

THE QUOTATION

Consider using a quotation as the basis for developing a conclusion. The quotation could come from some well-known historical or literary figure, from the artist, or from another artist. The following conclusion is from a review in *ARTnews* titled "Italy: Liliana Moro" by Meyer Raphael Rubinstein. This example is particularly intriguing because the writer is quoting the artist, who is quoting a literary figure.

In a recent exhibition at the Casoli gallery in Milan, Moro did a collaborative installation with fellow Lazzaro Palazzi veteran Bernhard Rudiger. While Rudiger filled the space with dozens of old gas stoves, Moro's contribution was a couple of miniature theaters set in boxes on the floor that one had to kneel down to see. Marking all of her work is precisely this fascination with the big and the small, the confrontation between the adult's body and the child's imagination. To help her audience understand the impulses underlying this theme, she quotes the Japanese writer Kobo Abe: "When you look at something small, you want to live. Drops of water … leather gloves soaked and restretched.… When you contemplate something big, you want to die. Like a house or parliament, or the map of the world."[28]

WELCOME OR CONGRATULATIONS

If a new artist is making his or her debut in the exhibition, and your review has been rather favorable, the conclusion might be a good place to roll out the welcome mat on behalf of art lovers. Likewise, if an established artist has veered off the path for a while but has now returned with strong and commendable work, you might elect to blow the "welcome back" trumpet. In addition, you might want to welcome a show to your particular city, especially if there is a specific link that artist has to the place.

Another possibility for a conclusion is to congratulate exhibitors for a job well done. The following excerpt concludes the earlier cited critique in *Ceramic Review* by Julia Pitts, who congratulates not just the artists but also the personnel and the institutions responsible for mounting the show.

> Bringing a group of graduates together is not always plain sailing. It has the potential to be the most stressful of the Contemporary Ceramic's exhibitions to manage, but it is here that the future of the CPA [Craft Potters Association] rests. As their first exhibition beyond graduation […] "Setting Out" gives an opportunity for new makers to meet and present themselves to the public. The show looks beyond the familiarity of the CPA's membership and brings with it new levels of energy and enthusiasm. This is an important show and one that could, if more heartily promoted to the increasing hungry media, bring benefits to the CPA and graduates alike. For now though congratulations should be sent to the graduates, tutors, technicians, colleges and the gallery for a genuinely impressive exhibition of new talent.[29]

THE FINAL IMPRESSION

Just as a review might begin with an introductory paragraph that records a critic's first impression, so also might a review conclude with a final impression. The following example is the concluding paragraph from a review by Brooks Adams in *Art in America*. Adams is reviewing an installation exhibition titled "Incident at the Museum or Water Music" by Ilya Kabakov.

> Sitting on one of the wonderfully deep, old-fashioned museum benches, I felt a sense of fatigue and relief, although I had been in the gallery only a few minutes. Possibly the experience of looking at art under such conditions

was intended as a metaphor for the sense of entropy and exhaustion attending all aspects of life in the late Soviet Union. Whereas in the past Kabakov's work, which often combines writing and illustration, had struck me as overburdened with obscurantist detail, I came away from this show a complete and fervent convert to his strangely mystical water music.[30]

PREDICT THE FUTURE

The conclusion is often a good place to predict the future of an artist, the future of a particular stylistic movement, or the effect that art will have on society in the future. The following paragraph, written by Barbara London for *Art in America,* concludes an article about several exhibitions of Japanese video art. The conclusion predicts the future of this relatively new art form.

> Video artists in Japan have had to be resourceful, given the limitations of their venues and markets and the restrictions imposed by traditional definitions of art. They have eked out livelihoods by teaching or freelancing in industry. Today a few visionary souls recognize the extraordinary potential video and computers have together, and they are persistently exploring new opportunities beyond mainstream mass entertainment. Perhaps these artists will point to new possibilities somewhere between Eastern and Western esthetics.[31]

ONE WORK OF ART

Sometimes an art critic will center the concluding paragraph around one particular work that stands out in the exhibition from all the other pieces. Often this work exemplifies the essence or the most salient characteristics of the entire show. In the following example from *Art in America,* Richard Kalina concludes his review by focusing on a signifying work by the artist.

> Among the most appealing of his works from the past few years are the urban, nocturnal landscapes such as *West 2,* where windows, knocked in with what appears to be a single pass of a wide, loaded brush, are set against the deep, undifferentiated purply black of the building's bulk. [Alex] Katz manages to capture, with an almost insouciant skill, that fluorescent-lit emptiness (punctuated here and there with activity) of an office building late at night. The painting is cool and distanced, and yet all the more romantic for it. Here is an artist operating at the peak of his powers.[32]

WRITING A TITLE

Invent a title for your review that both attracts the reader's attention and captures the essence of the review. For example, your review of an exhibition called "Erotic Art" will not be titled "Erotic Art." Nor should it be anything so mundane as "A Review of Erotic Art." Create something eye-catching, such as John Canaday's review title, "This Way to the Big Erotic Art Show."

You might use a familiar phrase for your title, as Peter Schjeldahl does in a review of a show of Netherlandish still-life paintings, cleverly titled "Going Dutch." You might use a phrase from the artist's own words, as Karen Wilkin does in her review titled "Knavery, Trickery, and Deceit." Or, ask a question, as Jed Perl does in his review titled "What Is Modern Art Anyway?" A particularly pertinent, but brief, quotation could work; you might even use a well-turned phrase from your own prose.

REVISING, EDITING, AND PROOFREADING YOUR REVIEW

This last step is a crucial one. To *revise* means to "see again." It would be wise to let your review settle for a while, at least overnight; returning to it with fresh eyes will produce better results.

Use the following checklist to be certain that your review is ready for submission. Consult the "Handbook" section at the end of this book for guidance in issues of sentence structure, grammar, punctuation, mechanics, and style.

REVISION CHECKLIST

- ☐ Thesis statement is clear and present. It makes an evaluative statement about the art.
- ☐ Introduction contains specific details. It develops a controlling idea.
- ☐ Body paragraphs are unified (containing *one* topic sentence), adequately developed (containing evidence in support of assertions), organized, and coherent (containing appropriate transitional expressions).
- ☐ Conclusion develops a controlling idea.
- ☐ Sentences are well constructed. There are no run-ons or fragments.
- ☐ Sentences are correctly punctuated.
- ☐ Words are correct and well chosen.
- ☐ All quotations use acknowledgment phrases.
- ☐ Sources are correctly cited in text.
- ☐ Title is appropriate.
- ☐ Review fulfills requirements particular to this assignment, such as length and subject matter.

WRITING THE RESEARCH PAPER

Choosing a Topic

Researching the Topic | *Searching the Library*
Searching the Internet

Planning the Research Paper | *Descriptive or Expository Research Paper Plan*
Descriptive or Expository Research Paper Outline
Argumentative Research Paper Plan
Argumentative Research Paper Outline

Writing the Research Paper | *Using Sources*
Incorporating Quotations into Your Paper

Citing Sources | *Numbered Notes System*
MLA (Modern Language Association) Documentation System

Two Sample Research Papers

Revision Checklist

The term **research paper** refers generally to several types of papers that use sources. **Term paper** may be the more specific term for a paper that is required to fulfill the requirements of an undergraduate course. **Thesis** is a term for a paper required in a graduate course. A **dissertation** is a paper written in pursuance of a doctoral degree.

The research paper is different from a critical essay in that it makes more conscious use of outside sources. The research paper's purpose is to contribute to the existing dialogue on art within the community. Many papers published in journals such as *The Art Bulletin,* for example, are research papers. Characteristically, the writers of these papers refer to each others' comments and observations as they pursue a particular idea about the art, thus expanding and extending the public discussion. In writing the research paper, you will capitalize upon ideas contained in previously published papers to advance your own ideas. You might use your sources in several

ways: as corroboration of your own ideas, as a springboard for your own ideas, or as an opinion against which to argue.

This chapter also contains information on quoting and paraphrasing sources, as well as the concept of plagiarism and ways to avoid it, under the section headed "Writing the Research Paper."

Under the section headed "Citing Sources," the chapter teaches two types of documentation systems: the numbered notes system and the MLA system. A research paper titled "Ben Shahn's Use of Photography in His Paintings" demonstrates the numbered notes system. A second research paper titled "The Elgin Marbles: Saved or Stolen?" demonstrates the MLA system.

CHOOSING A TOPIC

Before you decide on a topic for your research paper, you need to understand your assignment clearly. A major consideration is the mode of discourse in which you're expected to write. Will your research paper be written in a descriptive, expository, or argumentative mode of discourse? It is important that you be certain about your answer to this question because your thesis statement must reflect your paper's main point as well as its mode of discourse. Consider the following examples:

> DESCRIPTIVE THESIS: Greece and the British Museum are in a dispute over the custody of the Elgin Marbles.

> EXPOSITORY THESIS: Returning the Elgin Marbles to Greece would constitute a significant loss to the British Museum's collection.

> ARGUMENTATIVE THESIS: The British Museum should return the Elgin Marbles to Greece.

In the preceding example, the *descriptive thesis* promises an impartial paper, one that describes the dispute without taking sides. The *expository thesis* promises a paper that will support the author's own idea about the effect upon the British Museum if it were to lose the marbles. This paper will not try to settle the dispute, however, according to this thesis. The *argumentative thesis* promises a paper that will take a side in the dispute and advocate a solution.

Your professor may have a specific design in mind for your paper that combines the modes of discourse. For example, you may be assigned to write about an artist's life and influences objectively, or in a descriptive mode of discourse, and then to explain that artist's work, through formal analysis or through speculation about the causes of the artist's choices or through the public's reaction to the art.

After you have settled generally on a topic, you will probably find that it needs narrowing. Some narrowing will come naturally as you begin the planning process, which entails formulating a thesis and points of proof. But you may be able to eliminate some material even now. The author of "The Elgin Marbles: Saved or Stolen?" for example, realized that a paper that

7-1 Iktinos and Kallikrates, Parthenon (Temple of Athena Parthenos), Acropolis, Athens, 447–438 B.C.E. (view from the northwest).

attempted to surmount every argument for returning the Elgin Marbles to Greece would be book-size. A ten-page research paper would have to be significantly narrowed. She finally settled upon an argument regarding legal ownership, based upon historical records.

RESEARCHING THE TOPIC

After you have chosen and narrowed your topic, you will collect as many books and articles on your topic as time and practicality will allow. Your library is likely to be your best resource; the Internet will probably prove second-best. Some basic instructions for library research are offered here, but for more extensive instructions, consult *The Oxford Guide to Library Research* by Thomas Mann. Remember: whether you are searching the library or the Internet, allot yourself more time than you think you need. Research takes time.

SEARCHING THE LIBRARY

FINDING BOOKS

To find books, use the library's computerized catalogue. First, you will probably search by **keyword**. Type in a word that will be contained in the title or the description of the book. For example, if you were writing a paper on classical Greek sculpture, you would type "Greek sculpture" as your keyword.

The computer would then generate a list of books on that topic. If there were too many choices, you would limit your search by use of another keyword, such as "classical." A search at the library of the University of Colorado at Denver yielded a list of sixty-two books using the words "Greek sculpture." The list was reduced to twelve when the search was limited by use of the additional word "classical."

FINDING PERIODICAL ARTICLES

Finding **periodical** articles can be a bit more involved than finding books. Periodicals are **magazines** written for general audiences, and **journals** are written for more specialized audiences. You might, for example, find an article on your topic in a magazine like *Newsweek* or in a journal like *Art History.* To find periodical articles, you could use **print indexes, electronic databases,** or **Internet** sources.

Print indexes: Sometimes the easiest way to obtain articles on your topic is through indexes in print. The best index in print for articles on art is the *Art Index.* This is a series of bound volumes, dating from 1932 to the current year, which lists articles about archaeology, architecture, art, film, and photography. Use the library's computer catalogue to obtain the call number, and then locate the *Art Index* on the shelves of your library. When you have found *Art Index,* you will see that the volumes are organized by year. Internally, each volume is organized alphabetically according to keywords. If, for example, you wanted to find the most recent articles on the Elgin Marbles (statuary from the Parthenon in Athens, which are now housed in the British Museum), you would open the most current volume and look under *E* for "Elgin Marbles." In the volume covering the period from November 1998 to October 1999, you would find the following list:

Elgin Marbles

Greater candor desirable. W. St. Clair. *Art Newspaper* v10 no. 84 p40 S 1998

Greek revival. Z. Leoudaki. col il por *ARTnews* v97 no8 p68S 1998

The Parthenon marbles custody case: did British restorers mutilate the famous sculptures? S. B. Brysac. col il *Archaeology* v52 no3 p74–7 My/Je 1999

Virtually visited marbles: Parthenon Galleries, British Museum, London. P. Lewis. col il *mus J* v98 no8 p21 Ag 1998

The key to abbreviations in the front of the volume translates the abbreviations. For example, the first entry, translated, tells you that you will find an article titled "Greater Candor Desirable," authored by W. St. Clair, in *Art Newspaper,* volume 10, number 84, page 40, of the September 1998 issue. If you would like to obtain that article, search your library's computerized catalogue for the periodical title *Art Newspaper.* The computer will tell you where to find the periodical: it may be collected on the shelves in a hard binding or on microfiche or microfilm. After you have located the periodical, you'll easily find the September 1998 issue. If your library does not subscribe

to *Art Newspaper,* you may be able to find out which libraries do subscribe and request that one of them send a copy of the article to you via interlibrary loan. If you wanted to broaden your search, you might look in the *Art Index* volumes for previous years, use other keywords, such as "Parthenon," or consult other indexes.

Other print indexes on art include *The Index of Twentieth Century Artists, Index to Nineteenth Century American Art Periodicals, Contemporary Art and Artists, Avery Index to Architectural Periodicals, World Architecture Index,* and *Twentieth Century Artists on Art.* An index to articles in more widely read magazines is the *Reader's Guide to Periodical Literature.* Consult your reference librarian for help in locating these indexes and periodicals.

Electronic databases: Another way to search for articles on your topic is through your library's electronic databases. Each database contains lists of books, articles, and/or other resources such as audio tapes and videocassettes. Some contain the full texts of the articles. Your library pays a subscription fee to these databases, and so you may have to be physically present in the library to conduct your search. Some college libraries, however, do give students and faculty an access code and password so that they can conduct the search from home.

Although it is not practical to instruct you here on all the possible avenues for researching your topic through computer databases, the following information should be enough to get you started.

First, select an electronic service that will search several or all of the library's databases for you. The University of Colorado at Denver, for example, subscribes to OCLC FirstSearch, which will search the following databases for articles written about art:

- ◆ *ArticleFirst:* An OCLC index of articles from nearly 12,500 journals
- ◆ *ContentsFirst:* An OCLC table of contents of nearly 12,500 journals
- ◆ *ECO* (Electronic Collections Online): An index of nearly 3,000 scholarly journals
- ◆ *NetFirst:* An OCLC database of Internet resources
- ◆ *PerAbs* (Periodical Abstracts): General topics and radio/TV transcripts
- ◆ *WilsonSelect:* Full-text articles in science, humanities, and business
- ◆ *WorldCat:* Books and other materials in libraries worldwide

To begin using OCLC FirstSearch, type a keyword beside "Search for" and select the type of search from the choices offered in the drop-down box. For example, if you wanted to write a research paper on the Elgin Marbles, you would type "Elgin Marbles" beside "Search for" and select "arts and humanities" from the drop-down box. You would learn that FirstSearch could give you a list of 150 items from *WorldCat,* 8 items from *WilsonSelect,* and 1 item from *ECO.* In an attempt to find more articles, you would again type "Elgin Marbles" beside "Search for" and select a "general" search, which would yield an additional thirty-one articles in *ArticleFirst* and thirty-seven articles in *PerAbs.* The lists would overlap to some degree; that is, sev-

eral of the articles would appear on more than one list. Still, there would be plenty of material from which to choose.

Next, peruse onscreen the articles that are available in full text online, make decisions about which ones you want copies of, and have the computer print those articles. The full texts of all articles listed in *WilsonSelect* are available online.

You might also search for databases by subject. When asked for a list of databases of information in the arts and humanities, the library computer at the University of Colorado at Denver offers a list of twenty-one databases, including *Arts & Humanities Search, Architectural Index, Repertoire international de la littérature de l'art (RILA), Art Abstracts, Bibliography of the History of Art,* and *Grove Dictionary of Art.*

Chances are good that you will want some of the articles that are not available in full text online. For example, one of the items on the Elgin Marbles listed in *ArticleFirst* shows that David Rudenstine wrote an article titled "Did Elgin Cheat at Marbles?" for *The Nation,* number 270, volume 21, in the year 2000, beginning on page 30. The article is four pages long. A search of the library's computer catalogue, under periodical title, for the call number of *The Nation,* yields information regarding the periodical, the volume, the issue, the page, and the article itself.

FINDING NEWSPAPER ARTICLES

If your topic has been written about in newspapers, you might expand your search to include newspaper articles. Like periodical articles, newspaper articles are indexed in both print indexes and electronic databases.

Print indexes: Use your keyword to find articles that have been printed in the *New York Times Index,* the *Los Angeles Times Index,* the (London) *Times Index,* the *Christian Science Monitor Index,* or any indexed local newspapers. The 1999 volume of the *New York Times Index,* for example, will tell you the title, issue, and page number of every article published in that newspaper that year. There is often an abstract of the article as well.

Electronic databases: You might first try an electronic service that will search several databases for you. Two such services are *InfoTrac* and *Northern Light.* Another useful index is the *National Newspaper Index.* After you have decided which articles you want, you may find that some of them are available in full text online. Others you will need to locate in the library either in hard copy or on microfiche or microfilm.

SEARCHING THE INTERNET

The Internet is another possible source of information on your topic, but you should realize from the start that the results of an Internet search are often unsatisfactory. One reason is that articles retrieved from the Internet are suspect. They may not have gone through the filtering processes of

editing, peer review, and library selection. Also, there are often far too many sources to manage. Certainly, some of the material might be useful, but sifting through it all could be impossible. The best matches, fortunately, appear at the top of the list. The author of the Elgin Marbles paper found that in a list of 1,321 Web sites, only the first 60 or 70 listings were relevant and far fewer were useful.

To begin an Internet search, simply type the name of the search engine you want to use in the frame at the top of your browser screen and press the "enter" key on your keyboard. Some popular search engines are *AltaVista, InfoSeek, Lycos, WebCrawler, Google,* and *Yahoo!.* Your computer will assume, if you enter the word "google," for example, that you mean "http:// www.google.com." After you have the home page of your search engine on your screen, you simply fill in the keyword in the search box and press "enter." The more words you enter, the narrower your search becomes, and the shorter the list of relevant Web sites becomes.

The ability to evaluate a Web site is useful. The suffix ".edu" in the Web site address, also known as the **URL** (uniform resource locator), denotes an educational organization, and these sources could be worthy of your attention. The suffix ".org" denotes an organization. Also look for Web sites that you recognize, such as news agencies. The eighth item in the list of 1,321 Web sites with information on the Elgin Marbles was the BBC (British Broadcasting Corporation) news agency. This is a reliable source that, when searched, offered even more information on the Elgin Marbles.

One particularly worthy Web site is the *Art History Research Centre.* This Web site contains links to newsgroups, library catalogues, bookstores, article indexes, art history departments at universities, galleries and museums, and more. It also contains a document titled "The Internet as a Research Medium for Art Historians," which contains much useful information on doing research on the Web. Another helpful Web site is Harcourt College Publishers' own Web site, www.harcourtcollege.com/arts/gardner.

TEMPLATES FOR PLANNING THE RESEARCH PAPER

Use the templates on the following pages to plan your research paper. Refer to Chapter One's section titled "The Process for Writing about Art" if you need guidance in filling in the blanks. Consult also Chapter Three for expository writing and Chapter Four for argumentative writing.

DESCRIPTIVE OR EXPOSITORY RESEARCH PAPER PLAN

1. My topic: _____

2. My research question: _____?

3. My thesis: _____

4. My proof question: _____?

5. My points of proof: (Fill in at least two blanks.)

 1. _____

 2. _____

 3. _____

 4. _____

 5. _____

DESCRIPTIVE OR EXPOSITORY RESEARCH PAPER OUTLINE

I. Introduction

 A. Introductory Remarks (Briefly): _____

 B. Thesis: _____

 C. List of Points of Proof: (Fill in at least two blanks.)

 1. _____

 2. _____

 3. _____

 4. _____

 5. _____

II. Body: (Develop each point of proof.)

(Copy your points of proof from C above; there should be at least two.)

 A. Point 1: _____

 B. Point 2: _____

 C. Point 3: _____

 D. Point 4: _____

 E. Point 5: _____

III. Conclusion _____

ARGUMENTATIVE RESEARCH PAPER PLAN

(Note: The number of counterpoints and constructive arguments is variable. The number of refutations should match the number of counterpoints.)

I. What My Opponent Believes (Counterthesis):_____
 A. Why my opponent believes it (Counterpoints): _____
 1._____
 2._____
 3._____
 4 _____
II. What I Believe (Thesis): _____
 A. Why I believe it (Constructive Arguments): _____
 1._____
 2._____
 3._____
 B. Why I think my opponent is wrong (Refutations):
 1._____
 2._____
 3._____

ARGUMENTATIVE RESEARCH PAPER OUTLINE

(Note: The number of counterpoints and constructive arguments is variable. The number of refutations should match the number of counterpoints.)

I. Introduction _____
 A. Introductory remarks _____
 B. Counterthesis _____
 1. Counterpoint 1 _____
 2. Counterpoint 2 _____
 C. Thesis_____
 1. Refutation 1 _____
 2. Refutation 2 _____
 3. Constructive Argument 1 _____
 4. Constructive Argument 2 _____
II. Body (Developed Refutations and Constructive Arguments) ____
 A. Refutation 1 _____
 B. Refutation 2 _____
 C. Constructive Argument 1 _____
 D. Constructive Argument 2 _____
III. Conclusion _____

WRITING THE RESEARCH PAPER

Having researched your topic, taken notes, and planned and outlined your paper, you are ready to begin writing the paper. As you write, keep in mind the following general advice on writing research papers:

◆ Incorporate the words of other authors who have written on the same or related topics.
◆ Synthesize sources of information to create a unique view of the topic.
◆ Give credit for borrowed words and ideas to their originators.
◆ Assume the voice of authority. You have read extensively and have assimilated much information on your topic. You are qualified to postulate a unique point of view.
◆ Do not let your sources speak for you.
◆ Use your sources to corroborate your own ideas, which you have written in your own words by means of your thesis and points of proof.

USING SOURCES

Paraphrasing versus Plagiarizing

Much of your research paper will consist of information gleaned from your sources and then paraphrased. To **paraphrase** is to relate your source's ideas, using your own words and style and giving your source credit for those ideas *in text*.

To **plagiarize** is to present someone else's words or ideas as your own. Plagiarism is not only a serious breach of ethics but also a crime, punishable at most colleges and universities by expulsion of the student who plagiarized. The most flagrant act of plagiarism is to submit an entire paper written by someone else as having been written by you. Many acts of plagiarism, however, are less flagrant and more the result of having committed one or more of the following mistakes:

◆ Copying the passage word for word without using quotation marks
◆ Merely substituting synonyms for the passage's original words
◆ Merely rearranging the sentence structure

Consider the following examples. The original passage has been copied from an article in the May 29, 2000, issue of *The Nation*, page 31, written by David Rudenstine.

Original Passage from Source

Indeed, as things turn out (and as somewhat surmised by Christopher Hitchens in his book *The Elgin Marbles*) the assumption shared by advocates on both sides of the debate—that the Ottomans gave Lord Elgin permission to remove the marbles—is no more than a grand illusion.

ILLEGITIMATE PARAPHRASE

> The supposition made by people on both sides of the argument—that Lord Elgin had permission from the Ottomans to remove the Parthenon sculptures—is illusory.

The preceding paraphrase matches the original far too closely. The writer has made some word substitutions, but the paraphrase is illegitimate. Both the sentence structure and the style have been lifted from the original passage. More perturbing, however, is that the writer has presented David Rudenstine's idea as his own.

LEGITIMATE PARAPHRASE

> According to David Rudenstine, author of an article titled "Did Elgin Cheat at Marbles?" there is little basis for the belief that Lord Elgin was authorized to take any sculptures from the walls of the Parthenon (31).

INCORPORATING QUOTATIONS INTO YOUR PAPER

Many writers make the mistake of overquoting their sources. You should quote only in certain circumstances: (1) when the source's phrasing is so apt, so well written, that you could not possibly say it better yourself, or (2) when it is important that the reader see the original words of the source.

If quoting is warranted, you must *weave* the quotations into your paper, not stick them in awkwardly. Each quotation should be accompanied by an acknowledgment phrase that tells who is being quoted and some statement about the relevance of the quotation. For example:

ACKNOWLEDGED QUOTATION: CORRECT

> Elgin probably exceeded the permission granted by the Turkish government. William St. Clair, Elgin's biographer, explains the subtleness of Elgin's trespasses: "There is a great difference, as many were later to say, between permission to excavate and remove and permission to remove and excavate" (90–91).

The preceding quotation is introduced by an acknowledgment phrase that tells who is being quoted and indicates the pertinence of the quotation. It is a mistake to present an unacknowledged quotation like the one that follows:

UNACKNOWLEDGED QUOTATION: INCORRECT

> Elgin probably exceeded the permission granted by the Turkish government. "There is a great difference, as many were later to say, between permission to excavate and remove and permission to remove and excavate" (St. Clair 90–91).

The reader does not know who is being quoted in the preceding passage, only that the quotation was taken from page 91 of St. Clair's book. Besides, the quotation seems stuck in, not woven into the paper. Always remember

that simply tacking a source citation onto the end of an unacknowledged quotation is not sufficient.

The first time you quote a person, give that person's first name and credentials as well. In the preceding acknowledgment phrase, William St. Clair is identified as Elgin's biographer. Afterward, you may simply refer to this person by last name as in "St. Clair."

CITING SOURCES

There are several systems for citing sources, but the ones currently in favor for arts and humanities papers are any of several numbered notes systems and the MLA (Modern Language Association) parenthetical notes system. In the past, art historians have preferred the numbered notes system. Since it is not practical for this textbook to show examples of every type of numbered notes system, we offer the following suggestions. If your professor requires you to use the Chicago style, consult *The Chicago Manual of Style* by John Grossman, 14th edition. If you professor requires the Turabian style, consult *A Manual for Writers of Term Papers, Theses, and Dissertations* by Kate Turabian, 6th edition. If you are required to use the *Art Bulletin* style, consult the June 1990 issue of *Art Bulletin*, "Notes for Contributors."

However, most humanities and many art history professors now accept the MLA parenthetical notes system, which cites sources by means of parenthetical notes instead of superscripted numbers. MLA offers its own numbered notes system as well. Both MLA systems are exemplified in this chapter. For information on these systems, consult *MLA Handbook for Writers of Research Papers*, fifth edition by Joseph Gibaldi.

NUMBERED NOTES SYSTEM

The system of using numbered notes and a bibliography is commonly used in art history research papers. Passages that require the citation of a source end, typically, with a raised (superscripted) number. The following passage from the sample research paper in this chapter, "Ben Shahn's Use of Photography in His Paintings," uses this system.

> On May 21, 1853, he wrote in his journal, "Let a man of genius make use of the daguerreotype as it should be used, and he will raise himself to a height that we do not know."[1] Such difference of opinion continued into the twentieth century, wherein we find Ben Shahn echoing Delacroix's sentiments. In defense of the photographic aid, Shahn once said, "Photographs give those details of forms that you think you'll remember but don't—details that I like to put in my paintings."[2]

[1]Van Deren Coke, *The Painter and the Photograph* (Albuquerque: U of New Mexico P, 1972) 9.

[2]Coke 107.

As you can see, the numbers occur consecutively throughout the text, marking the passages that use sources. The sources are then documented in either **footnotes** at the bottom of the page or **endnotes** collected together on a separate page at the end of the text. The paper on Ben Shahn demonstrates the endnote option. If you are required to use footnotes rather than endnotes, you can see how footnotes would appear at the bottom of this page.

Footnotes are separated from the text by a line that is made by pressing the underline key on your computer keyboard twenty times, beginning at the left-hand margin. The footnotes are then arranged under the line in numerical order.

Notes give detailed information about the passages they designate. They may be **reference notes,** which give detailed publication information about the source, or **content notes,** which comment on the text. You should cite sources for (1) all quotations, (2) any facts that are not widely available, and (3) any paraphrased or borrowed ideas.

The standard reference note consists of the following: author's full name, the title of the work, the facts of publication, and the page number from which the information was borrowed. Titles of books, magazines, journals, newspapers, and works of art should be either underlined or italicized. Titles of shorter works—articles within journals, for example—should be enclosed in quotation marks.

FIRST, FULL REFERENCE

1. Reference to a book with one author
 [1]Van Deren Coke, *The Painter and the Photograph* (Albuquerque: U of New Mexico P, 1972) 9.

2. Reference to an article in a journal
 [3]Jean Charlot, "Ben Shahn," *Hound and Horn* 3 (1933): 633.

3. Reference to an article in a general interest magazine
 [6]Malcolm Jones, "An American Eye," *Newsweek* 31 Jan. 2000: 62.

4. Article in a newspaper
 [13]John Canaday, "This Way to the Big Erotic Art Show," *New York Times* 9 Oct. 1966: II, 27.

5. Reference to an essay in an anthology
 [23]Aldous Huxley, "Variations on El Greco," *Writers on Artists,* ed. Daniel Halpern (San Francisco: North Point, 1988) 59.

6. Work for which author is unknown
 [29]"Sacco-Vanzetti Series," *Art Digest* 6 (1932): 31.

7. Work that has been translated
 [20]Italo Calvino, "The Birds of Paolo Uccello," trans. Patrick Creagh, *Antaeus* 54 (Spring 1985): 26–27.

8. Review of an art exhibition
 [13]Helen Dudar, "Time Stands Still in the Harmonious World of Vermeer," rev. of Vermeer exhibition, *Smithsonian* October 1995: 110+.

9. Article that has been reproduced electronically
 [41]Donald O. Henry, "Prehistoric Cultural Ecology in Southern Jordan," *Science* 15 July 1994. 18 March 2001. <http://web1.infotrac.galegroup.com/itw/infomark /612/651/28506909w3>.

10. Article originally published in an electronic publication
 [44]"Ben Shahn," *Ben Shahn Cosmopolis,* July 2000. 7 Jan. 2001. <http://www
 .cosmopolis.ch/english/cosmo8/benshahn.htm>

SECOND, OR SUBSEQUENT, REFERENCES

Shorten the reference to works previously referred to. If you are using more than one work by the same author, indicate by the first word or two of the title which work is being referenced.
 [6]Hess.
 [10]Charlot 634.
 [18]Rosenblum, *Transformations* 65.

BIBLIOGRAPHY

Last comes the **bibliography,** an alphabetical listing of the sources you consulted in writing your research paper. Refer to page 165 to see a sample bibliography. Notice the following characteristics of the bibliography:

◆ The page is double-spaced throughout.
◆ The first line of each entry begins at the left-hand margin. Subsequent lines of an entry are indented a half-inch.
◆ The bibliographical entries are arranged alphabetically, according to the last name of the author. If no author is given, alphabetize according to the first word of the title of the work. If the first word of the title is one of the articles *a, an,* or *the* use the second word of the title to determine the work's place in the alphabetical order.
◆ The bibliography may contain entries for works cited in the paper as well as for those consulted but not cited.
◆ Titles of books, journals, magazines, and works of art may be either underlined or italicized, but not both. Titles of articles in newspapers, journals, and magazines appear inside quotation marks.
◆ Cities are not accompanied by states unless the city is obscure or multiple states contain cities with that name.
◆ Names of publishers are shortened whenever possible to one word.
◆ "UP" means University Press.
◆ The months, except for May, June, and July, are abbreviated.

Your instructor may request that before you submit your paper you submit a **working bibliography.** This is a list of the sources you intend to use in your paper, although your instructor will understand that changes often occur during the course of writing the paper.

You might also submit an **annotated bibliography.** The format is the same as that of any bibliography, except for the addition of a brief description of each work's usefulness. For example:

 Wolff, Theodore F., and George Geahigan. *Art Criticism and Education.* Urbana:
 U of Illinois P, 1997.
 It is one of the most clearly written overviews of the various types of art
 criticism.

A SAMPLE RESEARCH PAPER

The following research paper demonstrates the numbered notes system. The paper's mode of discourse is descriptive.

7-2 UPI, *Bartolomeo Vanzetti and Nicola Sacco in the Prisoner's Dock*, 1921. Photograph.

7-3 Ben Shahn, *Bartolomeo Vanzetti and Nicola Sacco*, 1931-1932. Tempera on paper, 10 1/2″ × 14 1/2″. Museum of Modern Art (gift of Mrs. John D. Rockefeller, Jr.).

Scaliese 1

Peter Scaliese

Art Topics: Photography 432

Professor Pearce

8 May 1986

Ben Shahn's Use of Photography in His Paintings

The value of the photograph as an aid to the
painter has been a matter of controversy since the
first half of the nineteenth century. Some felt that
it posed a great danger to painting and that in time
it would take the place of painting. Sympathizers
with this viewpoint, such as Charles Baudelaire,
also feared that referring to photographs could ham-
per a painter's creativity. Others lauded photogra-
phy and viewed it as a valuable tool to assist the
artist. Eugene Delacroix, for example, used both the
paper print and the daguerreotype in his own work.
On May 21, 1853, he wrote in his journal, "Let a man
of genius make use of the daguerreotype as it should
be used, and he will raise himself to a height that
we do not know."[1] Such difference of opinion contin-
ued into the twentieth century, wherein we find Ben
Shahn echoing Delacroix's sentiments. In defense of
the photographic aid, Shahn once said, "Photographs
give those details of forms that you think you'll
remember but don't--details that I like to put in my
paintings."[2] This statement is not surprising,
considering Ben Shahn's pragmatic approach to art.
Anything that would help him to achieve the desired

Scaliese 2

final effect of a painting, he would use, photogra- *Thesis*

phy included. Photography aided Shahn's use of line, *Points of proof*

his composition, and his content.

"Line" was an important component of Shahn's *First point of proof*

artistic vocabulary, perhaps as a result of his

childhood apprenticeship to a lithographer. Critic

Jean Charlot proclaimed Shahn's lines "as keen as

the sharpest silver point, which would superimpose

its own version of the subject, sometimes in agree-

ment with the mass modeling, but more often unbind-

ing itself from it and creating a version of its

own."[3] Critic Thomas Hess found Shahn's lines to be

reminiscent of Klee's in their ability to "describe

bulky forms, but still suggest nuances of literary

content."[4] The use of the camera reinforced Shahn's

natural proclivities in style. The camera operates

with a single eye, thereby seeing in a relatively

flat pattern. Thus, line stands out as one of the

most evident elements of a photograph. These linear

patterns and strengths would be more obvious to

Shahn by looking at photographs than by simply using

the naked eye for observation.

Shahn also used photographs to arrive at a pleas-

ing composition. Whenever possible, he preferred to *Second point*

use what he called "hybrid vision,"[5] which consisted

of seeing partly through one's eyes and partly

through the lens of the camera. In one of his most

well-known and best-received paintings, *Nocturne,*

Shahn combined elements from many different photo-
graphs. In this work are presented two folk singers
seated on a park bench, soulfully singing at each
other. For a period of time, Roosevelt, New Jersey,
where Shahn resided, was a popular gathering place
for folk singers. To define the content of *Nocturne,*
Shahn drew from old photographs, sketches, and his
own memories. Some of the photographs were of
singers in the midst of a performance, the profile
of a friend silhouetted against a lemon plant, and
the lithe trees growing around his studio.

After Shahn chose and arranged the selected ele-
ments into a desired composition, he still experi-
enced certain problems with the painting. He was
unable to find what he termed the "hook" of the
painting, which was that "with which the artist can
pull the picture through."[6] It developed that the
guitar player's right arm was the "hook" of *Noc-
turne.* It was readjusted many times, originally
appearing as it did in the red filter photograph,
almost directly under the guitarist's chin. It went
through various positional changes and finally ended
up in a central position. This type of continual
rearrangement of an element until it was in the per-
fect spot of presentation was a lifetime practice of
Shahn, aided by the use of photography.

Content was one of the most important considera-
tions to Shahn in his work. He remarked that "form

Scaliese 4

takes its cue from content, becomes varied, origi-
nal, interesting according to the demands made upon
it by content."[7] This attention to content may seem
anomalous because by the mid-fifties, "content ...
had become almost universally ostracized from paint-
ing, sculpture, and even poetry," according to one
of Shahn's biographers, Bernarda Bryson Shahn.[8] But
Shahn considered communication to be a chief aim of
art, and he found that through content paintings,
his ideas were expressible.

The camera proved to be an invaluable aid to him
in his content paintings. Often he juxtaposed ele-
ments from one photograph onto elements from another,
thereby producing an entirely new and different
scene. Another advantage offered by the photograph
to Shahn was that it enabled him to capture those
strangely accidental, transient, and cynical moments
in which he so delighted. Later, in making a paint-
ing of the subject, he would have the exact expres-
sion, scene, or moment before him. He felt that
"what the photographer can do that the painter can't
is to arrest that split second of action in a guy
stepping into a bus, or eating at a lunch counter."[9]
It was the commonplace, the ordinary, presented in
an extraordinary way that made the image so exciting
to him. As far as Shahn and the camera were con-
cerned, "a man, however intellectually eminent,
[would] exist mainly through the bunch of folds and

Third point

Scaliese 5

creases which are his clothes, his buttons, his
shoe-laces, his grotesque shadow on a brick wall,
the baroque mouldings on the arm of his chair."[10] A
minute detail could be enormously stimulating. Shahn
especially liked the little details and contrasts
that he felt make people human. The camera enabled
him to focus his attention on the individual. With
the camera, Shahn could recall the exact setting in
which these people existed and extract the elements
that most reflected the character and feelings of
those people at that very moment.

One of the most important reasons for the cre-
ation of many of Ben Shahn's works is as an instru-
ment of social change. A famous series of this type
of didactic painting is the Nicola Sacco/Bartolomeo
Vanzetti works. Sacco and Vanzetti had been given
the death penalty for murder, but public opinion was
that they were being persecuted because they were
immigrants and outspoken anarchists. Shahn realized
he had the power to comment upon the situation in a
way that would reach many people. Over a period of
seven months, Shahn produced twenty-three small
gouache paintings and two large panels. One of the
first steps Shahn undertook in preparing to paint
the series was to scrutinize the many press photo-
graphs that had been taken during the trial. One of
his paintings resulted from a photograph of 1921,

which shows Sacco and Vanzetti seated side-by-side
in the prisoner's dock, handcuffed to each other.
Compositionally, Shahn included many of the same
elements that appear in the photograph. A few alter-
ations are apparent, however. He has moved the ver-
tical moldings behind Vanzetti's head in the photo-
graph to the left of his head, creating a more
interesting pattern. In the same vein, he brought
what looks like a window, which is next to Sacco's
head in the photograph, over to behind his head,
thus setting up a system of superpositions, thereby
implying distance in this otherwise flat presenta-
tion. Instead of merely portraying a look of deep
concern, which is immediately apparent on their
faces in the photograph, Shahn shows the tragic
intensity of their faces. By placing Vanzetti's eyes
in a slightly uneven position, he has expressed
their fear and mournfulness. Although the geometric
rigidity of the composition shows Shahn's use of
abstract design, he is sacrificing none of the real-
ism and content of the story itself. The slumped
shoulder, the indented cheek, the square-set chin of
Sacco, the drooping mustache of Vanzetti all add to
the feeling of the hopelessness of their situation.

The somber colors used in this painting--black,
grays, brown--and the only bright color--the red of
the cushions upon which they sit--depict their anger

Scaliese 7

and courage. By using the basic gestures, setting, and various details in the photograph, Shahn has retained the visual energy of the figures. A certain sense of authenticity is preserved as well by his close adherence to the basic presentation in the photograph.

These are not the only examples of Shahn's use of the photograph in his paintings. They do, however, demonstrate the congenial manner in which these two mediums can work together to produce great works of art.

Notes

[1] Van Deren Coke, *The Painter and the Photograph* (Albuquerque: U of New Mexico P, 1972) 9.

[2] Coke 107.

[3] Jean Charlot, "Ben Shahn," *Hound and Horn* 3 (1933): 633.

[4] Thomas B. Hess, "Ben Shahn Paints a Picture," *ARTnews* May, 1949: 22.

[5] Coke 109.

[6] Hess 21.

[7] "Artist's Point of View," *Magazine of Art* Nov. 1949: 269.

[8] Bernarda Bryson Shahn, *Ben Shahn* (New York: Abrams, 1972) 46.

[9] John D. Morse, "Ben Shahn: An Interview," *Magazine of Art* Apr. 1944: 141.

[10] Charlot 634.

Scaliese 8

Bibliography

Alper, M. Victor. "American Mythologies in Painting:
City Life and Social Idealism." *Arts* Dec. 1971:
31-34.

"Artist's Point of View." *Magazine of Art* Nov. 1949:
266-69.

"Ben Shahn." *Art Digest* 15 Nov. 1940: 8.

Charlot, Jean. "Ben Shahn." *Hound and Horn* 3 (1933):
633.

Coke, Van Deren. *The Painter and the Photograph.*
Albuquerque: U of New Mexico P, 1972.

Hess, Thomas B. "Ben Shahn Paints a Picture."*ARTnews*
May 1949: 20-22+.

Lane, James W. "New Pictures by Shahn."*ARTnews* 18
May 1940: 11.

Morse, John D. "Ben Shahn: An Interview." *Magazine
of Art* Apr. 1944: 136-141.

"Sacco-Vanzetti Series." *Art Digest* 15 Apr. 1932: 31.

Shahn, Ben. "Artist and the Politician."*ARTnews*
Sept. 1953: 34-35+.

Shahn, Ben. "The Education of an Artist." *American
Artist* May 1971: 5.

Shahn, Bernarda B. *Ben Shahn.* New York: Abrams,
1972.

Soby, James. *Ben Shahn: His Paintings.* New York:
Braziller, 1963.

Whiting, P. "Ben Shahn." *American Magazine of Art*
Aug. 1935: 492-96.

MLA (MODERN LANGUAGE ASSOCIATION) DOCUMENTATION SYSTEM

The MLA system uses in-text parenthetical notes, or source citations, plus a list of works cited. The following condensed instructions may be comprehensive enough for your paper on art, but if they are not, refer to the *MLA Handbook for Writers of Research Papers,* fifth edition, by Joseph Gibaldi.

MODELS FOR PARENTHETICAL SOURCE CITATIONS

The source citation should point the reader to the first word on the left-hand margin of the works cited list. You should cite (1) all quotations, (2) any facts that are not widely available, and (3) any paraphrased or borrowed ideas.

1. Standard source citation (Name the author and page number.)

 When Egypt had been restored to the Turks, Elgin was honored in celebrations and given diamonds, horses, and a jewel from the Sultan's own turban (St. Clair 82).

2. Author of the quotation or borrowed idea has been named in the passage. (Do not name the author again in parentheses.)

 The retentionists' case is probably best articulated by Michael Daley, an artist and director of ArtWatch UK. Daley claims, "The marbles were not taken from the capital of today's Greece—the state was not formed until 1829—but from a small town that had for three and a half centuries been part of the Ottoman Empire" (52).

3. If the source is an anonymous work or if the author is unidentified, use the first word or two from the title of the source plus the appropriate page numbers. If the source is an article, enclose the shortened title in quotations marks; if the source is a book, movie, or television show, underline or italicize (not both) the shortened title.

 Prime Minister Tony Blair has no plans to return the Elgin Marbles to Greece ("Britain").

4. One source is quoted in another.

 "None," Hunt replied (qtd. in Hitchens 67).

5. The works cited page lists more than one work by the same author.

 The 1937 British "cleaning" of the Elgin Marbles resulted in some surface damage (Daley, "Beware" 57).

6. Use a semicolon to separate multiple references for the same assertion.

 Lord Elgin explained to Parliament in hearings held in 1816 that his motive in seeking permission to carry away the sculptures was to save them from the destruction of war and vandalism as well as to enhance the arts in England (Hitchens 44; 47).

7. A work with two or three authors (List the names in the same order that they are listed on the title page of the work.)

 (Veit, Gould, and Clifford 252).

8. A work with more than three authors

 (Hodges et al. 67).

9. Two authors with the same last name (Include the authors' first names.)

 (Brad Eliot 313)
 (T. S. Eliot 25)

10. A multivolume work (The volume number precedes the page number[s].)

 (Gray 2:98).

11. A reference to a work as a whole (No page numbers are listed.)

 (Gombrich).

12. A reference to discontinuous pages

 (Alberge 1; 10).

13. An interview, an electronic publication, or other source without pages

 (Daley)

SPECIAL PUNCTUATION CONSIDERATIONS WHEN CITING SOURCES

In general, you should treat the source citation as part of the sentence.

1. A sentence ending in a period: the period follows the note.

 The military governor, said St. Clair, "received bribes equivalent to 35 times his official annual salary in return for turning his eyes aside" (qtd. in Alberge).

2. A quotation ending in a question mark or exclamation mark: the end mark should stay as set in the original, and a period should follow the note.

 Benjamin Haydon reacted to Payne Knight's attempts to discredit the authenticity of the marbles: "These are the productions which Mr. Payne Knight says may be original! May be!" (qtd. in St. Clair 257).

3. Indented quotation: The note should follow the final period.

 A letter from Lusieri to Elgin downplays the damage done to the Parthenon in removing a metope:

 > I have, my Lord, the pleasure of announcing to you the possession of the 8th metope, that one where there is the Centaur carrying off the woman. This piece has caused much trouble in all respects, and I have even been obliged to be a little barbarous. (Qtd. in Hitchens 30)

THE WORKS CITED PAGE

A sample works cited page is on page 182. This is an alphabetical list of the sources you have cited in your paper. As you study the page, please notice the following:

◆ The works cited page should be double-spaced, and the first line of each entry is at the left-hand margin with subsequent lines of each entry being indented.
◆ Titles of books, journals, and plays may be either underlined or italicized, but not both.
◆ Cities are not accompanied by states unless a city is obscure or multiple states contain cities with that name.
◆ Names of publishers are shortened to one word.
◆ "UP" means "University Press."
◆ Disregard the articles—*a, an, the*—when alphabetizing works cited; use the second word for alphabetical placement, but do not rearrange the words in the entry.
◆ The months, except for May, June, and July, are abbreviated.

A SAMPLE RESEARCH PAPER

The following research paper demonstrates the MLA system of documentation. The paper's mode of discourse is argumentative.

7-4 *Three Goddesses,* from the east pediment of the Parthenon, c. 438–432 B.C.E. Marble, approx. 4′5″. British Museum, London (Elgin Marbles collection).

O'Connor 1

Emily O'Connor

Professor Esquivel

Art History 4030

10 July 2000

The Elgin Marbles: Saved or Stolen?

If you are planning a visit to London's British
Museum in the near future, walk, don't run, to the
Duveen Gallery, which houses the Elgin Marbles,
because these art treasures may not be there much
longer. The Elgin Marbles were collected, or looted,
depending upon your point of view, during the first
decade of the nineteenth century.

Greece was occupied by the Turkish Ottoman Empire
while Great Britain, the Turks, Egypt, and France,
among others, were engaged in the Napoleonic wars.
During the confusion, the British ambassador to
Turkey, Thomas Bruce, also known as the Seventh Earl
of Elgin, seized the opportunity to walk away with
several sculptures that had been attached to or
housed in the Parthenon and other buildings atop the
Acropolis in Athens. These Parthenon sculptures com-
prise the nucleus of a wider collection of antiqui-
ties called the Elgin Marbles. The Parthenon sculp-
tures now reside in the British Museum, but Greece
wants them back. Naturally, the British Museum does
not want to give them up.

The grounds for debate include questions about
Lord Elgin's motives for acquiring the sculptures:

Background information

O'Connor 2

Did he take them for their own good and for the good
of the arts in England, or were his motives greed
and self-aggrandizement? The sculptures' safekeeping
is also under discussion: Does the fact that the
British Museum has protected the marbles for 175
years give the museum permanent entitlement to the
marbles? The consequences of returning this particu-
lar exhibit to its original home are also being
examined: Will the return of the marbles lead to the
dismantling of the entire British Museum? The cen-
tral question, however, is "Under what authority did
the British Museum first acquire the Elgin Marbles?"
If the marbles were legitimately acquired, then the
museum need not feel compelled to give them back to
Greece, no matter how much public pressure mounts,
no matter what Lord Elgin's motives, no matter which
country has done or would do the better job of pre-
serving the sculptures, and no matter what the con-
sequences to the British Museum's remaining collec-
tion of antiquities.

Counterpoint 1 The British Museum's case for retaining the
sculptures is based on the fact that Elgin obtained
permission from the Turkish government, which had
been in control of the territory for 350 years, not
Counterpoint 2 from some upstart, transitory government. Moreover,
the marbles were given to the museum by an act of
Parliament only after an 1816 investigation by the

O'Connor 3

House of Commons Select Committee into the circum-
stances under which the marbles had been acquired.

The case for a legal right to the marbles, how- *Transition*
ever, contains numerous flaws, nearly all of which
can be ascertained from the historical records them-
selves. The British Museum should return the Elgin
Marbles to Greece because the sculptures were never *Thesis*
rightfully Elgin's, nor the British government's,
nor the British Museum's. Elgin exceeded the author-
ity he had been granted by the Turkish government, *Refutation 1*
that is, if authority was ever granted at all.
Elgin's actions also exceeded the authority granted
him by the British government as an ambassador and
violated British policies against plundering. And *Refutation 2*
Parliament's appropriation of the sculptures was an
act of expediency, not justice.

The retentionists' case is probably best articu-
lated by Michael Daley, an artist and director of
ArtWatch UK. Daley claims, "The marbles were not *Counterpoint*
taken from the capital of today's Greece—the state *1 fully*
explained
was not formed until 1829—but from a small town that
had for three and a half centuries been part of the
Ottoman Empire" (51). In 1801, the Porte (the gov-
ernment of the Ottoman Empire) in Constantinople
allegedly granted Lord Elgin and his team of artists
permission by means of a document called a "firman"
to carry off the sculptures. The firman granted
sweeping rights to Elgin's men and required that

O'Connor 4

neither the disdar (the military commandant of the
Acropolis) nor the voivode (civil governor) should
interfere:

> [...] use your diligence to act conformably to
> the instances of the said Ambassador, as long as
> the said five Artists dwelling at Athens shall
> be employed in [...] excavating, when they find
> it necessary, the foundations, in search of
> inscriptions among the rubbish; that they be not
> molested by the said Disdar, nor by any other
> persons ... and that no one meddle with their
> scaffolding or implements, nor hinder them from
> taking away any pieces of stone with inscrip-
> tions or figures [...]. (Qtd. in Cook 56)

Lord Elgin explained to Parliament in hearings
held in 1816 that his motive in seeking permission
to carry away the sculptures was to save them from
the destruction of war and vandalism as well as to
enhance the arts in England (Hitchens 47; 44). Thus
it seems Lord Elgin employed not only a legal but
also a moral right to take the sculptures to
England, where they would be properly cared for.

Elgin, however, probably exceeded the intentions
of the firman granted by the Porte. The firman per-
mitted Elgin's men to excavate around the Parthenon
and remove any interesting pieces of marble that
resulted from the excavation. That the firman

Refutation 1

allowed Elgin's men to remove the sculptures from the buildings themselves is doubtful. There is, as William St. Clair says in his book, *Lord Elgin and the Marbles,*

> a great difference [...] between permission to
> excavate and remove and permission to remove
> and excavate. The first implies that one can
> take away anything of interest that is dug up:
> the second lets one take away anything of
> interest from whatever place one likes. The
> interesting thing about the firman, if one
> reads the last part closely, is its clear indi-
> cation that the Turks, if they considered the
> point at all, only intended to grant permission
> to excavate and remove. After all the tedious
> detail about things which the artists are to be
> permitted to do the permission to remove is
> very much an afterthought. (90-91)

Neither Lord nor Lady Elgin interpreted the fir-
man as permitting such liberties as Elgin's men
ultimately took. A letter from Lady Elgin to her
parents summarized the firman as granting permission
to "copy and model everything in [the citadel], to
erect scaffolds all round the Temple, to dig and
discover all the ancient foundations, and to bring
away any marbles that may be deemed curious by their
having inscriptions on them [...]" (91). And a

letter from Lord Elgin to his artist-in-charge,
Giovanni Battista Lusieri, said that they would "be
able to take away exact models of the little orna-
ments or detached pieces if any are found which
would be interesting for the Arts [...] and whether
it be in painting or a model, exact representations
of such things would be much to be desired" (92).
Nowhere is there an indication that Elgin's men were
being given permission to saw off the sculptures
from the buildings themselves or to destroy adjoin-
ing masonry in so doing. That idea occurred later,
as Elgin's ambition grew.

The very existence of the firman is also at
issue. Under a cloud of suspicion and scandal, accu-
sations of spoliation and political opportunism,
Elgin was requested to present the firman to the
House of Commons Select Committee in 1816, to which
he explained that the original document had been
given to Ottoman officials in Athens in 1801. Yet,
according to David Rudenstine, a fellow in Princeton
University's law and public affairs program, no
researcher, including Rudenstine himself, has been
able to uncover the original document, despite the
wealth of other documents from the period contained
in the Ottoman archives (30).

Elgin said that he could not produce any document
that verified his authority to remove the sculp-

tures. And then, suspiciously, upon the realization that some documentation was needed, the Reverend Phillip Hunt, Elgin's embassy chaplain, presented the committee with what he said was an English translation of an Italian translation of the original Ottoman document (Rudenstine 32). Parliament credulously accepted the document as authentic.

Lord Elgin not only may have exceeded Turkish authority to collect his art, but also he may have exceeded British authority. Collecting art was not part of the job of being an ambassador. Lord Elgin's project, initially, was simply to hire a few artists to make drawings and casts of the Acropolis sculptures. But the British government never lent its support to the project, refusing to pay the salaries of artists, writing,

> [...] I do not think that we could (at least from any funds at the disposal of the Foreign Department) defray *with any propriety* the expense of that encouragement which a person, qualified as you mention, would be entitled to expect for such an undertaking. (Qtd. in St. Clair 8) [italics added]

In other words, it simply was not proper for the British government to fund art collecting on the part of ambassadors. If Elgin wanted to collect art, he would have to do so at his own expense. Elgin,

O'Connor 8

therefore, hired an artist, Giovanni Battista Lusieri, a well-known Italian landscape painter, for £200 per year, and it was their understanding that all of Lusieri's work was to be the sole property of Lord Elgin (St. Clair 29).

Even though Elgin wasn't authorized by the British government to collect art, he used his position as ambassador in the acquisitions. First, he took advantage of a fortuitous turn of events in the Napoleonic wars. Napoleon had overcome Italy, Austria, Spain, Russia, and Egypt. Only the British and the Turks had successfully resisted his aggression. Napoleon attempted to reinforce his army in Egypt, but the British and the Turks joined forces and won back Egypt for the Ottoman Empire. Lord Elgin was a very popular man in Constantinople, having supplied food, horses, and various provisions to the British forces collecting at Malta. When Egypt had been restored to the Turks, Elgin was honored in celebrations and given diamonds, horses, and a jewel from the sultan's own turban (St. Clair 82).

Elgin's embassy chaplain, Reverend Hunt, also blackmailed the disdar into cooperating. Hunt complained to the voivode that the disdar had treated Elgin's men with disrespect and had demanded money from them. The disdar himself was ill, and so the voivode sent for his son, who had hopes of succeeding his father to the office of disdar. The voivode

O'Connor 9

threatened to make the young man a slave as punish-
ment for his father's offenses. Hunt interceded,
obtained a pardon for the young man, and thus had
the new disdar in his pocket. Hunt wrote to Elgin,
"He [the young disdar] is now submissive to all our
views in hopes of your speaking favourably for him
to the Porte" (qtd. in St. Clair 94).

New evidence that Elgin resorted to bribery has
recently surfaced. There had been rumors of gifts
and bribery ever since Elgin delivered the first
shipment of marble sculptures from Greece. But
according to William St. Clair, Lord Elgin's most
authoritative biographer, a thorough study of
Elgin's financial accounts had been largely ignored
because they are "in all kinds of languages" and in
the Ottoman currency, piastres. On November 27,
1999, St. Clair revealed that a recent study of
Elgin's archives proves that Elgin bribed Turkish
officials. The military governor, said St. Clair,
"received bribes equivalent to 35 times his official
annual salary in return for turning his eyes aside."
St. Clair also said, "This transaction wasn't a rit-
ual exchange of gifts between nations, but a commer-
cial concession to dig up antiquities" (qtd. in
Alberge). St. Clair further asserted that Elgin paid
roughly £4,000 in bribes altogether, and this was at
a time when the entire costs of the British Museum
were £3,000 per year (qtd. in Alberge).

Clearly, Elgin had violated British policy, if not
law, in using his position to collect Greek antiqui-
ties. There were no actual international laws regard-
ing plundering until the Hague Convention of 1954
(Stamatoudi). But the Hague Convention merely
reflects the sentiments against spoliation that
already existed. Such sentiments certainly existed
during Lord Elgin's time. If such sentiments had not
existed, Elgin would not have been compelled to
defend himself against charges of receiving gifts
improperly and of bribing Turkish officials:

Refutation 2

> Insinuations have, I'm told, been thrown out,
> tending to create an impression as if I had
> obtained a considerable share of these marbles
> in presents from the Porte and without expense
> . . . and that during my Embassy I received pres-
> ents beyond the usual practice in other European
> courts, and out of proportion with the various
> persons concerned in the operation for the
> recovery of Egypt. I had no advantage from the
> Turkish government beyond the Firman given
> equally to other English travellers. (Qtd. in
> Hitchens 52)

If British policy against plundering hadn't exist-
ed, the House Select Committee wouldn't have asked
the Reverend Hunt whether there was "any opposition
shown by any class of the natives" (qtd. in Hitchens
67) as he carried away their treasures. "None," Hunt

replied (qtd. in Hitchens 67). Hunt's reply is con-
tradicted, however, by a letter from Lusieri to
Elgin dated January 11, 1802, which says:

> The details of these various little monuments
> are masterpieces. Without a special firman it
> is impossible to take away the last (the Pan-
> droseion). The Turks and the Greeks are
> extremely attached to it, and there were mur-
> murs when Mr. Hunt asked for it. (Qtd. in
> Hitchens 67)

Perhaps "murmurs" were not perceived by Hunt and
Lusieri as true opposition to their sawing away at
the ancient temples, but then Lusieri was not
inclined anyway to take any Greek opposition seri-
ously. In an undated letter to Elgin, Lusieri made
his attitude toward the natives clear: "I intend
from henceforth to have nothing to do with the
Greeks. I don't need them. I talk the language suf-
ficiently, and shall begin directly to learn Turk-
ish, to dispense with them (qtd. in Hitchens 48).

If British policy against plundering had not
existed, Mr. Hugh Hammersley of the House of Commons
would not have condemned the manner in which the
Parthenon sculptures had been obtained:

> That this Committee having taken into considera-
> tion the manner in which the Earl of Elgin
> became possessed of certain ancient sculptured

O'Connor 12

marbles from Athens, laments that this Ambas-
sador did not keep in remembrance that the high
and dignified station of representing his sover-
eign should have made him forbear from availing
himself of that character in order to obtain
valuable possessions belonging to the government
to which he was accredited; and that such for-
bearance was peculiarly necessary at a moment
when that government was expressing high obliga-
tions to Great Britain. (Qtd. in Hitchens 63)

In other words, Hammersley publicly lamented that
Lord Elgin had availed himself of the marbles at a
time when the Ottoman Empire was so grateful to
Great Britain that Elgin was in a position to
extract whatever tokens of gratitude he desired.
Hammersley went on to recommend that Parliament
appropriate £25,000 to buy the collection "in order
to recover and keep it together for that government
from which it has been improperly taken" (qtd. in
Hitchens 63).

Parliament simply failed to investigate the situ-
ation diligently, perhaps because it needed to pro-
tect itself from the charge of piracy. The marbles
were in England and were not likely to be returned
to war-torn Athens, where, by now, Parliament
believed the "barbarous" Turks would surely destroy
them or the French would abscond with them to the

O'Connor 13

Louvre. The court of public opinion, however, needed legal sanction for the retention of the marbles, and so Parliament found it.

Elgin's men probably exceeded the intentions of the firman. Elgin probably took advantage of his position, and Hunt probably engineered the intimidation of the young disdar and falsified a document. That's a lot of "probably"s, and many people are of the opinion that the British Museum cannot send the marbles back to Greece on a "probably," but of course it can and it should.

Much has been made of the dangerous precedent of sending the Parthenon sculptures back to Greece. The fear is that the British Museum's entire collection of antiquities will dwindle away under international pressures, many of which will be ill-founded. No doubt there will be more claims against the museum, and each claim will have to be decided on a case-by-case basis. In this case, however, the British Museum must accede. The acquisition of the Elgin Marbles has never been right; there is too much evidence of wrongdoing to be ignored. Lord Elgin's behavior was underhanded and felonious, behavior that does not merit keeping the booty.

Retention of the sculptures will result only in the diminishing of the British Museum's reputation, whereas restitution of the sculptures will win for

O'Connor 14

the museum worldwide approval and patronage. The
Greeks are building an Acropolis Museum at the foot
of the Athenian Acropolis, a stone's throw from the
Parthenon itself. This large building, which could
beautifully accommodate and showcase the Elgin Mar-
bles, should be finished in time for the Olympic
games in 2004. What a gesture of international peace
and cooperation it would be to return the sculptures
to their rightful home.

Works Cited

Alberge, Dalya. "Elgin Paid Massive Bribes for Mar-
 bles." *The Times of London* 28 Nov. 1999. 12 June
 2000. <http://museum-security.org/99/102.html>.

Cook, B. F. *The Elgin Marbles.* Cambridge: Harvard
 UP, 1984.

Daley, Michael. "Romancing the Stone." *Art Review*
 June 1999: 51–52.

Hitchens, Christopher. *Imperial Spoils: The Curious
 Case of the Elgin Marbles.* New York: Hill, 1987.

Rudenstine, David. "Did Elgin Cheat at Marbles?"
 The Nation 29 May 2000: 30–34.

Stamatoudi, Irini A. "The Law and Ethics Deriving
 from the Parthenon Marbles Case." 12 June 2000.
 <http://museum-security.org/elginmarbles.html>.

St. Clair, William. *Lord Elgin and the Marbles.*
 London: Oxford UP, 1967.

REVISING, EDITING, AND PROOFREADING YOUR RESEARCH PAPER

Use the following checklist to be certain that your paper is ready for submission. Consult the "Handbook" section at the end of this book for guidance in issues of sentence structure, grammar, punctuation, mechanics, and style.

REVISION CHECKLIST

- ☐ Thesis is clear and present. It is written in the appropriate mode of discourse. The thesis is narrow and specific enough to be adequately supported in the space of the paper but general enough to need support.
- ☐ Points of proof are clear and present. Each point answers the proof question. Each point is narrow and specific enough to be supported adequately in one to three paragraphs but general enough to need support. If the paper is argumentative, points of proof include refutations of counterpoints.
- ☐ Introduction contains specific details. It leads the reader to the thesis; it does not lead the reader to believe that the essay will be about something it is not about. If the essay is argumentative, the introduction contains a counterthesis and counterpoints, and it clearly identifies opponents.
- ☐ Essay adheres to the essay plan set out in the points of proof.
- ☐ Body paragraphs are unified (containing only one topic sentence), adequately developed (containing evidence in support of assertions), organized, and coherent (containing appropriate transitional expressions).
- ☐ Conclusion finds a way to solidify the paper's main point without resorting to mere repetition of the thesis and points of proof. Conclusion is unified and developed. Conclusion does not bring up any new issues.
- ☐ Sentences are well constructed. There are no run-ons or fragments.
- ☐ Sentences are correctly punctuated.
- ☐ Words are correct and well chosen.
- ☐ All quotations use acknowledgment phrases.
- ☐ Sources are correctly cited in text. Works cited page or bibliography is properly formatted.
- ☐ Title is appropriate.
- ☐ Paper is properly formatted.
- ☐ Paper fulfills requirements particular to specific assignment, such as length and subject matter.

HANDBOOK

Definitions of Basic Terms	*Parts of Speech*
	Sentence Parts
	Phrases
	Clauses
	Sentence Types
Choosing Words	*Choosing Verbs*
	Choosing Pronouns
	Wordiness
	Nonsexist Language
	Tone
Sentence Structures	*Sentence Fragments*
	Run-on Sentences
	Awkward Sentence Constructions
Punctuation	*Comma*
	Semicolon
	Colon
	Dash
	Apostrophe
	Quotation Marks

After you have drafted and revised your essay, the next step is to edit it. This step is best saved for last; it would be a waste of time to edit the material before you are certain that it is properly organized or before you have thought through your thesis, points of proof, and supporting facts and details.

No matter how interesting and insightful the content of your paper, your reader's interest will flag if there are distracting errors in sentence structure, grammar, usage, punctuation, and mechanics. This section of *The Art of Writing about Art* is designed as a reference manual to assist you in avoiding such errors.

Throughout the "Handbook" section, incorrect sentences will be marked with an "X."

DEFINITIONS OF BASIC TERMS

PARTS OF SPEECH

The eight parts of speech are the basic elements of English grammar. An understanding of these parts of speech is prerequisite to any deeper under-

standing of grammar. In every sentence, every word functions as *one* part of speech. A word cannot be two parts of speech at once. The same word, however, can function as one part of speech in one sentence and as another part of speech in another sentence. In the sentence, "Henry Moore's sculptures appeal to senses other than sight," the word "appeal" is a verb. In the sentence, "The genius of Henry Moore's sculptures lies in their appeal to more than one of our senses," the word "appeal" is a noun. Knowing the parts of speech enables you to use words correctly.

Noun: A noun is a word that names a person, place, or thing. Nouns can be possessive, singular or plural, proper or common, concrete or abstract. Possessive nouns contain apostrophes; proper nouns are capitalized. Verb forms known as gerunds (ending in *ing*) are nouns. The nouns are underlined in the following sentences.

> Henry Moore decided in Sunday school, after learning about Michelangelo, to become a sculptor. His decision to enter Leeds's art school led to a long and brilliant career in sculpting.

Pronoun: A pronoun is a word that takes the place of a noun. Pronouns come in the form of subjective, objective, and possessive cases. They also can be first, second, and third person. Pronouns possess gender: masculine, feminine, and neuter. Pronouns can be singular or plural. There are many types of pronouns: personal, possessive, intensive, reflexive, relative, demonstrative, indefinite, reciprocal, and interrogative. The pronouns are underlined in the following sentences.

> Moore's drawing, *Reclining Nude*, is naturalistic; his sculpture *Reclining Figure* is more abstract. It shows us the human body in a new way. His war drawings are equally famous; they depict Londoners enduring the horrors of war in what Winston Churchill called their "finest hour."

Verb: Verbs are words that express action or state of being. Verbs can be regular or irregular; active or passive; imperative, subjunctive, or indicative; simple or progressive; singular or plural; transitive or intransitive. One type of intransitive verb is the linking verb. Verbs have four principal parts: present, past, past participle, and present participle. A verb in the English language will be in one of six tenses: present, past, future, present perfect, past perfect, or future perfect. Some verbs are main verbs; some are helping verbs. Helping verbs are the various forms of *have, do,* and *be.* Modals are a subset of helping verbs: They are *can, could, may, might, must, should, will,* and *would.* A verb consists of the main verb plus any helping verbs. The verbs are underlined in the following sentences.

> Moore wrote, "The human figure is what interests me most deeply, but I have found principles of form and rhythm from the study of natural objects."

Adjective: Adjectives are words that modify or describe nouns and pronouns. Adjectives usually answer one of the following questions: Which

one? What kind of? How many? The articles—*a, an, the*—are classified as adjectives. Some verb forms, called *participles,* are used as adjectives. For example, the word "recurring" in the extract that follows is a verb form being used as an adjective modifying the noun "theme," and the word "reclining" is a verb form being used to modify the noun "female." In English, adjectives usually precede the nouns they modify. The adjectives are underlined in the following sentences.

> A <u>recurring</u> theme in Moore's work is <u>the</u> <u>reclining</u> female. Like Brancusi, Moore strove to capture not <u>the</u> <u>outward</u> form but <u>the</u> essence of <u>natural</u> figures and landscapes by making use of <u>abstract</u> symbolism.

Adverb: Adverbs are words that modify or describe verbs, adjectives, and adverbs. The adverbs are underlined in the following sentence.

> We can<u>not</u> <u>fairly</u> judge Henry Moore's art unless we <u>first</u> try <u>earnestly</u> to understand modern art.

Preposition: A preposition is a word that shows how a noun or pronoun is related to the sentence containing it. The prepositions are underlined in the following sentence.

> Henry Moore and artists <u>like</u> him may have been drawn <u>toward</u> primitivism <u>out of</u> discontent <u>with</u> civilization.

Conjunction: Conjunctions are connectors. There are three kinds of conjunctions: coordinate, subordinate, and correlative. Coordinate conjunctions connect items of equal importance in sentences. There are only seven coordinate conjunctions: *but, or, yet, for, and, nor, so.* You can remember them by memorizing the acronym BOYFANS. The coordinate conjunctions in the following sentence are underlined.

> Henry Moore <u>and</u> Constantin Brancusi simplified the shapes of their subjects, <u>but</u> neither suggested a simple interpretation of his subject.

Subordinate conjunctions connect subordinate clauses to main clauses. Some common subordinate conjunctions are *if, when, whenever, although, even though, unless, because, after, whereas, wherever,* and *since.* The subordinate conjunctions are underlined in the following sentence.

> <u>Although</u> Henry Moore's sculptures are abstract, they carry tactile sensations <u>because</u> they make us want to feel them.

Correlative conjunctions come in pairs—*either/or, neither/nor, not only/but also.* The correlative conjunctions are underlined in the following sentence.

> <u>Either</u> you like Henry Moore's work <u>or</u>, like Clement Greenberg, you don't.

Interjection: Interjections are words used to express surprise or emotion. Interjections like *wow* and *hooray* are usually set off from sentences and followed by exclamation marks. Mild interjections, like *oh* and *well,* are usually incorporated into sentences and set off with commas. Interjections hardly

ever find their way into formal writing and therefore do not usually cause grammatical mistakes.

SENTENCE PARTS

A sentence is a word group that contains at least a subject and a verb (actor and action). Every word, phrase, or clause in a sentence has a function or plays a part in the sentence. Following are the parts of sentences: *subject, verb, object, modifier, complement, connector.* Following are the basic sentence structures.

1. Subject and verb (Picasso sculpted.)
2. Subject, verb, and direct object (Picasso sculpted heads.)
3. Subject, verb, and subject complement (Picasso was a sculptor.)

Longer sentences are achieved by compounding any of the preceding elements and by adding modifying phrases and clauses.

Verb: A verb is a word that shows action or state of being. The word *verb* applies both to its part of speech and to its function. If the word is a verb, it functions as a verb. Every sentence contains at least one verb.

Subject: To be complete, your sentence needs a subject. To find the subject, first find the verb. Then ask "Who or what _____?" (Fill in the blank with the verb.)

EXAMPLE: The city of Chicago unveiled its Picasso sculpture on August 15, 1967, in Civic Center Plaza.

Find the verb first: "unveiled." Ask "Who or what unveiled?" The answer is "The city of Chicago." Therefore, "The city of Chicago," or simply "city," is the subject of the sentence.

Direct object: Not every sentence has a direct object. To find a direct object, find the verb first. Then ask: "_____ what or whom?" (Fill in the blank with the verb.)

EXAMPLE: The city of Chicago unveiled its Picasso sculpture on August 15, 1967, in Civic Center Plaza.

Find the verb first: "unveiled." Ask "Unveiled what or whom?" The answer is "Picasso sculpture," or simply "sculpture."

Complement: Some sentences are not complete unless they contain a subject complement. Subject complements either rename or describe the subject of the sentence. They follow **linking verbs,** which are some form of the verb *be* or some word that approximates the meaning of *be.* To find the subject complement, find the linking verb first. Then ask "_____ who or what?" (Fill in the blank with the verb.)

EXAMPLE: The Picasso sculpture might be a sphinx.

Find the linking verb first: "might be." Ask "Might be what?" The answer is "a sphinx." The word "sphinx" renames the subject, "Picasso sculpture."

Rather than rename the subject, the subject complement might describe it. In this case, the subject complement will be an adjective.

EXAMPLE: The Chicago Picasso was controversial.

The word "controversial" describes the Chicago Picasso.

Modifier: Many sentences contain more than the basics. These additional parts are modifiers. Think of them as describing words, if you like. The simplest modifiers are one-word adjectives and adverbs. Many phrases and clauses function as modifiers as well.

PHRASES

A phrase is a group of words that does not contain both a subject and a verb. Some phrases function as essential parts of sentences like subjects, subject complements, and objects. Others function as modifiers. The phrases in the following sentences are underlined.

Prepositional phrase: Prepositional phrases begin with a preposition and end with the object of the preposition (a noun or pronoun).

Brancusi's *Bird in Space* began as a naturalistic image of a bird standing at rest.

Appositive phrase: Appositive phrases are noun or adjective phrases that rename or describe other nouns.

Brancusi, formerly an assistant to Rodin, tried to preserve the original character of the stone in Rodin's famous sculpture, *The Kiss*.

Infinitive phrase: Infinitive phrases usually begin with an infinitive, which consists of the word *to* plus the basic form of a verb. The phrase includes all of the modifiers and objects that belong to the infinitive.

Two of Brancusi's objectives in creating *Torso* may have been to reduce the human body to its simplest terms and to use light to reinforce the length and roundness of the shapes.

Gerund phrase: A gerund is a verb form that ends with *ing* and is used as a noun. A gerund phrase usually begins with a gerund and includes all of its objects and modifiers.

Understanding Brancusi's tendency toward minimalism is helpful in acquiring a taste for contemporary minimalists like Scott Burton.

A gerund or gerund phrase will function in a sentence the same way a noun functions—as subject, object, complement, or appositive.

Participial phrase: A participle is a verb form that is being used as an adjective. A participial phrase usually begins with the participle and includes all of its objects and modifiers.

<u>Blurring the boundaries between sculpture, furniture, and architecture</u>, Brancusi created *Endless Column* and *Table of Silence*, both of which are <u>situated in a park at Tirgu-Jiu</u>.

Adjectives are not essential parts of sentences, and because participles and participial phrases function as adjectives, they are also nonessential. You should be able to read a complete sentence without the participial phrase.

Absolute phrase: Absolute phrases would be sentences in their own right if some form of the verb *be* had not been omitted.

Brancusi's *Torso of a Girl*, <u>its simplicity reminiscent of the art of Cycladic civilization</u>, throws new light on ancient cultures and their art.

CLAUSES

Clauses are word groups that contain both subjects and verbs. There are two kinds of clauses: independent (or main) and dependent (or subordinate).

Independent clause: An independent clause can stand by itself as a complete sentence.

Christo's *Surrounded Islands* project expanded many people's ideas about art.

Dependent clause: A dependent clause does contain a subject and a verb, but it cannot stand alone as a sentence. There are three kinds of dependent clauses: adjective, adverb, and noun.

Adjective clause: Adjective clauses work the same way that adjectives work: they modify or describe nouns and pronouns. Adjective clauses begin with a relative pronoun, usually *who, whose, whom, which,* or *that*.

The islands, <u>which were surrounded by a pink gossamer fabric</u>, actually benefited from Christo's project.

Adverb clause: Adverb clauses work the same way that adverbs work: they modify or describe verbs, adverbs, or adjectives. Adverb clauses begin with subordinate conjunctions. Some common subordinate conjunctions are *if, when, whenever, although, even though, unless, because, before, after, as, whereas, wherever,* and *since*.

<u>After Christo's workers dismantled the project</u>, the islands experienced an increase in the population of manatees.

Noun clause: Noun clauses function just as nouns do: as subjects, objects, complements, or appositives. Because they are clauses, they contain subjects and verbs. Noun clauses begin with relative pronouns, usually *who, which, that,* or *what*.

No one predicted <u>that Christo's *Surrounded Islands* in Biscayne Bay would be so popular</u>.

SENTENCE TYPES

There are four sentence types in the English language. You should try to use all four types in your writing; doing so will ensure variety in length and structure. Using too many sentences of the same length creates monotony.

Simple sentence: Simple sentences contain only one independent clause. They may contain more than one subject or verb, but they are not divisible into more than one clause.

Mrs. N's Palace is one of Louise Nevelson's most famous works.

Compound sentence: Compound sentences contain two or more independent clauses.

Nevelson's relief sculptures have four sides, but they are meant to be viewed from the front only.

Complex sentence: Complex sentences contain one independent clause and at least one dependent clause.

Mrs. N's Palace, which is made of odds and ends, is a world unto itself.

Compound-complex sentence: A compound-complex sentence contains two or more independent clauses, making the sentence compound, and at least one dependent clause, making the sentence complex.

The pieces that are assembled in Louise Nevelson's sculptures create a sense of order out of chaos, and the monochromatic color, which is usually black, further signifies unity.

CHOOSING WORDS

CHOOSING VERBS

One way to improve your writing is to choose your verbs carefully. The wrong verb can set your sentence adrift, whereas the right one will anchor your sentence in clarity.

Active versus passive verbs: Choose active instead of passive verbs whenever possible. In an active construction, the subject of the verb is doing the acting. In a passive construction, the subject is passively being acted upon.

ACTIVE CONSTRUCTION: Some African masks caricature human characteristics such as bravery.

PASSIVE CONSTRUCTION: Human characteristics such as bravery are caricatured by some African masks.

To create a passive verb, use some form of the verb *be*—*am, is, are, was, were, been,* or *being*—with the past participle of another verb.

Passive verbs are inadvisable because they create unnecessarily wordy sentences. Passive constructions also lead to other mistakes in sentence structure, such as dangling and misplaced modifiers.

Strong verbs versus weak verbs: To produce strong writing, you need strong verbs. As a rule, choose simple, active verbs. To ensure that your verbs are simple and active, find all of the forms of *be, have,* and *do* and replace as many of them as possible with a simplified version of the same verb or another verb altogether.

Weak	Strong
is painting	paints
has a likeness to	resembles
does an imitation	imitates
is a symbol of	symbolizes
is afraid of	fears
is of the opinion that	believes

Verb tenses: As a rule, stay in the present tense whenever you are describing a work of art. Use the present tense as well when speaking of the artist's act of creation, even if the artist is dead.

EXAMPLE: The sculptor of the married couple from Zaire creates a sense of harmony while reflecting traditional gender roles.

Subject-verb agreement: A verb must agree with its subject in number. That is to say, if the subject is singular, the verb must also be singular. Likewise, if the subject is plural, the verb must also be plural.

 subject verb
EXAMPLES: The Satimbe mask represents all women.

 subject verb
 Satimbe masks represent all women.

Words that come between the subject and its verb tend to confuse writers.

 subject
EXAMPLE: **X** The Satimbe mask, as well as other celebratory and commem-

 verb
 orative masks, help to dramatize creation stories.

The subject of the verb "help" in the preceding sentence is "mask." You wouldn't write "mask help"; you would write "mask helps."

EXAMPLE: The Satimbe mask, as well as other celebratory and commemorative masks, helps to dramatize creation stories.

Remember that you will never find the subject of a verb inside a prepositional phrase, so when examining your sentence for subject-verb agreement, cross off all of the prepositional phrases to simplify the task.

EXAMPLE: The shrines ~~to Mamy Wata~~ blend beliefs about water spirits with modern ideas of money and progress.

Subject-verb disagreements often occur when the subjects are singular, indefinite pronouns. The following indefinite pronouns are singular and thus require a singular verb.

one	nobody
anyone	anything
everybody	someone
something	either
no one	nothing
anybody	everyone
everything	somebody
each	neither

The subject and verb in the following sentence disagree.

EXAMPLE: **X** Not one of Europe's or America's texts on the African arts have captured the complexity of the work.

The verb "have" is plural. Its subject, "one," is singular. Corrected, the sentence reads as follows.

EXAMPLE: Not one of Europe's or America's texts on the African arts has captured the complexity of the work.

CHOOSING PRONOUNS

Avoiding *I:* Although using the first-person pronouns *I* and *me* in essays is not unequivocally wrong, it is a mistake to write more about yourself than about the art. The following example is more focused on the author than on the art.

EXAMPLE: **X** When I was assigned the task of writing about Leonardo da Vinci's *Last Supper*, I panicked because I didn't fully understand the painting. But now that I have read some essays on the *Last Supper*, I realize that each group of three disciples conveys a particular emotion.

Pronoun case: Pronouns have three cases: subjective (or nominative), objective, and possessive. Choose the subjective pronoun when your verb needs a subject or subject complement, an objective pronoun when your verb or preposition needs an object, and a possessive pronoun when you need to show possession.

When you have a compound subject or object, the easiest way to be sure that you are using the correct pronoun is to cross off all of the words in the group except the pronoun in question.

EXAMPLE: Salvador Dali may not seem to have much in common with Leonardo da Vinci, but ~~both Leonardo and~~ he painted Christ's *Last Supper*.

EXAMPLE: To ~~both Leonardo and~~ him, the *Last Supper* occasions the exposition of betrayal.

Subject complements should be in the subjective case.

EXAMPLE: Judas reveals, by holding a bag of money, that it is he who has betrayed Christ.

Choose *who* when the word will serve as the subject for a verb.

EXAMPLE: It is Judas who holds the bag of money in the *Last Supper*.

Choose *whom* if the word will serve as an object of a verb or a preposition.

EXAMPLE: To whom does Christ refer when he says, "One of you will betray me"?

Pronoun-antecedent agreement: A pronoun usually refers to some specific noun. That noun is the pronoun's antecedent.

	antecedent	**pronoun**

EXAMPLE: Each <u>disciple</u> in Leonardo's the *Last Supper* reveals <u>his</u> surprise at Christ's pronouncement.

Pronouns must agree with their antecedents in three ways:

1. Number (singular or plural)
2. Gender (masculine, feminine, or neuter)
3. Person (first, second, or third)

Mistakes occur most often when the antecedent is a singular, indefinite pronoun. The following sentence suffers from pronoun-antecedent disagreement.

EXAMPLE: **X** In the *Last Supper*, everyone expresses their surprise.

EXAMPLE: In the *Last Supper*, everyone expresses his surprise.

The second preceding sentence is grammatically correct because the word "everyone" is singular, and all of the characters in the *Last Supper* are masculine. But what if a singular, indefinite pronoun refers to both males and females?

EXAMPLE: **X** Every artist wishes they could create a work of art as memorable as the *Last Supper*.

You might correct the sentence as follows:

EXAMPLE: Every artist wishes he or she could create a work of art as memorable as the *Last Supper*.

OR: All artists wish they could create a work of art as memorable as the *Last Supper*.

The indefinite pronouns *each, either,* and *neither* are often followed by prepositional phrases that begin with *of*. Any pronoun referring to these indefinite pronouns must be singular, even if the object of the preposition *of* is plural.

EXAMPLE: **X** Each of the disciples reveals their own individual character.

EXAMPLE: Each of the disciples reveals his own individual character.

In short, the words *they, them, their,* and *themselves* must refer to some specific word. Find that word. If that word is singular, do not use any form of the word *they* in reference to it. Change the pronoun or change the antecedent, but the two words must agree in number, gender, and person. Another excellent option is to avoid the use of pronouns whenever possible.

Unclear pronoun references: A pronoun must refer to something specific. The pronouns *this* and *it* are most often the culprits in an unclear reference.

EXAMPLE: **X** Most of the disciples hold their hands in an expression of surprise. This creates a sense of rhythm.

The pronoun "this" in the preceding sentence refers to an idea conveyed in the sentence that precedes it but not to any specific word.

EXAMPLE: Most of the disciples hold their hands in an expression of surprise. The placement of the hands creates a rhythmical pattern.

The word *it* is often misused in the same way as *this* and should be corrected in the same way. When proofreading, circle every *it* and *this* and replace these words with more specific words whenever possible.

WORDINESS

Your writing should be terse, free of unnecessary words. Wordiness is not related to sentence length. Many long sentences are terse; many short sentences are wordy.

To proofread for wordiness, look for redundancies and unnecessary prepositional phrases.

Wordy	Better
red in color	red
shaped like a rectangle	rectangular
overexaggerate	exaggerate
basic fundamentals	basics (or fundamentals)
form of media	medium
come to the conclusion	conclude
in the event that	if
in the painting, it shows	the painting shows
in the article, it says	the article says

Repetitiousness is another cause of wordiness.

EXAMPLE: **X** Willem de Kooning paints large and massive women.

X Jackson Pollock's works are abstract and unrealistic.

X The painting's universality and appeal to viewers everywhere are its strengths.

Passive and weak verbs cause wordiness, as does the *there is/are* construction.

EXAMPLES: **✗** Women are portrayed satirically as love goddesses by de Kooning.

✗ Paint is splattered and dripped by Jackson Pollock.

✗ There is a sensuous appeal to viewers everywhere in Dale Chihuly's glass art.

BETTER EXAMPLES: De Kooning satirically portrays women as love goddesses.

Jackson Pollock splatters and drips paint.

Dale Chihuly's sensuous glass art appeals to viewers everywhere.

Another step you must take to eliminate wordiness is to delete the word *very* every time it occurs. If you are left with a weak word or phrase, change it to a strong one; for example, change "very large" to "massive" or "huge," "very many" to "numerous," and "very many times" to "often" or "frequently." Never write "very unique." If a thing is unique, it is one of a kind and cannot be made more unique by adding "very." Eliminate the words *basically* and *totally* as well.

Finally, remove all announcements of your intentions and statements of purpose. Make your point without announcing it.

NEEDLESS PHRASES: **✗** In this essay I will show that ...

✗ The purpose of this essay is to ...

NONSEXIST LANGUAGE

Use *humanity, humankind,* or *people* instead of *man* or *mankind.* Refer to the hypothetical doctor, nurse, lawyer, astronaut, or secretary as *he or she* (or *she or he*). However, overusing *he or she* can be distracting, so simply avoid using pronouns whenever possible.

Naturally, if the gender of the individual being referred to is known, use the appropriate pronoun. You may also assign a hypothetical person a gender, just so long as it is clear that you are not automatically assigning the masculine gender to those with power and the feminine gender to those without power.

TONE

Naturally, if you are writing or speaking informally, you may say anything you want. If you are writing or speaking formally, however, there are correct and incorrect choices. If *whom* is correct, use it, even if it sounds stilted.

Also, avoid cliches and overworked phrases such as "all in all," "to make a long story short," "easier said than done," and "better late than never."

H-1 *Queen Mother Head*, from Benin culture, Nigeria, early 16th c. Bronze, 20″ high. National Museum, Lagos, Nigeria.

Choose vivid, specific words. You can "make a picture" or you can "paint a landscape." Which is more vivid? You may write, "In African art, some women have fancy hairdos." Or you may write, "In the African Benin sculptures, the Queen Mother wears a coiffure called the 'chicken beak.'" (Fig. **H-1**) Which description is more interesting? You might describe Mary Cassatt's *The Bath* by writing, "The woman bathes a child," or you might write, "The mother holds the toddler gently on her lap, dipping the child's foot into the clear water of a bathing bowl." Which description gives the reader a clearer sense of the painting?

Most importantly, avoid words or phrases that dictionaries label as informal, slang, colloquial, archaic, illiterate, nonstandard, obsolete, or substandard. The word *butt,* for example, is a coarsened version of "buttocks" and is not considered polite language. Think of your audience as a reader of newspapers such as the *New York Times* or journals or magazines such as *Art in America.* Such a reader has heard, read, and may occasionally use coarse language but is not accustomed to finding it in tasteful reading material. Such words distract your reader and lower the tone of your essay.

SENTENCE STRUCTURES

SENTENCE FRAGMENTS

Sentence fragments are word groups that pose as complete sentences but are incomplete because they are missing one or more essential parts—usually a subject or a verb. Although they are deliberately used at times for creative effect, they are usually mistakes in essays and should be eradicated.

Length is not the issue when it comes to fragments. A very short word group may be a complete sentence, just as a very long word group may be a fragment.

COMPLETE SENTENCE: Dale Chihuly works with glass.

FRAGMENT: **X** Dale Chihuly, whose expanding importance as an artist results largely from his public installations.

A frequent cause of fragments is mistaking an adverb clause (a type of dependent clause) for an independent clause.

EXAMPLE: **X** Because Chihuly attributes his popularity to his medium—glass.

Another frequent cause of fragments is mistaking participles for verbs. Participles are verb forms that are being used as adjectives, not verbs.

EXAMPLE: **X** Photographs of glass spilling onto the dirt floor of his workshop.

Fragments are often easy to identify in isolation. However, when they are positioned inside a paragraph, they are harder to identify because the paragraph sounds correct when it is read quickly.

EXAMPLE: **X** In an intentional "accident," glass spilled across the dirt floor of Chihuly's workshop. Creating a flood of sizzling glass that the artist captured in photographs.

You could repair the fragment simply by attaching it to the previous sentence or by giving it a subject and a verb.

EXAMPLE: In an intentional "accident," glass spilled across the dirt floor of Chihuly's workshop, creating a flood of sizzling glass that the artist captured in photographs.

OR: In an intentional "accident," glass spilled across the dirt floor of Chihuly's workshop. The spill created a flood of sizzling glass that the artist captured in photographs.

RUN-ON SENTENCES

Run-on sentences are a common but crucial mistake. Like fragments, run-ons reveal a fundamental problem in writing—the failure to realize where a sentence begins and ends. No matter how sophisticated your ideas, your writing will seem immature if it contains run-on sentences.

Run-on sentences consist of two or more independent clauses that have been incorrectly joined. There are two types of run-on sentences.

1. *Fused sentences* join independent clauses without the benefit of any punctuation.

 EXAMPLE: **X** The left panel of Hieronymus Bosch's *Garden of Earthly Delights* shows God and Adam relaxing the Garden of Eden is a lovely place.

2. *Comma splices* join independent clauses with only a comma.

 EXAMPLE: **X** The left panel of Hieronymus Bosch's *Garden of Earthly Delights* shows God and Adam relaxing, the Garden of Eden is a lovely place.

There are many ways to repair a run-on sentence, but following are four of the easiest ways.

1. Separate the two independent clauses into separate sentences.

 EXAMPLE: The left panel of Hieronymus Bosch's *Garden of Earthly Delights* shows God and Adam relaxing. The Garden of Eden is a lovely place.

2. Separate the two independent clauses with a comma plus a coordinating conjunction. (To remember the seven coordinating conjunctions, use the acronym BOYFANS: *but, or, yet, for, and, nor,* and *so.*)

 EXAMPLE: The left panel of Hieronymus Bosch's *Garden of Earthly Delights* shows God and Adam relaxing, for the Garden of Eden is a lovely place.

3. Separate the two independent clauses with a semicolon.

 EXAMPLE: The left panel of Hieronymus Bosch's *Garden of Earthly Delights* shows God and Adam relaxing; the Garden of Eden is a lovely place.

4. Convert one of the independent clauses into a dependent clause.

 EXAMPLE: The left panel of Hieronymus Bosch's *Garden of Earthly Delights* shows God and Adam relaxing because the Garden of Eden is a lovely place.

A frequent cause of run-on sentences is connecting independent clauses with adverbs like *however* instead of coordinating conjunctions.

EXAMPLE: **X** The left panel of *Garden of Earthly Delights* depicts a pleasant scene, however, the right panel depicts a nightmare.

Another frequent cause of run-on sentences is forcing a pronoun into the same sentence as the noun to which it refers.

EXAMPLE: **X** The right panel depicts a nightmare, it contains surreal elements of violence like walking knives and musical instruments of torture.

AWKWARD SENTENCE CONSTRUCTIONS

Misplaced and dangling modifiers: A misplaced modifier is an adjective, adverb, or modifying phrase or clause that is in the wrong place in the sentence.

EXAMPLE: **X** A surrealistic painting, Frida Kahlo painted herself in the center of *The Wounded Table*, which exhibits her identification with Christ as a victim of betrayal.

The sentence should be arranged as follows.

EXAMPLE: Frida Kahlo painted herself in the center of *The Wounded Table*, a surrealistic painting that exhibits her identification with Christ, a fellow victim of betrayal.

Another faulty sentence construction arises from the dangling modifier, a more subtle problem. In this construction, the word that the modifier is supposed to modify (or describe) is missing from the sentence, leaving the modifier "dangling."

EXAMPLE: **X** Placing herself in the center of the table, it is apparent that *The Wounded Table* expresses identification with Christ, a fellow victim of betrayal.

In the preceding sentence, "Placing herself in the center of the table" is a participial phrase that should modify "Frida Kahlo," because she's the artist who did the placing. But "Frida Kahlo" (or simply "Kahlo") is missing from the sentence altogether. Following is a corrected version of the preceding sentence.

EXAMPLE: Placing herself in the center of *The Wounded Table*, Frida Kahlo expresses her identification with Christ, a fellow victim of betrayal.

Faulty predication: *Faulty predication* is the term for a sentence that claims that someone or something is being or doing something unlikely or impossible.

EXAMPLES: **X** An example of Kahlo's sense of abandonment is the nurse who holds the infant Frida unaffectionately.

X An example of Kahlo's sense of abandonment is *My Nurse and I*.

The preceding faulty sentences might be written as follows.

EXAMPLE: Kahlo's sense of abandonment is conveyed in *My Nurse and I*, wherein the nurse holds the infant Frida unaffectionately.

OR: One example of Kahlo's work that conveys her sense of abandonment is *My Nurse and I*.

Faulty comparisons: One common mistake in comparing is to make an incomplete comparison.

EXAMPLE: **X** Frida Kahlo's work is more personal.

Finish the comparison as follows.

EXAMPLE: Frida Kahlo's work is more personal than Diego Rivera's.

Another mistake is comparing incomparable things.

EXAMPLE: **X** In *Still Life:Viva la Vida y el D. Juan Farill*, one sees that political concerns exist but are less prevalent than in Diego Rivera's work.

You might write, instead, one of the following.

EXAMPLE: In *Still Life:Viva la Vida y el D. Juan Farill*, one sees that political concerns exist but are less prevalent than the political concerns shown in Diego Rivera's work.

OR: In *Still Life:Viva la Vida y el D. Juan Farill*, one sees that political concerns exist but are less prevalent than those shown in Diego Rivera's work.

A note about the difference between the words *like* and *as* is in order here. In comparisons, *like* is a preposition; it is the first word of a prepositional phrase. *As* is a subordinate conjunction; it is the first word of a clause. Following is an example that misuses the word *like*.

EXAMPLE: **X** Kahlo often expresses her grief at Diego Rivera's rejection of her, like she does in *The Two Fridas*.

A corrected sentence would use the word *as* instead of *like*.

Faulty definitions: The most common faulty definition incorrectly defines a thing as a place or a time.

EXAMPLE: **X** An example of surrealism in Frida Kahlo's work is when she suspends images, such as body parts, in midair.

EXAMPLE: **X** An example of surrealism in Frida Kahlo's work is where she suspends images, such as body parts, in midair.

The preceding sentences define an example of surrealism first as a time and second as a place, whereas an example of surrealism is neither. Simply avoid the *is when* or *is where* construction unless the thing you are defining really is a time or a place.

Another common but faulty construction is the *is because* construction.

EXAMPLE: **X** The reason Frida Kahlo includes a purple orchid in *Henry Ford Hospital* is because Diego Rivera brought her one while she was in the hospital.

The preceding sentence would be correct if it used the word *that* instead of *because*.

Unnecessary shifts: Be consistent in the use of person. In grammar, the first person is the person speaking, either individually or as a group. The

second person is the person being spoken to. The third person is the person(s) or thing(s) being spoken about. The most common mistake is shifting from one person to another.

> EXAMPLE: **X** Viewers of Kahlo's self-portraits have noticed that the portraits are hard and unflattering, whereas Kahlo herself was exotically beautiful. You sense that she was painting herself as she felt, not as she looked.

It is also a mistake to shift verb tense, voice, or mood. The following example shifts from present tense in the first sentence to past tense in the second sentence.

> EXAMPLE: **X** Tehuana clothing is the subject of several of Kahlo's paintings. *The Two Fridas* contrasted modern and traditional dresses.

Whenever possible, use the active voice. The next example shifts from active voice to passive voice.

> EXAMPLE: **X** *The Broken Column* symbolizes Kahlo's broken physical and emotional conditions. Her spinal cord is revealed as a cracked ionic column, and her emotional vulnerability is heightened by her nudity.

Avoid shifting from the imperative mood (a command) to the indicative mood (an assertion).

> EXAMPLE: **X** Read Kahlo's biography, and then you should see her work.

Mixed constructions: Sometimes beginning writers start a sentence one way and end it another way. For example, the following sentence begins as a statement and ends as a question.

> EXAMPLE: **X** Frida Kahlo asks us to examine her personal tragedies and what can we learn from them.

The following mixed construction begins as a complex sentence (with adverb clause) and then switches to a compound sentence (with the coordinate conjunction *but*).

> EXAMPLE: **X** Although Frida Kahlo's still lifes are richly colorful and textured, but they are also disturbing.

The mixed construction that follows has a prepositional phrase (beginning with the word "By") incorrectly serving as the subject of the verb "reveals."

> EXAMPLE: **X** By using flowers and fruit as metaphors for the female genitalia reveals Frida Kahlo's suggestion that the female body is both fragile and a thing to be consumed.

Parallel construction: Parallelism adds elegance and rhythm to your sentences. The idea is to present two or more similar items in like grammatical form. For example, there is a Marc Chagall painting titled *Woman, Flowers, and Bird*. For good reason, the title is not *Woman, Some Flowers, and a White Bird;* although not technically wrong, the structure would be unsettling.

The following sentences could be improved by using parallel construction. The underlined words in the faulty constructions are the items that should be presented in like grammatical form. Immediately following each undesirable example is its more appropriately structured counterpart with the corrected parallel words underlined as well.

EXAMPLES: **X** Frida Kahlo's work arises from her sterility, ill health, Diego Rivera's treatment of her, and the anxiety caused by her mother's neglect.

Frida Kahlo's work arises from her sterility, her ill health, and her feelings of rejection, which arose from the treatment she received from her mother and her husband, Diego Rivera.

X Kahlo's still lifes combine images of mangled fruit and coconuts that cry.

Kahlo's still lifes combine images of mangled fruit and crying coconuts.

X Whether one defines Kahlo as primarily a Mexican artist, a surrealist, or as a Marxist/feminist artist, her reputation continues to grow.

Whether one defines her art as primarily Mexican, surrealistic, or Marxist/feminist, Kahlo's reputation continues to grow.

PUNCTUATION

COMMA

Four basic rules, if followed, will usually result in the correct use of the comma.

Rule 1: Use a comma after an introductory modifying phrase or adverb clause.

EXAMPLES: By using the science of perspective, Dürer increased the sense of reality of his woodcuts.

After he read a description of a beast he had never seen, Albrecht Dürer created his amusing woodcut titled *Rhinoceros*. (Fig. **H-2**)

In accordance with this rule, it would be a mistake to place a comma after an introductory noun clause or phrase serving as the subject of a verb. It is a mistake to separate a subject from its verb with a comma.

Example: **X** What Dürer created in his self-portrait, is a masterpiece of narcissism.

Rule 2: Use commas between words, phrases, and clauses that appear in a series of three or more. Do use a comma before the word "and" that introduces the final item in the series.

EXAMPLE: Dürer's works include woodcuts, engravings, and watercolors.
Dürer's *Life of the Virgin*, *St. Jerome*, and *The Four Horsemen* represent his immersion in the theological discourse of his time.

Rule 3: Use a comma before a coordinating conjunction—*but, or, yet, for, and, nor,* and *so* (remember BOYFANS)—that links independent clauses. (An independent clause would be able to stand alone as a complete sentence.)

> EXAMPLE: Dürer was the first German artist to embody the principles of the Renaissance, and he was also the first non-Italian artist to achieve celebrity.

It would be a mistake to place a comma before a coordinating conjunction that is not linking main clauses.

> EXAMPLE: **X** Dürer painted *The Four Apostles* on two wood panels, and gave them to the city of Nuremberg in 1526.

Rule 4: Set off nonessential words, phrases, and clauses with commas. A word, phrase, or clause is nonessential if the sentence retains its complete meaning without the word, phrase, or clause.

> EXAMPLE: *The Great Piece of Turf,* like Leonardo's *Embryo in the Womb,* conveys the sixteenth-century idea that nature is a worthy subject for an artist.

H-2 Albrecht Dürer, *Rhinoceros,* 1515. Woodcut, 8 3/8″ × 11 5/8″. Metropolitan Museum of Art, New York.

Clauses beginning with *that* are essential and are not set off with commas.

> EXAMPLE: The style of Dürer's *Apocalypse* says that Dürer had synthesized the literal and the sublime.

Adjective clauses beginning with *which* are nonessential and are set off with commas.

> EXAMPLE: Dürer's *Apocalypse*, which synthesizes the literal and the sublime, draws from classical iconography.

Adjective clauses beginning with the words *who, whom,* or *whose* can be essential or nonessential. If the adjective clause refers to a specific person, it will be nonessential and should be set off with commas.

> EXAMPLE: Adam, who has acquired knowledge, covers himself in the Bible as well as in Dürer's *The Fall of Man.*

If the adjective clause does not refer to someone specific, the clause will be essential and should not be set off with commas.

> EXAMPLE: Anyone who sees Dürer's *The Fall of Man* can begin to appreciate his humanistic treatment of theological ideas.

When quoting, consider the acknowledgment phrase—the phrase that tells who is speaking or writing—as nonessential and set it off with commas.

> EXAMPLE: In reference to his engraving *The Knight, Death, and the Devil,* Dürer writes, "Hark, thou knight of Christ, ride forth at the side of Christ our Lord, protect the truth, obtain the martyr's crown."

Consider *yes, no,* mild interjections, terms of direct address, tacked-on questions, and sharply contrasting elements as nonessential.

> EXAMPLES: Yes, Albrecht Dürer was fascinated with classical ideas.
>
> No, Dürer was not an Italian.
>
> Well, Dürer was a writer as well as an artist.
>
> Fellow Germans, please learn about Albrecht Dürer.
>
> Albrecht Dürer had many talents, didn't he?
>
> Dürer, not Grünewald, is considered the "Leonardo of the North."

SEMICOLON

Use a semicolon to separate independent clauses not joined by a coordinating conjunction. Think of the semicolon as a weak period.

> EXAMPLE: Albrecht Dürer's portrait of his mother forces the viewer to reevaluate standards of beauty; she is old, careworn, and, although not beautiful, the subject of a beautiful drawing.

COLON

A colon separates a summary or series from an independent clause.

Examples: *Melancholia* is surrounded by instruments of science: a saw, a plane, a
 hammer and nails, scales, a melting pot, a polyhedron, and a sphere.

OR: A saw, a plane, a hammer and nails, scales, a melting pot, a polyhedron, and
 a sphere: these are the instruments of science that surround *Melancholia*.

In accordance with this rule, it would be a mistake to put a colon after a
word group that is not an independent clause.

EXAMPLE: **X** The instruments of science surrounding *Melancholia* are: a saw, a plane, a
 hammer and nails, scales, a melting pot, a polyhedron, and a sphere.

Another use of the colon is to introduce a quotation that follows an
acknowledgment phrase that is an independent clause.

EXAMPLE: From Venice, Dürer wrote to a friend about the chilly reception he had
 received in southern Italy: "Many of them are my enemies; they copy my
 works in the churches and wherever they can find them; and then they
 decry my work and say it was not in the manner of the classics and
 therefore it was no good."

DASH

Think of the dash as a strong comma. It has two main uses. The first is to set
off a short summary after a complete main clause.

EXAMPLE: Albrecht Dürer may have possessed a wild imagination, but his ability to
 mirror nature is particularly evident in a famous watercolor—*Hare*.

The second use of the dash is to set off an appositive phrase that consists
of items in a series separated by commas.

EXAMPLE: The three figures of *The Nativity*—Mary, Joseph, and the Child—seem
 insignificant compared to the ramshackle stable that shelters them.

Your computer keyboard probably does not have a dash key, as such.
Instead, there is a key for the hyphen. To make a dash, simply press the
hyphen key twice.

APOSTROPHE

Apostrophes have two main uses. The first is to create contractions such as
don't, can't, they're, and *it's*. Contractions are two words condensed. The
apostrophe stands for the omitted letters. Avoid using contractions in formal
writing.

The second use of the apostrophe is to show possession. To make nouns
possessive:

1. If the noun is singular, add 's.

 EXAMPLE: St. Michael thrusts his huge spear into the dragon's throat.

2. If the noun is plural and does not end in s, add 's.

 EXAMPLE: The four horsemen's weapons are drawn for battle.

3. If the noun is plural and does end in *s*, just add an apostrophe.

 EXAMPLE: The four apostles' words are written on the frames of the panels.

The personal possessive pronouns—*hers, ours, theirs, yours, whose,* and *its*—do not contain apostrophes.

QUOTATION MARKS

Copy quoted material exactly, including the internal punctuation. Some adjustments can be made, however, to the end marks and capitalization.

Quotation marks: Place quotation marks around direct quotations.

EXAMPLE: "The works produced by Albrecht Dürer at the turn of the fifteenth century mark the beginning of the Renaissance style in the North," writes Erwin Panofsky in *Meaning in the Visual Arts.*

Do not put quotation marks around indirect quotations or paraphrases (usually signaled by the word *that*).

EXAMPLE: Erwin Panofsky believes that Albrecht Dürer's woodcuts, drawings, and engravings indicate the influence of the Italian Renaissance.

Place quotation marks around the titles of songs, short stories, essays, poems, and articles in newspapers and magazines. In general, underline *or* italicize titles of plays, books, magazines, newspapers, journals, movies, television programs, and works of art. In short, put quotation marks around the titles of smaller works and underline or italicize the titles of larger works.

EXAMPLE: An article in *Partisan Review* titled "Contemporary Artists and Their Influences" compares Susan Rothenberg's woodcuts to those of Albrecht Dürer.

This use of quotation marks applies only when referring to other published works in your paper. The title of your own paper should remain unadorned—no quotation marks, no underlining, no italics. Books of the Bible are neither underlined nor set in quotation marks.

Quotation marks may enclose words intended in a special or ironic sense. Use this option sparingly.

EXAMPLE: The "greatness" of Dürer's piece of turf lies in the beauty of nature unadorned.

Single quotation marks: Use single quotation marks for quoted material inside of quoted material.

EXAMPLE: Gardner's *Art Through the Ages* says, "Dürer circulated and sold prints in single sheets, which people of ordinary means could buy and which made him a 'people's artist.' It also made him a rich man."

Capitalization in quotations: Capitalize the first word of a complete quotation but not the first word of a partial quotation.

EXAMPLES: Dürer wrote of his stay in northern Italy, "Here I am a lord, at home a parasite."

Dürer wrote that in northern Italy he was a lord but in Germany "a parasite."

USING OTHER PUNCTUATION MARKS WITH QUOTATION MARKS: Commas and **periods** always go inside the closing quotation marks.

EXAMPLES: *St. Michael's Fight against the Dragon* illustrates Revelation 12:7: "And there was war in heaven: Michael and his angels fought against the dragon; and the dragon fought and his angels, and prevailed not; neither was their place found any more in heaven."

"And there was war in heaven," according to Revelation 12:7, which *St. Michael's Fight against the Dragon* illustrates.

Question marks and **exclamation marks** go inside the closing quotation marks when they are part of the quoted material.

EXAMPLE: In his *Great Piece of Turf,* Dürer seems to be asking the question, "Isn't even the most humble piece of ground a worthy subject for art?"

Question marks and exclamation marks go outside the closing quotation marks when they are not part of the quoted material.

EXAMPLE: How does *St. Michael's Fight Against the Dragon* illustrate the biblical passage in Revelation 12:7, "And there was war in heaven"?

Colons, semicolons, and **dashes** are placed outside the closing quotation marks.

EXAMPLE: The sign Adam holds says, "Albertus Durer Noricus Faciebat 1504"; it is Latin, meaning "Albrecht Dürer of Nuremberg made [this engraving] in 1504."

Quotations may be introduced with an acknowledgment phrase followed by a **comma.** However, if the acknowledgment phrase is an independent clause, it is followed by a **colon.**

EXAMPLE: Kenneth Clark describes Dürer's inordinate vanity: "His self-portrait, now in Madrid, with its ringlets of hair framing a face that insists on its sensibility, is a masterpiece of self-love; and two years later he went even further, by portraying himself in the traditional pose and likeness of Christ."

Indent quoted passages of four or more lines. Notice that the indented material is double-spaced and that there are no quotation marks around the

quoted material. Indentation takes the place of quotation marks. Look at the research paper on the Elgin Marbles in Chapter Seven to see how indented material should look on the page.

ALTERING QUOTATIONS: Sometimes you will have occasion to leave out parts of quotations or to clarify their contents. You may use ellipsis dots or brackets for these tasks.

> ORIGINAL PASSAGE BY ALBRECHT DÜRER: In what honor and esteem this art was held by the Greeks and Romans is sufficiently indicated in the ancient books. Subsequently, though, it was completely lost and hidden for more than a millennium; and only within the past two hundred years has it been brought to light again by the Italians.

Ellipsis points show that you have omitted material from a quoted passage. Use three points when omitting material at the beginning or in the middle of a sentence. Space once before the first point and once after each point. Enclose the ellipses in brackets.

> EXAMPLE: "In what honor and esteem this art was held by the Greeks and Romans is sufficiently indicated in the ancient books," wrote Dürer. "Subsequently, though, it was completely lost [...] and only within the past two hundred years has it been brought to light again by the Italians."

Use three points and an end punctuation mark when leaving out material at the end of the sentence.

> EXAMPLE: Of classical themes, Dürer writes, "In what honor and esteem this art was held by the Greeks and Romans is sufficiently indicated by the ancient books. Subsequently, though, it was completely lost and hidden for more than a millennium. [...]"

Brackets: Use brackets to add clarifying words or to substitute clear words for unclear ones.

> EXAMPLE: Dürer writes, "In what honor and esteem this [classical] art was held by the Greeks and Romans is sufficiently indicated by the ancient books."

Brackets can also correct capitalization for the purpose of maintaining grammatical and mechanical integrity in your sentence. In the original passage, as written by Dürer, the "o" of "only" was lowercase because "only" was not the first word of the sentence. In the following example, words before "only" have been omitted; "only" is the first word of a new sentence and therefore should be capitalized.

> EXAMPLE: "In what honor and esteem this art was held by the Greeks and Romans is sufficiently indicated in the ancient books," writes Dürer "[... O]nly within the past two hundred years has it been brought to light again by the Italians."

CREDITS

LITERARY

Adams, Brooks "Ilya Kabakov at Ronald Feldman" by Brooks Adams from ART IN AMERICA, December 1992, p. 109. Originally published in **ART IN AMERICA,** December 1992, Brant Publications, Inc. Reprinted by permission.

Baxendale II, Ronald E. *"Chantet Lane*: A Post-Impressionist Walk in the American Southwest" by Ronald E. Baxendale. Used by permission of the author.

Canaday, John "This Way to the Big Erotic Art Show" by John Canaday from *The New York Times*, October 9, 1966. Copyright © 1966 by The New York Times. Reprinted by permission. "Max Beckmann, German" by John Canaday from *The New York Times*, December 20, 1964. Copyright © 1964 by The New York Times. Reprinted by permission. "Too Bad, Because At First It Sounded So Good" by John Canaday from *The New York Times*, June 2, 1968. Copyright © 1968 by The New York Times. Reprinted by permission.

Ebony, David "Tom Duncan at G.W. Einstein" by David Ebony from ART IN AMERICA, June 1992, pp. 114-115. Originally published in **ART IN AMERICA**, June 1992, Brant Publications, Inc. Reprinted by permission.

Gomez, Edward "An Abstractionist Maintains the Faith in a Skeptical Era" by Edward Gomez from *The New York Times*, September 17, 2000. Copyright © 2000 by The New York Times. Reprinted by permission.

Gothberg, Rachel "Gothic Nightmares in Romantic Painting" by Rachel Gothberg. Used by permission of the author. "Nobility in Human Suffering in the Work of Théodore Géricault" by Rachel Gothberg. Used by permission of the author.

Kalina, Richard "Alex Katz at Marlborough and Brent Sikkema" by Richard Kalina from ART IN AMERICA, March 2000, pp. 127-128. Originally published in **ART IN AMERICA**, March 2000, Brant Publications, Inc. Reprinted by permission.

Lippard, Lucy R. Excerpt from "Judy Chicago's Dinner Party" by Lucy R. Lippard from ART IN AMERICA, April 1980, pp. 115-126. Originally published in **ART IN AMERICA**, April 1980, Brant Publications, Inc. Reprinted by permission.

Lorio, Jim "The Artist's Statement" by Jim Lorio. Used by permission of the author.

Perl, Jed "Our Dadaist" by Jed Perl from NEW REPUBLIC, April 13 & 24, 2000, pp. 66-70. Reprinted by permission of THE NEW REPUBLIC, © 2000, The New Republic, Inc. "Theory for Gallerygoers" by Jed Perl from NEW REPUBLIC, March 20, 2000, pp. 25-28. Reprinted by permission of THE NEW REPUBLIC, © 2000, The New Republic, Inc. "The Death of Pierrot" by Jed Perl from NEW REPUBLIC, September 6, 1999, pp. 30-35. Reprinted by permission of THE NEW REPUBLIC, © 1999, The New Republic, Inc.

Schiff, Bennett, "Titian: art's Venetian lion." Originally appeared in SMITHSONIAN (November 1990). Copyright © 1990 Bennett Schiff. Reprinted by permission of the author.

Schulze, Franz "Wilhelmine Berlin" by Franz Schulze from ART IN AMERICA, April 2000, pp. 144-147. Originally published in **ART IN AMERICA**, April 2000, Brant

Publications, Inc. Reprinted by permission.

Wilkin, Karen "Knavery, Trickery, and Deceit" by Karen Wilkin from ARTnews, September 1996, pp. 116-119.

PHOTO CREDITS

Photo 1-1 © Francis G. Mayer/CORBIS

Photo 1-2 Réunion des Musées Nationaux/Art Resource, NY

Photo 1-3 Judy Chicago, *The Dinner Party*, 1979, photo © copyright Donald Woodman.

Photo 1-4 Museum of Modern Art, New York (gift of Mrs. Simon Guggenheim). Copyright © 2002 The Museum of Modern Art, New York.

Photo 2-1 Henry Lillie Pierce Fund. Courtesy, Museum of Fine Arts, Boston.

Photo 2-2 © 1995 ARS, NY/SPADEM, Paris

Photo 2-3 Copyright © 2002 Artists Rights Society (ARS), New York. Photo by Jacqueline Hyde - CNAC/MNAM/Dist Réunion des Musées Nationaux/Art Resource, NY.

Photo 2-4 Reproduced by courtesy of the Trustees of the National Gallery, London.

Photo 2-5 © 1995 ARS, NY/ADAGP, Paris. Philadelphia Museum of Art: The Louise and Walter Arensberg Collection.

Photo 2-6 © 2002 The Andy Warhol Foundation for the Visual Arts/ARS, NY

Photo 2-7 *Chantet Lane*, 1926, Andrew Dasburg, Denver Art Museum Collection, Albert Wassench Collection, 1927.2. Copyright Denver Art Museum 2002.

Photo 3-1 Canali Photobank, Italy

Photo 3-2 The Detroit Institute of Arts. Gift of Mr. and Mrs. Bert L. Smokler and Mr. and Mrs. Lawrence A. Fleishman.

Photo 3-3 Museo del Prado, Madrid

Photo 3-4 Studio Kontos

Photo 3-5 © Réunion des Musées Nationaux, Paris

Photo 4-1 Phoenix Art Museum, Gift of Mr. and Mrs. Read Mullan and others, by exchange. Photo by Craig Smith.

Photo 5-1 © Réunion des Musées Nationaux, Paris

Photo 5-2 Museo del Prado, Madrid

Photo 6-1 Harry Ransom Humanities Research Center, University of Texas at Austin

Photo 6-2 The Norton Simon Foundation, Pasadena, CA.

Photo 6-3 © Succession H. Matisse, Paris/ARS, NY. Hermitage, St. Petersburg, Russia.

Photo 6-4 Philadelphia Museum of Art, gift of Dr. & Mrs. Wolgin.

Photo 7-1 Studio Kontos

Photo 7-2 © Bettmann/CORBIS

Photo 7-3 © 2002 The Museum of Modern Art, New York

Photo 7-4 Courtesy of the Trustees of the British Museum, London

Photo H-1 National Commission for Museums and Monuments, Lagos

Photo H-2 © Bettmann/CORBIS

NOTES

CHAPTER ONE

[1]William Faulkner, *Faulkner in the University*, Session 8, 1959.

[2]Barbara Tuchman, *Practicing History* (New York: Random, 1980) 231–32.

[3]Aldous Huxley, *Themes and Variations* (New York: Harper, 1943) 188–89.

[4]Horst W. Janson, *Sixteen Studies* (New York: Abrams, 1973) 291.

[5]Jim Lorio, "Artist's Statement," Dec. 2000.

[6]Denver Art Museum, in-house guidelines for writing museum labels.

[7]Charles F. Stuckey, *Claude Monet 1848–1916* (Chicago: Art Institute of Chicago, 1995) 212.

[8]Leanin' Tree Museum, Boulder, Colorado, museum label.

[9]Richard Brettell et al., *The Art of Paul Gauguin* (Washington, D.C.: National Gallery of Art, 1988) 187.

[10]Robert Rosenblum, "Johns's *Three Flags*," *On Modern American Art* (New York: Abrams, 1999) 153.

[11]Clement Greenberg, "Master Léger," *Partisan Review* 21 (1954): 91.

[12]Sigmund Freud, *Leonardo da Vinci and a Memory of His Childhood* (New York: Norton, 1964) 63–64.

[13]Frances K. Pohl, "Constructing History: A Mural by Ben Shahn," *Arts Magazine* 62 (1987): 36–41.

[14]Lucy Lippard, "Judy Chicago's *Dinner Party*," *Art in America* Apr. 1980: 115.

[15]Colette Chattopadhyay, "Betye Saar," *Sculpture* 17 (1998): 77–78.

[16]William Safire and Leonard Safir, eds., *Good Advice on Writing* (New York: Simon, 1992) 29.

[17]Guy Davenport, "Henri Rousseau," *Antaeus* 54 (Spring 1985): 167–68.

[18]Stephen Koch, "Caravaggio and the Unseen," *Antaeus* 54 (Spring 1985): 103–04.

[19]Ralph Ellison, "The Art of Romare Bearden," *Going to the Territory* (New York: Random, 1986) 238.

[20]Safire, 49.

[21]Safire, 210.

CHAPTER SIX

[1]Michael Fried, *Art and Objecthood* (Chicago: U of Chicago P, 1998) 28.

[2]Malcolm Jones, "An American Eye," *Newsweek* 31 Jan. 2000: 62.

[3]Karen Wilkin, "Knavery, Trickery and Deceit," *ARTnews* Sept. 1996: 116–19.

[4]Karen Wilkin, "Jackson Pollock's Retrospective at the Museum of Modern Art," *Partisan Review 66* (1999): 165.

[5]John Canaday, "This Way to the Big Erotic Art Show," *New York Times* 9 Oct. 1966: II, 27.

[6]William Wilson, "James Rosenquist," *Artforum* Dec. 1964: 12.

[7]John Canaday, "Young Italians, Indeed!" *New York Times* 2 June 1968: II, 23.

[8]Robert Pincus-Witten, "Walter de Maria, Mark di Suvero, Richard Serra," *Artforum* Apr. 1968: 65.

[9]Julia Pitts, "Setting Out 2000," *Ceramic Review* May 2000: 42.

[10]Jane Harrison Cone, "Alice Neel," *Artforum* Mar. 1968: 55.

[11]Jed Perl, "The Death of Pierrot," *The New Republic* 6 Sept. 1999: 30.

[12]Edward M. Gomez, "An Abstractionist Maintains the Faith in a Skeptical Era," *New York Times* 17 Sept. 2000: 36.

[13]J. Gluckstern, "Artists Shed Light on America through Images, Icons," *Daily Camera* [Boulder] 21 May 2000: 7D.

[14]Roger Green, "Full Circle," *ARTnews* Mar., 1996: 67.

[15]Robert Hughes, "The Color of Genius," *Time* 28 Sept. 1992: 69.

[16]Harry Cooper, "Jack Tworkov," *Artforum* Apr. 2000: 139.

[17]Shannen Hill, "Thirty Nine Minutes: Installations by Nine Artists," *African Arts* (Summer

1999): 76.

[18]David Ebony, "Tom Duncan at G. W. Einstein," *Art in America* June 1992: 115.

[19]Katy Siegel, "Frank Stella," *Artforum* Apr. 2000: 137.

[20]Jed Perl, "Our Dadaist," *The New Republic* 17 & 24 Apr. 2000: 67.

[21]Jed Perl, "Theory for Gallerygoers," *The New Republic* 20 Mar. 2000: 25–26.

[22]Alisa Tager, "Robert Rauschenberg," *ARTnews* Mar. 1993: 107–08.

[23]Theodore F. Wolff, "Kollwitz Gave Modern Form to Humanity's Most Essential Questions," *Christian Science Monitor* 14 Dec. 1987: 22.

[24]Franz Schulze, "Wilhelmine Berlin," *Art in America* Apr. 2000: 144–45.

[25]Bennett Schiff, "Titian: Art's Venetian Lion," *Smithsonian* Nov. 1990: 67.

[26]Karen Wilkin, "Knavery, Trickery and Deceit," *ARTnews* Sept. 1996: 118–19.

[27]John Canaday, "The Germanness of Max Beckmann," *New York Times* 20 Dec. 1964: II, 23.

[28] Meyer Raphael Rubenstein, "Italy: Liliana Moro," *ARTnews* May 1993: 114.

[29] Julia Pitts, "Setting Out 2000," *Ceramic Review* May 2000: 43.

[30] Brooks Adams, "Ilya Kabakov at Ronald Feldman," *Art in America* Dec. 1992: 109.

[31] Barbara London, "Electronic Explorations," *Art in America* May 1992: 157.

[32] Richard Kalina, "Alex Katz at Marlborough and Brent Sikkema," *Art in America* Mar. 2000: 128.

BIBLIOGRAPHY

Adams, Brooks. "Ilya Kabakov at Ronald Feldman." *Art in America* Dec. 1992: 109.

Brettell, Richard. *The Art of Paul Gauguin.* Washington, D.C.: National Gallery of Art, 1980.

Canaday, John. "The Germanness of Max Beckmann." *New York Times* 20 Dec. 1964: II, 23.

———. "This Way to the Big Erotic Art Show." *New York Times* 9 Oct. 1966: II, 27.

———. "Young Italians, Indeed!" *New York Times* 2 June 1968: II, 23.

Chattopadhyay, Colette. "Betye Saar." *Sculpture* 17 (1998): 77–79.

Cone, Jane Harrison. "Alice Neel." *Artforum* Mar. 1968: 55–56.

Cooper, Harry. "Jack Tworkov." *Artforum* Apr. 2000: 139.

Davenport, Guy. "Henri Rousseau." *Antaeus* 54 (Spring 1985): 167–68.

Ebony, David. "Tom Duncan at G. W. Einstein." *Art in America* June 1992: 114–15.

Ellison, Ralph. "The Art of Romare Bearden." *Going to the Territory.* New York: Random, 1986.

Freud, Sigmund. *Leonardo da Vinci and a Memory of His Childhood.* New York: Norton, 1964.

Fried, Michael. *Art and Objecthood.* Chicago: U of Chicago P, 1998.

Gibaldi, Joseph. *MLA Handbook for Writers of Research Papers,* 5th ed. New York: Modern Language Association of America, 1999.

Gluckstern, J. "Artists Shed Light on America through Images, Icons." *Daily Camera* [Boulder] 21 May 2000: 7D.

Gomez, Edward M. "An Abstractionist Maintains the Faith in a Skeptical Era." *New York Times* 17 Sept. 2000: 36–37.

Green, Roger. "Full Circle." *ARTnews* Mar. 1996: 67.

Greenberg, Clement. "Master Léger." *Partisan Review* 21 (1954): 90–97.

Hill, Shannen. "Thirty-Nine Minutes: Installations by Nine Artists." *African Arts* (Summer 1999): 76–77.

Hughes, Robert. "The Color of Genius." *Time* 28 Sept. 1992: 67–69.

Huxley, Aldous. *Themes and Variations.* New York: Harper, 1943.

Janson, Horst W. *Sixteen Studies.* New York: Abrams, 1973.

Jones, Malcolm. "An American Eye." *Newsweek* 31 Jan. 2000: 62.

Kalina, Richard. "Alex Katz at Marlborough and Brent Sikkema." *Art in America* Mar. 2000: 127–28.

Koch, Stephen. "Caravaggio and the Unseen." *Antaeus* 54 (Spring 1985): 103–04.

Lippard, Lucy. "Judy Chicago's *Dinner Party.*" *Art in America* Apr. 1980: 115–26.

London, Barbara. "Electronic Explorations." *Art in America* May 1992: 120+.

Lorio, Jim. "Artist's Statement," Dec. 2000.

Perl, Jed. "The Death of Pierrot." *The New Republic* 6 Sept. 1999: 30–35.

———. "Our Dadaist." *The New Republic* 17 & 24 Apr. 2000: 66–70.

———. "Theory for Gallerygoers." *The New Republic* 20 Mar. 2000: 25–28.

Pincus-Witten, Robert. "Walter de Maria, Mark di Suvero, Richard Serra." *Artforum* Apr. 1968: 63–65.

Pitts, Julia. "Setting Out 2000." *Ceramic Review* May 2000: 42–43.

Pohl, Frances K. "Constructing History: A Mural by Ben Shahn." *Arts Magazine* 62 (1987): 36–41.

Rosenblum, Robert. *On Modern American Art.* New York: Abrams, 1999.

Rubenstein, Meyer Raphael. "Italy: Liliana Moro." *ARTnews* May 1993: 114.

Safire, William, and Leonard Safir, eds. *Good Advice on Writing.* New York: Simon, 1992.

Schiff, Bennett. "Titian: Art's Venetian Lion." *Smithsonian* Nov. 1990: 67–68.

Schulze, Franz. "Wilhelmine Berlin." *Art in America* Apr. 2000: 144–47.

Siegel, Katy. "Frank Stella." *Artforum* Apr. 2000: 137.

Stuckey, Charles F. *Claude Monet 1848–1916.* Chicago: Art Institute of Chicago, 1995.

Tager, Alisa. "Robert Rauschenberg." *ARTnews* Mar. 1993: 107–08.

Tuchman, Barbara. *Practicing History.* New York: Random, 1980.

Turabian, Kate. *A Manual for Writers of Term Papers, Theses, and Dissertations*, 6th ed. Chicago: U of Chicago P, 1996.

Wilkin, Karen. "Knavery, Trickery and Deceit." *ARTnews* Sept. 1996: 116–19.

———. "Jackson Pollock's Retrospective at the Museum of Modern Art." *Partisan Review* 66 (1999): 165–74.

Wilson, William. "James Rosenquist." *Artforum* Dec. 1964: 12.

Wolff, Theodore F. "Kollwitz Gave Modern Form to Humanity's Most Essential Questions." *Christian Science Monitor* 14 Dec. 1987: 21–22.

Wolff, Theodore F., and George Geahigan. *Art Criticism and Education.* Urbana: U of Illinois P, 1997.

INDEX

Page numbers in italics indicate illustrations.

Abe, Kobo, 140
Absolute phrase, 190
Abstract art, 31
Abstract Expressionism, 40, 88, 116
Active verb, 186, 191, 192
Actual shape, 35
Actual texture, 34
Adams, Brooks, 140
Adjective, 186-87, 189
Adjective clause, 190
Adverb, 187, 189, 199
Adverb clause, 190
Aeneid, 2
Aerial perspective, 36
African art, 61
African Arts, 132
AltaVista, 149
Analysis, 3
Analyze, 7, 42
Annotated bibliography, 156
Apostrophe, 206-07
Appositive phrase, 189
Architectural Index, 148
Argument, 1, 2, 5, 6, 7, 87-103
Argumentative essay, 5, 6, 7, 18, 20, 87-103
Argumentative research paper, 8, 143, 144, 151
Art Abstracts, 148
Art Bulletin, 143, 155
Art critic, 7, 116
Art criticism, 11-17
ArticleFirst, 147
Artforum, 126, 127, 128, 131, 133
Art History, 146
Art History Research Centre, 149
Art in America, 133, 136, 140, 141
Art Index, 146, 147
ARTnews, 131, 135, 139, 146
Art Newspaper, 146, 147
Arts & Humanities Search, 148
Artist's statement, 1, 8
Ashcan School, 63
Assyrian art, 62
Asymmetrical balance, 38
Atmosphere perspective, 36

Audio program, 115, 123
Avery Index to Architectural Periodicals, 147
Axial balance, 37

Balance, 12, 37, 133
Baroque, 62, 106
Baxendale II, Ron E., 7, 42, 43-49
Bearden, Romare, 26
Beardsley, Aubrey, 128
Beckmann, Max, 139
Bibliography, 7, 26, 156
Bibliography of the History of Art, 148
Bilateral balance, 37
Blake, William, 88, 105
Block method, 24, 75
Boccioni, Umberto, 36
 Unique Forms of Continuing Space, 36
Bosch, Hieronymus, 30
 Garden of Earthly Delights, 30
Botticelli, Sandro, 27
 The Birth of Venus, 27
Bourgeois, Louise, 60
Brackets, 209
Brainstorming, 17
Braque, Georges, 34
Brancusi, Constantin, 189-190
 Bird in Space, 189
 Endless Column, 190
 Table of Silence, 190
 Torso of a Girl, 190
British Museum, 144, 169-83
Brochure, 123

Canaday, John, 126, 139, 141
Canova, Antonio, 61
 Pauline Borghese as Venus, 61
Card, 123
Caravaggio, 3, 24, 63
 Repose on the Flight into Egypt, 24
 Magdalene Repentant, 24
Caro, Anthony, 116
Carriera, Rosolba, 63
Cassatt, Mary, 61, 197
 The Bath, 197
Çatal Hüyük, 63
Catalogue, 10, 123
Catalogue entry, 1, 10
Ceramic Review, 127, 140

Cézanne, Paul, 62, 88, 120
Chagall, Marc, 202
 Woman, Flowers, and Bird, 202
Chattopadhyay, Colette, 17
Chiaroscuro, 34
Chicago, Judy, 15, 16
 The Dinner Party, 15, 16, *16*
Chicago Manual of Style, 115
Chihuly, Dale, 198-99
Christian Science Monitor, 135
Christian Science Monitor Index, 148
Christo, 190-91
 Surrounded Islands, 190-91
Cimabue, 61
 Madonna Enthroned, 61
Classical art, 88, 146
Clauses, 190-91
Coffelt, Donald, 75-77
Colon, 206, 208
Color, 12, 33, 34, 35, 131
Column of Trajan, 61
Comma, 203-05, 208
Comma splice, 199
Comparative essay, 6-7, 66-74
Comparison paragraph, 24
Complement, 188-89
Complementary colors, 34
Complex sentence, 191
Composition, 12, 36
Compound sentence, 191
Compound-complex sentence, 191
Concluding sentence, 22
Conclusion, 25, 141, 86, 138-41
Cone, Jane Harrison, 128
Conjunction, 187, 199, 204
Contemporary Art and Artists, 147
Content, 30
Content note, 154
ContentsFirst, 147
Contour line, 33
Controlling idea, 125
Contrapposto, 58
Constructive argument, 5, 92, 93, 94
Contextualist criticism, 1, 3
Contrast, 12
Cooper, Harry, 131
Cornell, Joseph, 135
Counterargument, 20
Counterpoint, 20, 88, 89, 92, 93, 94, 95
Counter-thesis, 20, 88, 89, 92, 93, 94
Courbet, Gustave, 63
 The Stone Breakers, 63

Couse, Irving, 96, 99
 The Captive, *96*, 99
Critic, 7, 116
Critical essay, 6, 7, 11
Criticism, 6, 11
Critique, 6
Cubism, Cubist, 62, 63, 88

Dadaism, Dadaist, 40, 134
Daily Camera, 130
Dali, Salvador, 193
Dangling modifier, 200
Dasburg, Andrew, 41, 43-49
 Chantet Lane, 7, 41, *41*, 42, 43-49
Dash, 206
Davenport, Guy, 23
David and Goliath, 19, 20, 58-60
David, Jacques-Louis, 61, 105, 107, 110, 111-
 113
 Madame Récamier, 61
 Oath of the Horatii, 107, *107*, 110, 111-13
Davis, Lionel, 132, 138
 Untitled, 132
Degas, Edgar, 7, 118-22, 138
 After the Bath, *119*, 120
 After the Bath, Woman Drying Herself, 119,
 120, 121
 Hélène Rouart in Her Father's Study, 121
 Millinery Shop, 121
 Red Ballet Skirts, 120
 Three Dancers in Yellow Skirts, 120
De Kooning, Willem, 88, 131, 132
Delacroix, Eugène, 88, 119, 120, 154, 158
De Maria, Walter, 127
Denver Art Museum, 9
Dependent clause, 190, 198
Description, 1, 2, 6, 7
Descriptive Essay, 2, 7, 18, 20
Descriptive research paper, 7, 143, 144, 150,
 158-65
Design, 133
Detail, 34
Diaristic criticism, 1, 12
Dimension, 36
Direct object, 188
Dissertation, 7, 143
Di Suvero, Mark, 127
Dix, Otto, 135
Donatello, 20
Duchamp, Marcel, 36, 37
 Nude Descending a Staircase, 36, 37
 Why Not Sneeze?, 134

Duncan, Tom, 133
 At Waverly Station, 133
 In Memory of John F. Kennedy, 133
Dürer, Albrecht, 203-209
 Apocalypse, 205
 Fall of Man, The, 205
 Great Piece of Turf, The, 204, 208
 Knight, Death, and the Devil, The, 205
 Hare, 206
 Four Apostles, The, 204
 Four Horsemen, The, 203
 Life of the Virgin, 203
 Melancholia, 206
 Nativity, The, 203, 204
 Rhinoceros, 203, 204
 St. Jerome, 203
 St. Michael's Fight against the Dragon, 207, 208

Ebony, David, 133
ECO (Electronic Collections Online), 147
Egyptian art, 62
Electronic database, 147, 148
Elements of style, 12
Elgin marbles, 8, 26, 144, 145, 146, 147, 148, 149, 152, 153, 154, 166-82
El Greco, 4, 5
 Baptism of Christ, 4, 5
 Burial of Count Orgaz, 5
 Dream of Phillip II, The, 5
Ellipsis points, 209
Ellison, Ralph, 26
Endnote, 143, 154, 155, 156
Energy-in-Reserve, 58
Essay examination, 105-13
Evaluation, 5
Evans, Walker, 116-17
 Alabama Tenant Farmer Wife, 116-17, *117*
Eyck, Jan van, 31, 34, 35
 Giovanni Arnolfini and His Bride, 31, 34, *35*
Exhibition, 115
Exhibition display, 124, 137
Exhibition review, 1, 7, 115-42
Exposition, 1, 2, 3, 6, 7, 52
Expository essay, 3-4, 6, 7, 18, 20, 51-85, 87
Expository research paper, 8, 143, 144, 150

Faulkner, William, 1
Faulty comparison, 201
Faulty definition, 201
Faulty predication, 200
Feminist criticism, 1, 15, 16

Fichner-Rathus, Lois, 208
FirstSearch, 147
Fishman, Louise, 130
Flaneur, 118
Flashcards, 106-07
Fluxus art, 116
Footnote, 143, 154, 155-56
Formal analysis, 7, 29, 40-49
Formal description, 40
Formal elements, 7, 12, 29, 33-36, 40, 124, 129, 131, 133
Formalistic criticism, 1, 12, 13
Format for essay, 27
Foreshortening, 36
Fragment, 198-99
Fragonard, Jean-Honoré, 62
 The Swing, 62
Frankenthaler, Helen, 61
 Bay Side, 61
Freewrite, 17
Fried, Michael, 116
Frieman, Thilo, 111
Freud, Sigmund, 5, 13, 14
Fuller, William, 99
 Crow Creek Agency, Dakota Territory, 1884, 99
Fused sentence, 199
Fuseli, Henry, 64, 65, 66-73, 105
 The Nightmare, 64, *65*, 66-73

Gallery, 9, 115, 122
Gardner's Art Through the Ages, 208
Gauguin, Paul, 11
 Farm at Arles, 11
 Haystacks, The or *The Potato Field*, 11
 Landscape at Le Pouldu, 11
Geahigan, George, 11, 156
Genre, 32
Gentileschi, Artemisia, 63, 88
Géricault, Théodore, 26, 52, 78-84
 Portrait of an Insane Man, 79-84
 Raft of the Medusa 78, 78-84
Gerund phrase, 189
Giotto, 39, 61
 Madonna Enthroned, 61
Gluckstern, J., 130
Gober, Robert, 134-38
Gogh, Vincent van, 34, 61, 63
 Night Café, 61
 Potato Eaters, 61
Gomez, Edward M., 130
Gothic architecture, 3, 61

Google, 149
Gothberg, Rachel, 7, 64, 66-73, 78-84
Goya, Francisco, 64, 65, 66-73, 105, 110, 111-13
 Los Caprichos, 66
 Sleep of Reason Produces Monsters, The, 64,
 65, 66-73
 Third of May, The, 110, 111-13
Greek art, 62, 63, 145
Green, Roger, 131
Greenberg, Clement, 12, 13
Grosz, George, 135
Grove Dictionary of Art, 148
Grünewald, Matthias, 61, 205
 Crucifixion, 61
 Resurrection, 61

Handbook, 185-209
Hanson, Duane, 15, 61
Harcourt College Publishers Web Site, 149
Hemingway, Ernest, 27
Hill, Shannen, 132, 138
Horror vacui, 62
Hue, 34
Hughes, Bill, 10
 Land of Condor, 10
Hughes, Robert, 131
Huxley, Aldous, 5

Iconography, 30
Ideological criticism, 14
Impasto, 34
Implied shape, 35
Implied texture, 34
Impressionism, Impressionist, 39, 60, 63, 118,
 120, 122, 138
Independent clause, 190, 191, 198, 199
Index cards, 19, 22, 124
Index of Twentieth Century Artists, The, 147
Index to Nineteenth Century American Art Peri-
 odicals, 147
Inductive leap, 3
Inductive reasoning, 3
Inference, 3, 51
Infinitive phrase, 189
InfoSeek, 149
InfoTrac, 148
Ingres, Jean-Auguste-Dominique, 88, 105,
 119
Intensity, 34
Interjection, 187-88
Internet, 143, 148-49
Interpretation, 5
Introduction, 21, 22, 41, 64, 88-92, 124-29

"Ism," 29, 134
Italo-Byzantine, 39, 63

Jewett, Williams, 98
 Promised Land—The Grayson Family, 1850,
 The, 98
Johns, Jasper, 12
 Three Flags, 12
Jones, Malcolm, 116-17
Journal, 7, 146

Kabakov, Ilya, 140
Kalina, Richard, 141
Kandinsky, Wassily, 32, 33, 62
 With the Black Arch No. 154, 32, 33
Katz, Alex, 142
 West 2, 141
Kelly, Ellsworth, 61
 Red Blue Green, 61
Keyword, 145
Klee, Paul, 152, 159
 Twittering Machine, 62
Kollwitz, Käthe, 135, 136
 Mothers, The, 136
Knossos, 75-78
Koch, Stephen, 24

Labels, 1, 9, 123
Lange, Dorothea, 61
 Migrant Mother, Nipomo, California, 61
Lamassu, 62
Laocoön, 2, 62
Lascaux, 18
Lawrence, Jacob, 131
 "Hiroshima," 131
 Man with Birds, 131
 Workshop, 131
Leanin' Tree Museum of Western Art, 10
Léger, Fernand, 12
 Three Women, 12
 Le grand déjeuner, 12
Leonardo da Vinci, 13, 14, 62, 88, 204
 Embryo in the Womb, 204
 Last Supper, 193-95
 Madonna and Child with Saint Anne, 13, 14
 Mona Lisa, 62, 88
 Saint Anne with Two Others, 13
Lin, Maya Ying, 61
 Vietnam Memorial, 61
Line, 12, 33, 35, 131
Linear perspective, 36
Linking verb, 186, 188
Lippard, Lucy, 16

London, Barbara, 141
[London] *Times Index*, 148
Lorio, Jim, 8
Los Angeles Times Index, 148
Lujan, Jason, 130
Lycos, 149

Magazine, 146
Malamud, Bernard, 17
Manet, Edouard, 18, 62
 Le déjeuner sur l'herbe, 62
Mannerism, Mannerist, 62
Maraccio, Fabian, 133
Marx, Karl, 15
Marxist criticism, 1, 15, 17
Master's thesis, 7
Matisse, Henry, 23, 120, 131, 132
 Conversation, 131, *132*
Meaning, 30
Medium, 7, 29, 39, 40, 124, 129, 133
Michelangelo, 5, 18, 19, 20, 21, 51, 52, 53, 54,
 55, 56, 57-60, 88
 David, 18, 19, 20, 21, 51, 52, *53*, 53, 54, 55,
 56, 57-60
 Moses, 5
 Sistine Ceiling, 88
Mills, Wes, 134, 135
Mind mapping, 17, 18, 106
Minoan art, 52, 61, 75-77
Misplaced modifier, 200
Mixed construction, 202
Modes of discourse, 1, 2-6
Modifier, 189, 200
MLA (Modern Language Association) docu-
 mentation style, 143, 144, 154, 155,
 166-68
MLA Handbook for Writers of Research Papers,
 The, 155, 166
Mondrian, Piet, 34
Monet, Claude, 9, 120
 Cliffs and Sea, Saint-Adresse, 9
Moore, Henry, 186-87
 Reclining Figure, 186
 Reclining Nude, 186
Moro, Liliana, 139-40
Moses, Grandma, 88
Motion, 33, 36, 131
Movement, 39
Multiculturalist criticism, 1, 16, 17
Munch, Edvard, 62
 The Scream, 62
Museum, 9, 115, 122
Mycenaean citadels, 61

Narration, 1, 2, 6
National Newspaper Index, 148
Neel, Alice, 127-28
Neoclassicism, 105, 106, 107
Newspaper article, 148
Nevelson, Louise, 191
 Mrs. N's Palace, 191
NetFirst, 147
Newsweek, 116, 146
New Republic, The, 128, 134
New York Times, 126, 130, 139
New York Times Index, 148
Noland, Kenneth, 120
Nonobjective art, 31, 32
Nonrepresentational art, 29, 31, 32, 88
Nonsexist language, 196
Northern Light, 148
Noun, 186
Noun clause, 190-91
Numbered notes system, 154-56, 158-66

O'Byrne, Susan, 127
O'Connor, Emily, 169-82
OCLC FirstSearch, 147
O'Keeffe, Georgia, 15, 62
Oldenburg, Claes, 61
 Clothespin, 61
Oppenheim, Meret, 62
 Object, 62
Outlining, 21, 56, 94, 108, 150, 151
Overlapping, 36
Oxford Guide to Library Research, The, 145

Painterly method, 34
Palette of Narmer, 62
Pamphlet, 123
Panofsky, Erwin, 207
Paragraph, 22
Paragraph coherence, 22, 25, 42, 129
Paragraph development, 22, 23, 42, 129
Paragraph organization, 22, 24, 42, 129
Paragraph unity, 22, 23, 42, 129
Parallel construction, 202-03
Paraphrasing, 144, 152
Parenthetical source citations, 154, 166-83
Parthenon, 39, 61, *145*, 147
Participial phrase, 190, 200
Partisan Review, 125, 207
Parts of speech, 185-88
Passive verb, 191, 192
Pei, I.M., 88
 Louvre pyramid, 88

PerAbs (Periodical Abstracts), 147
Performance art, 116
Period style, 39, 134
Periodical, 146
Periodical articles, 146-48
Perl, Jed, 128, 134, 135, 138, 142
Personal style, 39
Perspective, 35
Phrase, 189-90
Picasso, Pablo, 3, 31, 32, 34, 62, 63, 88, 135,
 188-89
 Chicago Civic Center Plaza sculpture,
 188-89
 Les Demoiselles d'Avignon, 62
 Three Musicians, 31, 32
Pincus-Witten, Robert, 127
Pisano, Nicola and Giovanni, 63
Pitts, Julia, 127, 140
Plagiarism, 144, 152
Pohl, Frances K., 15
Point-by-point method, 24, 75
Points of proof, 20, 22, 56, 88, 92, 93, 94
Pollock, Jackson, 3, 125
Post-Impressionism, 40, 63
Pottery, 8-9, 63
Poussin, Nicholas, 61
Preposition, 187, 189
Prepositional phrase, 189
Prewriting, 17, 18
Primary colors, 34
Principles of design, 7, 29, 36-39, 40, 124, 129,
 133
Print index, 146, 148
Process for writing, 1, 17-28
Pronoun, 186, 193-95
Pronoun-antecedent agreement, 194-95
Pronoun case, 193-94
Pronoun reference, 195
Proportion, 38, 39, 133
Proposition, 88
Proof question, 20, 56
Proto-Renaissance, 39
Psychoanalytical criticism, 1, 13, 14
Punctuation, 203-09

Queen Mother Head, 197, *197*
Quotations, 143, 153, 209
Quotation marks, 207-09
Radial balance, 38

Raphael, 35
Rauschenberg, Robert, 61, 135
Reader's Guide to Periodical Literature, 147
Rebuttal, 5

Reference note, 154
Refutation, 5, 20, 87, 92, 93, 94, 95
Rembrandt, van Rijn, 34, 61, 120
 Night Watch, The, 34
Renaissance, 39, 52, 137
Repetition, 12, 25
Representational art, 29, 31, 88
Research question, 18, 22, 52
Research paper, 1, 7, 143-83
Retrospective, 125
Review, 115-42
Rhythm, 39, 133
Ribera, José, 62
 The Martyrdom of St. Bartholomew, 62
RILA (*Repertoire international de la littérature de
 l'art*), 148
Rivera, Diego, 201
Rodin, Auguste, 3, 34, 120
 Kiss, The, 34
 Monument to Balzac, 34
Rococo, 62
Roman art, 88
Romantic paintings, 7, 26, 51, 64, 66
Rosenblum, Robert, 12
Rosenquist, James, 126
Rothenberg, Susan, 207
Rousseau, Henry, 23
 The Sleeping Gypsy, 23, *23*
 La bohemienne endormie, 23, *23*
Rubens, Peter Paul, 62
 Rape of the Daughters of Leucippus, The, 62
Rubinstein, Meyer Raphael, 139
Rudiger, Bernard, 140
Rudenstine, David, 148, 152, 153
Run-on sentence, 199-200

Saar, Betye, 17
 Tangled Roots, 17
Saturation, 34
Scale, 38, 133
Scaliese, Peter, 158-65
Scharf, Kenny, 133
Schiff, Bennett, 137
Schjeldahl, Peter, 142
Schulze, Franz, 136, 137, 138
Secondary colors, 34
Segal, George, 61
Semicolon, 199, 205
"Sensation," 88
Sentence, 191, 198-203
Sentence parts, 188-89
Sentence structure, 198-203
Sentence types, 191
Serdab, 62